2003

ADOLPH GOTTLIEB: A RETROSPECTIVE

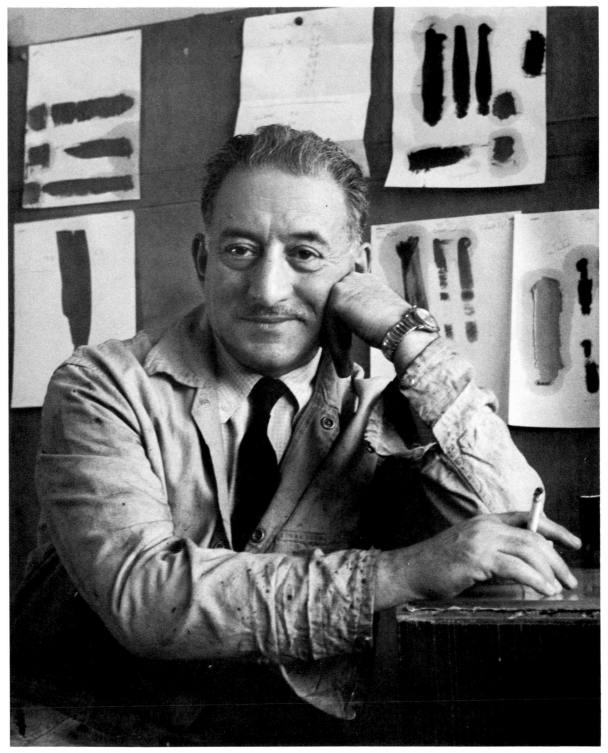

Adolph Gottlieb in his 23rd Street studio, ca. 1965 Photo © Marvin P. Lazarus

ADOLPH GOTTLIEB
A RETROSPECTIVE

Organized by
Sanford Hirsch
and
Mary Davis MacNaughton

Text by
Lawrence Alloway
and
Mary Davis MacNaughton

Published by
The Arts Publisher, Inc.

in association with the
Adolph and Esther Gottlieb Foundation, Inc.

Distributed by
Hudson Hills Press, New York

Published by The Arts Publisher, Inc., New York, in association with the Adolph and Esther Gottlieb Foundation, Inc., 1981

Library of Congress Catalog number: 81-65351

Book design: Dana Levy
Editors: Taffy Swandby
 Kennie Lyman

Distributed by Hudson Hills Press, Inc., Suite 1308, 230 Fifth Avenue, New York, NY 10001-7704.
Distributed in the United States, its territories and possessions, Canada, Mexico, and Central and South America through National Book Network.
Distributed in the United Kingdom, Eire, and Europe through Art Books International, Ltd.
Exclusive representation in Asia, Australia, and New Zealand by EM International.

ISBN 1-55595-125-2

Contents

Acknowledgements

This survey of the work of Adolph Gottlieb relfects the diligence and dedication of many people, several of whom are mentioned below. To those whose names do not appear I extend my sincere apologies, and trust that they will understand the limitations inherent in this type of listing. I hope that all those who were involved in this undertaking will take some satisfaction in knowing that the successful organization and completion of this project is a direct result of their good efforts.

A special note of gratitude is due Esther Gottlieb. Owing to her dedication to her husband's painting, she took upon herself the financial support of their household, as well as Gottlieb's painting supplies, for many years. At the same time, Mrs. Gottlieb acted as studio assistant, confidant, critic, registrar and archivist. Her active support of her husband's career lasted from the time of their marriage in 1932 to the time of his death in 1974. When Gottlieb suffered a stroke in 1971 which confined him to a wheelchair, it was Mrs. Gottlieb, acting against the advice of his doctor, who saw to it that her husband was able to resume painting. If not for the devotion and support of his wife, Gottlieb's career would have been vastly different. Without Mrs. Gottlieb's continuing support of our efforts, this project could not have been organized.

I would like to thank Mary Davis MacNaughton for her invaluable assistance in organizing this retrospective and selecting the works to be shown and discussed; as well as for her fine essay on the first phases of Gottlieb's career. In the past four and one half years, Dr. MacNaughton has, as a result of her determined research, made many important contributions to the appreciation and understanding of Gottlieb's work, and the period of the 40's and 50's in general. Her intensive efforts in this regard made her the natural choice as co-organizer of this project. Her patience, perserverance, and friendship have added immensely to my satisfaction with its results.

Thanks also to Mr. Lawrence Alloway for his essay on Gottlieb's later work. Mr. Alloway's generosity in undertaking this endeavor on short notice, and sharing with us his thoughts and well-considered opinions are greatly appreciated. He has been a great source of advice and encouragement.

I would like to express my gratitude to my assistant Nancy Pierson, for her patience, endurance and hard work throughout. Ms. Pierson has performed all the thankless tasks without which no project of this size can be completed. She has proven herself a master at tying up the loose ends that all of us worked so hard to create.

Mr. Dana Levy deserves credit for his fine design of this book, and thanks for his good advice and support of our efforts. Mr. James Witt of The Arts Publisher has also been a strong supporter of our project, and has made an extraordinary effort in seeing that the production of this book conformed to his high standards. My thanks

to Otto and Marguerite Nelson, who are responsible for the majority of the beautiful photographs of Gottlieb's paintings. Mr. and Mrs. Nelson have been, as usual, most kind and pleasant to work with. Thanks also to Ms. Elizabeth Cellato of the Guggenheim Museum, who went to great lengths on our behalf in obtaining photos and locating collectors. My deep appreciation to Dr. Dick Netzer and Mr. Palmer Wald, directors of the Adolph and Esther Gottlieb Foundation, whose assistance with and belief in my efforts were an important asset in coordinating the various phases of this retrospective.

I am also indebted to Jane Livingston of the Corcoran Gallery of Art for her assistance and advice in planning the exhibition phase of this project. Thanks are also due to the following people for their advocacy of and participation in the exhibition: Mr. Robert T. Buck, Jr. of the Albright-Knox Gallery of Art, Dr. Anthony Janson of the Indianapolis Museum of Art, Dr. Richard Murray of the Birmingham Museum of Art, Dr. Andrea Norris of the University Art Museum at Austin, Mr. Robert Phillips of the Toledo Museum of Art, Mr. Earl A. Powell III and Mr. Maurice Tuchman of the Los Angeles County Museum of Art, Dr. Richard Wattenmaker of the Flint Institute of Arts. My deep appreciation to Bill and Doris Zamprelli, who were responsible for the crating and shipping of the paintings.

A large debt of thanks is owed to the owners of the works included in this retrospective, who are listed elsewhere in this publication. All of these individuals and institutions have been most kind in lending their paintings for an extended period, and in cooperating in the publication of this book.

Finally, my thanks to all of the following people whose help, advice, labors, and generosity have made a significant contribution to this project: Anita Duquette, Ann Freedman, Caroline Goldsmith, Deborah Beblo Hirsch, Alkis Klonaridis, Everard Lee, Kennie Lyman, Gordon Marsh, Charles Millard, Steven Nash, William Pall, Cora Rosevear, William Rubin, Myrna Smoot, Louise Svendsen, Taffy Swandby, Richard Tooke, and Fred Tuerck and his crew.

Sanford Hirsch
Administrator/Curator
Adolph and Esther Gottlieb
Foundation, Inc.

Introduction

Within the past few years, there has been a renewed interest in the group of artists known as the Abstract Expressionists. Investigation into the development and contributions of each of these artists has led to a greater insight into their concerns and has contributed to our understanding of the vast changes in the visual arts for which they are responsible. It is as a part of this effort to comprehend this diffuse and explosive group and its times that the Adolph and Esther Gottlieb Foundation has organized this retrospective survey of the work of Adolph Gottlieb.

One of the distinguishing characteristics of this group of artists is the informal nature of their coalitions. The alliances that these artists formed were made up of a few individuals and were designed mainly to allow for discussions of their aims among themselves. Over a period of approximately twenty-five years, a number of groups were formed. Each had different members, and none lasted for more than a few years. The common goal which unified these artists was a dedication to a vital contemporary American art. However, they also shared the belief that this art must embody the personal experience of each artist.

The relationship of Adolph Gottlieb to his contemporaries is fairly representative of the group. He joined the Artist's Congress in 1935. In 1939 he resigned in protest over the Congress's political activities and became a founding member of the Federation of Modern Painters and Sculptors, serving as president of this group in 1944. In 1943 Gottlieb and Mark Rothko, with the assistance of their friend Barnett Newman, drafted the often-quoted letter to Edward Jewell of the *New York Times* (Appendix A) proclaiming the goals of the modern American artist. Also in 1943, Gottlieb organized a group called New York Artist-Painters, and in 1944 he helped organize The Graphic Circle. It was Gottlieb who, in 1950, organized the famous "Irascibles" group to protest the organization of and selection of jurors for an exhibition at the Metropolitan Museum of Art in New York. In the open letter which he drafted on that occasion, Gottlieb reflects the common concern of the group:

> The organization of the exhibition and the choice of jurors . . . does not warrant any hope that a just proportion of advanced art will be included.
>
> We draw to the attention of those gentlemen the historical fact that, for roughly a hundred years, only advanced art has made any consequential contribution to civilization.

From 1932 to 1956 Gottlieb mainly lived and worked in Brooklyn, away from the majority of his peers in Manhattan. He claimed to prefer the less hectic pace which allowed him to concentrate on his painting. As he wrote to his friend Harold Baumbach on January 3, 1938:

> . . . this [feeling about progress in his paintings] may be purely the result of working alone. Perhaps having someone else comment on your work every other day tends to sidetrack one, and also having a sympathetic commentator close at hand may be a form of self-indulgence.

It is not surprising, then, that one of the distinguishing features in Gottlieb's work is the intensity and concentration which he devoted to each painting. This attitude was the result of a decision Gottlieb made in Arizona in 1938. In another letter to Baumbach, dated January 18, he wrote:

> Another thing—I have changed my mind about an idea of Milton's [Avery]—as he says, "don't try to paint a masterpiece." It seems to me now that that is the very thing to do—try to make a masterpiece—it probably won't be one anyway. Of course, from his point of view, Milton's right, there are many pictures that would be pretty good if they were not belaboured and worked to death in trying for perfection. But right now I am sick of the idea of all the *pretty good* pictures and want a picture that is either *damn good* or no good.

Gottlieb retained this attitude for the rest of his life.

One of Gottlieb's concepts was that each painting should contain as much information as possible. In order to allow himself to concentrate on the things which were important to him in each painting, he developed a unique approach to the idea of style. It was Gottlieb's practice to develop a style of painting based on the general range of ideas which he wanted to explore. This allowed him to accept certain limitations as given, and thereby devote his energies to the crucial issues of a specific painting. In the case of the Pictographs, for example, the grid presupposes a certain formal structure to the painting, while allowing for endless invention within its boundaries. After he had worked with one style for a certain period, Gottlieb found that the ideas he chose to pursue had been refined through his approach. At that point, he would develop a new style in order to continue his exploration. In selecting examples for this retrospective, we counted twelve fully developed styles in which Gottlieb worked.

Given this approach to style, it is unfortunate that the popular notion still remains that the Burst paintings of the late 50's are the culmination of Gottlieb's career. As important as the Burst paintings are, they are only one of the results of a life-long process of refining ideas, which continued for eighteen years after the development of the Burst paintings. Within this process there is no one point of greatest importance, as each new work builds on its predecessor. Gottlieb's was a complex, highly personal and, finally, very subtle method of working. It was, by nature, so personal an exploration that it did not readily attract a large audience. This is something which Gottlieb accepted and spoke of many times. He felt that great art, advanced art, could not be understood by a large audience—there would always be a small, dedicated elite group that would comprehend and accept art of consequence. The challenge for Gottlieb, as well as for many of his peers, was to work towards the creation of the ultimate visual statement. This goal is reflected in an address which Gottlieb delivered to a conference of the Pacific Art Association in April, 1956

> His [the artist's] values have to center around creativity and nothing else. Therefore, to paint well, to express one's own uniqueness, to express something of the uniqueness of one's own time, to relate to the great traditions of art, to communicate with a small but elite audience, these are the satisfactions of the artist.

<div align="right">Sanford Hirsch</div>

Adolph Gottlieb: His Life and Art

Mary Davis MacNaughton

Part I: Student Years And Early Work, 1903-1940

Growing Up in New York

East Tenth Street, across from Tompkins Square Park, is a quiet island in the noisy ocean of New York City—a tranquil neighborhood of modest brownstones. It looks much the same today as it did on March 14, 1903, when Adolph Gottlieb was born there to his parents, Emil (1872–1947) and Elsie (1882–1958) Gottlieb.[1] As children they had emigrated with their families to the United States from an area of the Austrian-Hungarian Empire, now Czechoslovakia. In New York Elsie Berger's father became a wholesale grocer, and Emil's father, Leopold Gottlieb, established a stationery supply business, called L. Gottlieb & Sons. On June 15, 1902, Elsie and Emil married and settled in New York, where Emil succeeded his father in the family business. Adolph (1903-1974), their first child and only son, was followed by Edna (1908-1956) and Rhoda (1914-).

During the years Gottlieb was growing up, his family lived in the Bronx until moving in the mid-twenties to 285 Riverside Drive, Manhattan.[2] "I'm a born New Yorker," he said. "I was born on Tenth Street . . . But I left Tenth Street when I was about five or six years old."[3] Gottlieb was raised in a comfortable Jewish home in which his parents hoped that he would eventually enter the family business. But even as a child he began to resist their career expectations for him. At an early age, sometime during his teenage years, he became interested in art. As a teenager Gottlieb rebelled by becoming preoccupied with art, which his parents, as he recalled, deplored.[4] In 1919, increasingly dissatisfied with high school, he dropped out and began working in his father's business. But stationery did not appeal to him either. This disappointed his parents, who worried about his impractical pursuit of art, yet they were unable to dim his enthusiasm.

Gottlieb exhibited an independent attitude at a young age, moving from one art school to another. During high school he had taken Saturday classes at the Art Students' League, and in the summer of 1920 he enrolled in a life drawing class at the Parsons School of Design. He also took a design course at Cooper Union, and in the winter and spring of 1921 attended Robert Henri's lectures at the League.[5] Henri's non-academic approach to painting, which he espoused in these lively talks, left its imprint on Gottlieb. He was especially affected by Henri's advice to paint directly on the canvas, instead of from a preliminary sketch. That Gottlieb absorbed Henri's method is seen in his preference throughout his career for working without sketches to ensure a freshness of expression.

At this time Gottlieb also studied basic techniques of painting from reading on his own. He recalled reading a "book on painting by a fellow named Hamilton Easter Field," which was probably *The Technique of Oil Painting and Other Essays* (1913).[6] Gottlieb remembered that it was from this book "I learned how to prime a canvas, how to size it . . . in the traditional way." From Field he also acquired a taste for low-keyed color, which he continued to hold for many years. Gottlieb recalled that Field recommended "the palette that the old masters used. Primarily earth colors . . . I still think it is quite sound because the greatest colors are these very simple colors."[7]

But more than Field, it was John Sloan who helped shape Gottlieb's early style. In 1921 Gottlieb enrolled in an illustration course with Sloan, who had established his reputation as a leading artist in the Eight, the group of realist painters who were the pioneers of American twentieth-century art. Sloan, who during the twenties taught artists as diverse as Alexander Calder, Gottlieb, John Graham, Reginald Marsh, and George L. K. Morris, was popular with students because he encouraged them to pursue individual directions in their art. Before developing their own styles, however, Sloan told students to "study the masters to learn what they did and how they did it, to find a reason for being a painter yourself."[8]

Gottlieb took Sloan's advice to heart. But he was not content with studying the art available in New York museums—he had to go to Europe. His parents were shocked when, in 1921, at the age of eighteen, Gottlieb announced that he was going abroad. In spite of their objections, he departed, accompanied by a high-school friend who, like him, had no passport. Gottlieb and his friend worked their way to Europe on a passenger ship bound for Le Havre.

Europe, 1921–1922

Gottlieb wanted to study art in Paris but had no money for tuition, so he went to the life drawing class at the Acadmie de la Grande Chaumière, an institution where registration cards were checked only periodically. So as not to be caught, Gottlieb worked from the model on the days between the instructor's visits. He attended only this sketch class and had no formal instruction in Paris. Instead, he spent most of his time doing what Sloan advised—studying the works of the old masters at first hand. Almost daily he visited the Louvre, where he was attracted to early Renaissance painting, in particular panel painting of the thirteenth and fourteenth centuries. Later he drew on his memory of these segmented, polyptych compositions as he formulated the grids in his Pictographs. Gottlieb was also interested in nineteenth-century painting, especially the work of Ingres, Delacroix, Courbet and the Post-Impressionists.[9] The modern painting he saw in Paris also impressed him immensely, and years later he vividly remembered first seeing Léger's *Three Women*, Picasso's *The Three Musicians* (both 1921, The Museum of Modern Art), as well as contemporary work by Matisse.[10]

Gottlieb explored Paris on his own, enjoying the role of the young bohemian, visiting galleries and frequenting the Sylvia Dietz Bookshop, then a popular meeting place for artists. But because he did not speak French, he did not make contacts with French artists. He was young and lacked confidence, so he also kept his distance from well-known Americans in Paris.[11]

Gottlieb's stay in Paris came to an end when he and his friend were finally caught without papers. They were taken to the American Embassy, where officials contacted Gottlieb's uncle, attorney Samuel Berger, who arranged for their papers and informed their parents of their whereabouts. As a result, Gottlieb, who had spent nearly all his money, had his finances temporarily replenished. This allowed him to travel to Vienna, Berlin, Dresden and Munich, where he spent most of his time, as he had in Paris, in museums and galleries, looking at works by the old masters and the German Expressionists.[12]

Gottlieb's excursion to Europe had an important effect on his development as an artist. From constant looking in museums and galleries he developed an appreciation of a wide range of art, from Renaissance panel painting to Cubism and Expressionism. Although at the age of eighteen he was not ready to adopt modernist styles in his own work, his early exposure to avant-garde painting made it easier for him to incorporate concepts from it at a later date. With the exception of Hofmann and de Kooning, who received their artistic training abroad, Gottlieb was the only Abstract Expressionist to acquire a direct knowledge of modern art in Europe at such a formative stage in his career. No doubt it was also this early awareness of contemporary European art that helped form his contempt for the provincialism of American scene painting and social realism. Moreover, Gottlieb's appreciation of the modern tradition, which began on this trip and grew during the twenties and

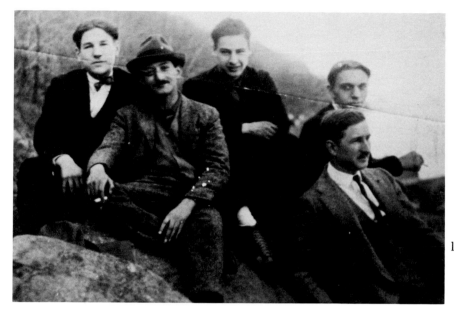

1. B. Newman, A. Gottlieb, A. Borodulin, O. Soglow and unidentified friend, Central Park, N.Y., ca. 1925.

thirties, enabled him in his Pictographs of 1941-42 easily to transform sources in Surrealism and abstraction for his own expressive purposes.[13]

Return to New York and John Sloan

After returning from Europe in 1922, Gottlieb naturally thought of himself as a sophisticated, urbane artist. While this attitude was not appreciated by his parents, it earned him special status among his friends, especially Barnett Newman. Newman looked up to Gottlieb, who was two years older and had traveled on his own through Europe. Newman thought of him as a "romantic figure . . . already a dedicated artist."[14] That he enjoyed this image of himself is seen in the photograph of Gottlieb, Newman and friends in New York in 1924 (fig. 1). Newman, then in City College, wearing a dark suit and bow tie, looks like the young professor, while Gottlieb, holding a cigarette and sporting a hat at a rakish angle, plays the part of the bohemian.

In New York, Gottlieb continued, as he had in Europe, to look at art. On weekends he and Newman spent hours visiting museums and galleries. One of their favorite haunts was The Metropolitan Museum of Art, where Gottlieb was attracted to the work of El Greco, Rembrandt, and Cézanne. Urged by his parents to finish school, in 1922 Gottlieb enrolled in Washington Irving High School in Manhattan, taking night classes, while working in his father's store. But his European trip had confirmed his desire to be an artist, so he continued to rebel against his parents' wish that he stay in the family business. They insisted that if he continued in art, he should at least get training to teach so that he could support himself. Consequently in 1923 he took the Teacher Training Program at the Parsons School of Design, graduating the next year.

In January 1923, Gottlieb also entered Sloan's painting class at the League, where he seriously took up painting. Gottlieb's earliest known paintings, *Portrait* (Illustration no. 1) and *Nude Model* (fig. 2), were probably done in Sloan's class in 1923.[15] Here in his dark palette and painterly technique Gottlieb assimilates the realism of Sloan, who in turn was influenced by the chiaroscuro styles of Velasquez and Rembrandt. Both the example of Sloan and the memory of works by these Baroque masters were no doubt fresh in Gottlieb's mind as he began his first paintings. In *Portrait* Gottlieb echoes Sloan's deep color range in his resonant tones of browns and greens. He also uses a traditional method of underpainting learned from Sloan, layering light and dark shades on a middle-toned ground to achieve a sense of sculptural volume in the model's head and shoulders.

In addition to these traditional methods, Gottlieb absorbed more advanced ideas from Sloan. Because he had studied under Henri, Sloan also believed in

painting directly on the canvas and broadly massing forms with color. Gottlieb followed this practice in figure studies, such as *Portrait*, in which, instead of merely recording his observations, he also draws from his memory of the model's forms. He recalled that Sloan encouraged him to "do things that were not exactly literal and to work from imagination and memory . . . he implanted that idea rather early in me."[16]

In emphasizing the evolution of Gottlieb's abstract style, the literature on his work has just begun to examine these first paintings and other works of the twenties and thirties.[17] But these early pictures are important, as they contain the roots of later tendencies in his art. First, in the areas of impasto in *Portrait* and *Nude Model* one can see Gottlieb's initial interest in creating a surface of textural variety, which he continues to develop in new ways throughout his career. Second, at the onset Gottlieb began painting directly on the canvas and drawing from his imagination; so he was naturally predisposed to the Surrealist method of automatism and was able to adopt it quickly to his own ends in his Pictographs of the early 1940s.

Most of all, Gottlieb appreciated Sloan's open-minded attitude towards avant-garde European art. Though Sloan did not adopt these styles himself, he introduced his students to them. "John Sloan had the most valuable influence on me because Sloan was a very liberal guy for his time. For any time. He was interested in Cubism, for example,"[18] Gottlieb said. But whereas Sloan presented Cubism only as a learning device, Gottlieb saw it as a viable means of expression in itself.

In 1924 Gottlieb graduated from Sloan's class and sometime later began painting on his own in a studio he rented on 17th Street. From 1926 to 1929 he took evening classes at the League with Richard Lahey. Around this time he also attended the sketch class at the Educational Alliance, a community center on East Broadway, where he came into contact with other artists, including Chaim Gross, Newman, Rothko, Louis Schanker, Moses and Raphael Soyer, and Ben Shahn.

The continuing influence of Sloan may be seen in the subdued palette of Gottlieb's work of the mid-twenties. In *Still Life-Gate Leg Table* (Illustration 2), signed and dated 1925, Gottlieb contrasted dissimilar textures of wood, cloth, and metal in muted tones of brown, ivory, and ochre. In *Grand Concourse* (c. 1927, Illustration 3) he enlivened his palette, painting the city street in soft shades of lavender and brown, accented by the brighter red and green tones in the tile roof and grass in the foreground.

But in the late twenties Gottlieb began to search for a more imaginative style than he had developed under Sloan. Since his trip to Europe in 1921, he had increasingly felt that American painting was provincial. While he had seen Cubism in Paris and had studied it in Sloan's class, Gottlieb at that time was more affected by Cézanne's art, which offered a subjective approach to perception while not sacrificing representation. Gottlieb looked closely at Cézanne's painting, which he could have seen at The Metropolitan Museum and in 1929 at the opening show of The Museum of Modern Art.[19] It was Cézanne's portraiture that had an impact on Gottlieb's painting of this period. In *Interior (Self-Portrait)* of c. 1927 (Illustration 5), his image of himself—seated at a table covered with books and leaning to one side, lost in thought—may have been based on a memory of Cézanne's later portraits, which reflect a similar mood of introspection. Another allusion to Cézanne is seen in Gottlieb's ambiguous space, which he creates by tilting the floor toward the picture plane so that objects on it fluctuate between two and three dimensions, as in the pattern of the rug at the lower right.

In 1929 Gottlieb began showing at the Opportunity Gallery on 56th Street, which featured monthly exhibitions of work by young artists, chosen by established figures such as Max Weber and Yasuo Kuniyoshi. In the January show, selected by Weber, Gottlieb, with five canvases, was singled out by an anonymous reviewer as "among the most developed of the oil painters."[20] It was at the opening of this show that Gottlieb met Milton Avery. About the same time he became a friend of Mark Rothko, who had also recently met Avery. Thus, in 1929 these three artists began lifelong friendships.

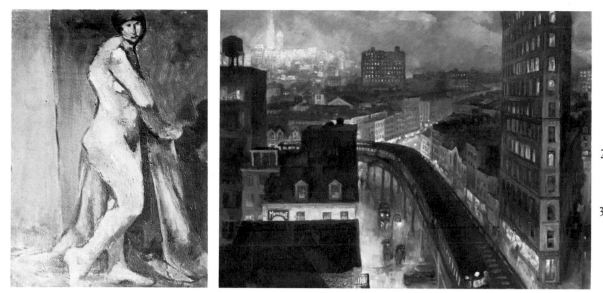

The Depression: From Realism to Expressionism

In 1929 Gottlieb also entered a nationwide competition for young artists, sponsored by the Dudensing Gallery in New York, in which he won a first prize along with Konrad Cramer. As an award, in May 1930 the gallery gave them one-man shows, Gottlieb's first. Among the works he exhibited were *South Ferry Waiting Room* (c. 1929, Illustration 6), *Brooklyn Bridge* (c. 1930, Illustration 7), and *The Wasteland* (c. 1930, Illustration 8).

The style of these pictures, which Gottlieb painted at the beginning of the Depression, is more expressionistic, reflecting his response to this period of stress and uncertainty. As he had in the twenties, Gottlieb continued to use a muted palette, as seen in *Brooklyn Bridge*. Although this picture is related to the tradition of Sloan's genre scenes of New York, such as *The City from Greenwich Village* (1922, fig. 3), its inward view is opposed to Sloan's dynamic vista. In contrast to Sloan's panorama, in which skyscrapers glow on the distant horizon like beacons of hope, Gottlieb's city is colored by his own reflection. In the tradition of Joseph Stella and Hart Crane, whose works he surely knew, Gottlieb adopted the Brooklyn Bridge as an emblem of New York. But instead of a gateway to a vital city, his bridge is a barrier before a ghostly metropolis. The figures in the picture have no contact with each other and are faceless strangers, trapped in a claustrophobic space, defined by the converging forms of the bridge. Gottlieb may have been inspired by a memory of Edvard Munch's haunting pictures of the loneliness of urban life in his evocation of brooding, suspended time. It was the introverted emotional focus of Expressionism that attracted Gottlieb during this time of anxiety in his own life and the world.

But this romantic side of Gottlieb's painting at the beginning of the thirties also derived from his interest in modern poetry. Later he recalled that during this time he had a "sympathy for the poets," especially Ezra Pound and T. S. Elliot.[21] Not surprisingly, Gottlieb liked poetry that echoed his own emotional state. Indeed, after reading T. S. Eliot's "The Wasteland" he painted a picture titled *The Wasteland* (c. 1930, Illustration 8). Inspired by the dispirited mood of Eliot's poem, he formulated a more symbolic expression in the figures who seem to embody a sense of alienation. The subjective tendency in his art that emerged at this time was to resurface in 1937-38 in his Arizona still lifes and again in 1941 in his first Pictographs. But here, as then, he avoids specific symbols in favor of ambiguous images. Works such as *The Wasteland*, which he remembered as "lonely figures in a desolate landscape,"[22] reflect his feelings of isolation as a young artist living through the Depression.

In the early thirties Gottlieb began to adopt a style revealing the influence of Avery and, ultimately, of Matisse. In *The Wasteland* Gottlieb simplifies forms,

15

defining them with thick, dark contour lines. Like Avery, he also contrasts painted and incised lines and brushes up to the edges of forms, surrounding them with shadows that do not create a sense of depth as much as reverberation. This haloing technique,[23] which Gottlieb first employed in his expressionist works of the early thirties, reappears later in abstract form in the auras around discs in the Bursts. But *The Wasteland* is a transitional work in Gottlieb's search for his own style. While he attempted a greater distillation of form, he still maintained a dark palette and a heavily painted surface, reflecting the lingering influence of Sloan.

At the age of twenty-six, with a solo show at Dudensing Gallery to his credit, Gottlieb felt as if his career had been launched. "There were only a few galleries in New York and since my show was well-received, this seemed to me that I was an artist. Nobody could say I wasn't an artist now," Gottlieb recalled. But the Depression shattered his optimism and youthful hopes for success.

On June 12, 1932, at the age of twenty-nine, Gottlieb married Esther Dick, a petite, attractive young woman from Connecticut who was working in New York in a design shop. They had little money, beginning their marriage in the middle of the Depression, and Gottlieb often painted over old canvases to economize on art supplies. He also took part-time jobs teaching art at settlement houses in New York, but as he only made a small amount of money, Esther secured a full-time position teaching sewing and design at a high school in Brooklyn.[24]

In November 1933 they moved from a small studio apartment at 14 Christopher Street in Greenwich Village to 155 State Street, near Borough Hall in Brooklyn. While living in this area near Brooklyn Heights and Cobble Hill, they made friends with several artists with whom Gottlieb associated throughout the thirties. Among these were Louis Schanker and Louis Harris, who later joined The Ten, the exhibiting group Gottlieb helped to found in 1935. A frequent visitor to Brooklyn was John Graham, whom Gottlieb had met in the early twenties at the Art Students' League and with whom he had formed a fast friendship, sponsoring Graham when he became a United States citizen.[25]

Other artist friends living in Brooklyn in 1933 were David Smith and his wife, Dorothy Dehner, and Edgar Levy and his wife, Lucille Corcos.[26] Within this circle Gottlieb was closest to David Smith, whom he frequently saw from 1934 to 1940, when Smith was making his sculptures at the Terminal Iron Works in Brooklyn. He felt an affinity with Smith because he was also attracted to European avant-garde art. Indeed, by 1932 Smith was developing an abstract style, making Cubist sculptures. During this time Gottlieb also came to know a friend of Smith's, an older artist and a former student of Robert Henri—Stuart Davis. Gottlieb admired this pioneer of modernism, who drew on Cubism—especially the art of Léger and Picasso—to create his distinctly personal style.

The Example of Milton Avery

More than Stuart Davis, however, Milton Avery was Gottlieb's mentor during the thirties. After meeting Avery in 1929, Gottlieb often visited him with Mark Rothko, first at the Averys' studio on Lincoln Square, then at 72nd Street, where they moved around 1930.[27] Gottlieb and Esther also saw the Averys during their summers outside New York. After they were married in June 1932, they stayed in Rockport, Massachusetts, near the Averys in Gloucester and Rothko at Cape Ann. The following summer, when Rothko did not join them, they rented a place in East Gloucester, where they saw the Averys every day.

Gottlieb and Rothko were the core of a group of artists, including Paul Bodin, George Constant, Joe Solman, and Vincent Spagna, who gathered around Avery in New York and Gloucester. To Gottlieb and his friends, Avery and his art were inspiring, offering them encouragement and support during their formative years. "Avery was older than us," Solman said, "and his style was so well developed. We were all seeking the flat, and the exaggerated, and the expressionist in our own, romantic, different ways. He had fulfilled it."[28]

Gottlieb admired Avery, as he did Davis, for being independent of realism,

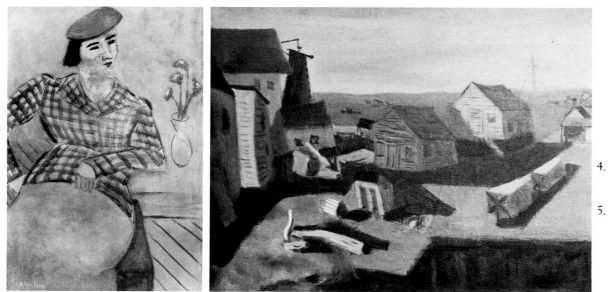

4. Milton Avery, MRS. AVERY IN A
 CHECKED JACKET, 1939
 Milton Avery Trust, New York.

5. Adolph Gottlieb, UNTITLED
 (GLOUCESTER HARBOR FISHERIES),
 ca. 1933
 Adolph and Esther Gottlieb
 Foundation, New York.

which dominated American painting at the time, and for being committed to modernism. Later he said in tribute to Avery:

> I have always thought he was a great artist. When social realism and the American scene were considered the important thing, he took an esthetic stand opposed to regional subject matter. I shared his point of view; and since he was ten years my senior and an artist I respected, his attitude helped to reinforce me in my chosen direction. I always regarded him as a brilliant colorist and draftsman, a solitary figure working against the stream.[29]

Avery's painting showed Gottlieb that the subjects closest to him—himself, his family, and his friends—were suitable themes for serious art. Before meeting Avery he had painted only a few portraits, such as *Aaron Siskind* (c. 1927, Illustration 4) and *Interior* (c. 1927 Illustration 5). But from 1929 through the mid-thirties, when he was closely associated with Avery, he took a special interest in portraiture, painting his wife in *Esther* (1931, Illustration 9), his father in *Untitled (Portrait of Emil)* (c. 1934, Illustration 11), and a friend in *Untitled (Max Margolis)* (c. 1935, Illustration 14).

Like Avery, Gottlieb revealed a genuine affection for his subjects, a feeling especially evident in his portraits of his wife. In *Esther* Gottlieb evoked a sense of serenity and warmth that echoes the placid mood in Avery's portraits of his wife Sally, as seen in *Mrs. Avery in a Checked Jacket* (1939, fig. 4). He also drew on Avery's stylistic method of distorting the figure, arbitrarily expanding his wife's shoulder in *Esther* to achieve a greater subjective expression. While Gottlieb also absorbed Avery's technique of thinly applying paint, his brushwork is more open, free, and impressionistic.

In other figural compositions of the thirties, Gottlieb alters the proportions of the human shape with a subtle sense of humor that echoes Avery's gentle, comic exaggerations of the figure in his works of the thirties. In *Man with Pigeons* (1932, Illustration 10) and *Seated Nude* (1934, Illustration 12) Gottlieb employs the Averyesque method of shrinking the head and magnifying the torso to create a droll, pyramidal figure. In these pictures Gottlieb also rhymes the figure's shape with other forms in the composition, comparing the stocky man with the corpulent pigeons, and the fleshy nude with the overstuffed chair. His satire is not biting; it shares Avery's attitude of amused detachment.

Instead of suggesting shapes with open brushwork, as in his previously discussed portrait of Esther, in these figural works he defines forms as closed color masses. For this greater distillation of form Gottlieb looked to Avery and to Avery's source, Matisse, whose art had been featured in 1931 in a retrospective show at The Museum of Modern Art. From them Gottlieb absorbed a preference for simplified

17

form which he reflected in his increasingly condensed compositions of the early thirties, displaying greater assurance than his previous work.

Avery also had an impact on Gottlieb's landscape painting of this time. Like Avery, Gottlieb loved the sea and painted it many times in watercolor and oil during the summers he spent in Gloucester from 1933 to 1938. He adopted Avery's method of sketching outdoors; unfortunately, however, the drawings from this period in Gottlieb's collection were lost in the fire that destroyed his studio in 1966. From these sketches he would work in his studio, painting many of the same subjects as Avery such as scenes of Gloucester's seaside industry. In *Untitled (Gloucester Harbor Fisheries)* (c. 1933, fig. 5) he paints the small town's fisheries, with the harbor and boats in the distance, as had Avery the year before in *Harbor at Night* (1932, fig. 6). The combination of soft-edged color masses and incised lines in *Surf Casting* (c. 1935, Illustration 13) also points to Avery's influence, although Gottlieb's palette in this picture is darker than Avery's of the same period.

There is an inward mood in Gottlieb's work that is alien to Matisse and Avery. While Gottlieb was formally indebted to the Fauvist tradition, he did not share its untroubled view of the world. The Depression, which has no effect on Avery's gentle art of the early thirties, gives a melancholy tone to pictures such as *Man with Pigeons* (Illustration 10). Here Gottlieb contrasts swiftly converging space with flatly painted areas, first seen in *Brooklyn Bridge*, to create an ambiguous, dreamlike scene.

The Ten, 1935–39

During the early thirties Gottlieb had a difficult time exhibiting his work, even though he had already had a one-man show in 1930 at the Dudensing Gallery. There were few galleries at that time that would represent a young artist. Through his friends Louis Harris and Rothko, he began showing at the Uptown Gallery at 249 West End Avenue, directed by Robert Ulrich Godsoe. Gottlieb and his friends were disappointed when Godsoe acquired a larger stable of artists. When he ignored their complaints, they withdrew from his gallery to form their own exhibiting group, "The Ten."

Gottlieb was a founding member of The Ten, which had its first meeting in 1935 in Solman's studio on 15th Street and Second Avenue. Solman recalled that the original group consisted of Ben Zion, Ilya Bolotowsky, Gottlieb, Harris, Yankel Kufeld, Rothko, Solman, and Naum Tschacbasov.[30] Though they were only nine in number, they planned to include a tenth member at a later date and so adopted the name, "The Ten." Critic Jerome Klein dubbed them the "Ten who are nine."[31] The Ten viewed themselves in the tradition of previous avant-garde movements, and most of the group also identified with the expressionist tradition. "We were allied to the broad stream of Expressionism," Solman said, referring to himself, Gottlieb and Rothko. "Design and subject matter had to be intermingled. Our feeling toward pictorial art was closer to the Fauves than the German Expressionists."[32] Indeed, their approach to composition was influenced by Fauvism filtered through Avery.

The Ten began showing their work in 1935 at the staid Montross Gallery at 785 Fifth Avenue in an exhibition entitled "The Ten: An Independent Group." Critics immediately noted their expressionist tendencies. A *New York Times* reviewer criticized them for "needless obscurity" and "reasonless distortion."[33] Marshal E. Landgren, after noticing their art in the Montross show, included The Ten in the opening exhibition in January 1936, at his WPA-sponsored Municipal Art Gallery at 62 West 53rd Street. Gottlieb's *Seated Nude* (1934, Illustration 12) was the most controversial picture in the show.[34] In November 1936, The Ten had their first European exhibition at the Galerie Bonaparte in Paris, arranged for them by the dealer Joseph Brummer. The following month they had their second show at the Montross Gallery, including Lee Gatch instead of Tschacbasov. They received a negative review from Edward Alden Jewell, *The New York Times* critic to whom Gottlieb and Rothko would later write in 1943.[35] In 1937–38 they had shows at the Georgette Passedoit Gallery on E.60th St, which brought them more recognition.

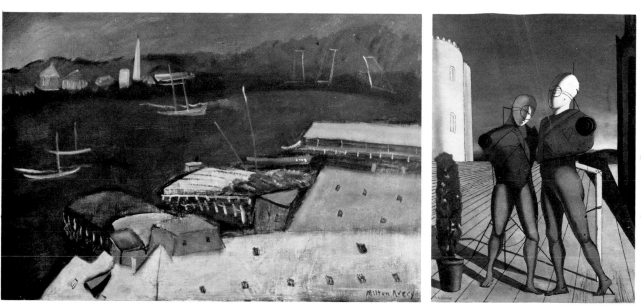

6. Milton Avery, HARBOR
 AT NIGHT, 1932
 The Phillips Collection,
 Washington, D.C.

7. Giorgio deChirico, THE
 DUO, 1915, oil on canvas
 32¼ x 23¼" Collection:
 The Museum of Modern
 Art, New York.

Although they exhibited together, The Ten had no esthetic credo. The various members were united only in their opposition to realism, which they considered to be outmoded. They expressed this view in November 1938, in their exhibition at Bernard Bradden's Mercury Galleries at 4 East Eighth Street. "Our group decided cockily to challenge the hegemony of the Whitney Museum," Solman said.[36] Thus, they titled the show, "The Ten: Whitney Dissenters." In the catalogue introduction The Ten voiced their contempt for American Scene painting. They charged that "the symbol of the silo is in the ascendant at our Whitney Museum" and objected to the museum's "reputed equivalence of American painting and literal painting."[37]

Because The Ten shared no common style, the esthetic differences among them contributed to their breakup in 1939. The core of the group, including Gottlieb, Harris, Rothko, and Solman, were expressionist in approach. But Schanker painted in a cubist style, and Bolotowsky, who had worked in a representational manner in the early thirties, turned to non-objective abstraction. This led Bolotowsky eventually to join the American Abstract Artists, a larger group of exclusively abstract painters which had formed in 1935 about the same time as The Ten.[38] Gottlieb, however, did not join: not only did he not paint in the abstract style required for membership, but with his expressionist bias it is doubtful that he wanted to be a part of the group. As he and Rothko suggested in 1943 in their letter to *The New York Times*, they felt that non-objective painting lacked what they valued in art—a content of feeling.

During 1936–37, Gottlieb was exhibiting with The Ten, he was also working on the government-sponsored Federal Art Project in the Easel Division. This was a desirable assignment because he could work in his own studio, instead of in a Project workshop. But Gottlieb did not enjoy working on the Project and did not view it positively.[39] Because Esther worked, he was not totally dependent on the WPA like many other artists; he could afford an independent attitude.

But Gottlieb did become involved in artists' organizations in the mid-thirties. In 1936 he joined the Artists' Union, which promoted job programs on the Project. Gottlieb also was a founding member of the American Artists' Congress, headed by Stuart Davis.[40] Gottlieb supported the Congress, which defended the WPA's cultural projects, organized an exhibition in 1937 entitled "In Defense of World Democracy—Dedicated to the Peoples of Spain and China," arranged the New York showing of Picasso's *Guernica* in 1939, and sponsored the exhibition of modern art in 1939–40 at the New York World's Fair.

While Gottlieb participated in these organizations, he did not agree with the social realists who dominated their ruling boards. In principle, Gottlieb objected to political content in art. With others in The Ten he protested the social realists' control of the editorial policy of the Artists' Union magazine, *Art Front*.[41] Politics,

19

however, did not play an important part in Gottlieb's life at this time. Although he attended a few Artists' Union meetings, he was not a political activist.[42]

The Impact of John Graham

As Gottlieb looked for an alternative to the expressionist style he had developed under Avery, he became increasingly interested in Cubism and Surrealism. In 1936 he saw two major exhibitions at the Museum of Modern Art: *Cubism and Abstract Art*, which included Cubism, Futurism, Constructivism, de Stijl, and Purism; and *Fantastic Art, Dada, and Surrealism*, which surveyed both Verist and Abstract Surrealism. Gottlieb was already familiar with Surrealism from exhibitions in the early thirties at the Julien Levy Gallery.

John Graham was the most important influence in fostering Gottlieb's interest in Surrealism. Unlike Avery, Graham was part of the European avant-garde. He had lived in Paris and knew prominent writers, such as André Breton and André Gide. Moreover, he continued to see these men and other artists on his excursions to Europe throughout the twenties and thirties. Upon his return Graham would inform Gottlieb, Davis and Smith of the latest developments in contemporary art, showing them his copies of *Cahiers d'Art*, containing illustrations of works by Léger, Gris, Ernst, Miró, Kandinsky, Picasso and others. Graham communicated his ideas to Gottlieb and his friends not only in discussions, but also in his book *System and Dialectics of Art* (1937). He gave Gottlieb an inscribed copy.[43]

Graham's influence was three-fold: First, he encouraged Gottlieb's interest in the late thirties in both Freud and Jung. Graham saw no conflict in their psychologies and freely combined them in *System and Dialects of Art* to support his assertion that the source of creativity is in the unconscious. Similarly, Gottlieb, who liked Graham's emphasis on the unconscious because he had long been interested in the imagination, later brought together aspects of Freud and Jung in his Pictographs of the forties.

Second, Graham fostered Gottlieb's interest in primitive art. Graham was a connoisseur of African sculpture and had assembled the Frank Crowninshield Collection; when Gottlieb began to collect primitive art, Graham advised him. In the spring of 1935, Gottlieb was impressed by the exhibition at the Museum of Modern Art, *African Negro Sculpture*. In the summer of 1935 he visited Paris with Esther and acquired several pieces of African sculpture from dealers suggested by Graham.[44] Like Graham, Gottlieb also appreciated Egyptian, Pre-Columbian, and American Indian art, which he saw in exhibitions in the late thirties and early forties. From Graham he inherited the belief in the unconscious expression in primitive art, and it is this sense of the unconscious which Gottlieb echoes in the primitivistic forms in the Pictographs.

Third, Graham supported Gottlieb's fascination with both Cubism and Surrealism. Graham fused ideas from both traditions in *System and Dialectics* in his statement that "art is a subjective point of view expressed in objective terms."[45] In this spirit of synthesis, Gottlieb later combines in his Pictographs aspects of Cubism and Surrealism and primitive and modern art.

Although Gottlieb absorbed these ideas from Graham in 1936–37, he did not reflect them in his art of that time. The influence of Avery is still seen in the diffuse color forms of *Luxembourg Gardens* (Illustration 15), which Gottlieb painted c.1936 in New York from sketches he had made in Paris during his two-month trip to Europe in 1935. As long as he continued to paint near Avery, it was difficult to break away. Indeed, it was not until he was physically separated from Avery for eight months in Arizona in 1937 and 1938 that he found his own direction in art.

Arizona, 1937–38

Because Esther had been advised by her doctor to go to a dry climate to improve her health, she and Gottlieb spent the winter and spring of 1937–38 in Arizona. They settled in Tucson on the outskirts of town in a small house, which they liked for its spectacular view of the desert, ringed by the Santa Catalina mountains. Gottlieb was immediately struck by the starkness of the desert landscape, which contrasted

dramatically with the lush foliage of Vermont, where he and Esther had spent the previous summer with the Averys. "I think the emotional feeling I had on the desert was that it was like being at sea," Gottlieb said. "In fact, when you're out on the desert, you see the horizon for 360° . . . so that the desert is like the ocean in that sense."[46]

In December Gottlieb began painting the desert landscape. But he was not happy with his first attempts, so he returned to painting from sketches he had made in Vermont. Yet he soon reached an impasse with these, too, as they had nothing to do with his experience in the desert. Frustrated, he dropped landscape painting and turned to still life. In December he began painting arrangements of objects in the studio, beginning with his chessboard and chessmen. Encouraged with the results, at the beginning of January, he began painting still lifes on a larger scale.[47]

In one of these works, *Untitled (Pink Still Life—Curtain and Gourds)* (1938, Illustration 20), Gottlieb combines chess pieces with cut-open vegetables (persimmons, avocados, and gourds) that he and Esther found at the market. The flattened style of this and other still lifes of this period suggests the continued influence of Avery. But Gottlieb thought of these still lifes as "studio painting" in the tradition of Cézanne.[48] Indeed, his simplified compositions of objects on a table against a wall were probably inspired by Cézanne's still lifes, which he had seen at The Metropolitan Museum. But in these works Gottlieb goes beyond Cézanne in radically flattening the space. In tilting the table top so that its edges are parallel with the picture plane Gottlieb recalls instead Matisse still lifes of the twenties. Gottlieb also may have been inspired by Picasso's synthetic cubist still lifes, which he had recently seen in *Cubism and Abstract Art*. Like Picasso he flattens forms into semi-geometric shapes, but he does not maintain a two-dimensional space. As seen in the meeting of the chessboard and gourd, Gottlieb contrasts plane with volume to produce an ambivalent space.

Gottlieb continues to develop this kind of condensed composition in related still lifes, such as *Untitled (Green Still Life—Gourds)* (1938, Illustration 21). Though he still suggests volume in shadows around the gourds, he gives them no sense of dimension in themselves, painting shadows as flat shapes. Here the simple, horizontal division of the background is a precursor to the design of his Imaginary Landscapes of the fifties.

The subdued palette of these still lifes—dusty browns, pinks and greens— echoes the muted tones of the desert. With these shades Gottlieb produced subtly textured surfaces. He applied paint in layers—light, sandy tints over dark, brown shades and vice versa—allowing colors to sound through each other. He also left brushstrokes from previous layers of paint visible. This technique of stratifying color reappears throughout his later art.

In other still lifes of this period Gottlieb paints in a more illusionistic style. Although he employs the same format in *Untitled (Still Life—Landscape in Window)* (1938, Illustration 21) as in the flattened still lifes, he includes, instead of a wall or curtain, a window view of the mountains outside their house. The strange space of Gottlieb's vista—at once far and near—echoes his own experience of the desert's unreal atmosphere, and in its dreamlike quality is distinctly Surrealist. In *Symbols and the Desert* (1937–38, Illustration 23) he creates a feeling of stopped time, doubtless inspired by Dali, which resurfaces later in 1939–40 in the magic realist still lifes Gottlieb painted in Gloucester.

Although Gottlieb had admired Dali's paintings in New York, it was the bizarre, open space of the Arizona desert that led him to incorporate aspects of Surrealism in his own art. Yet because of his preference for painterly edges, which he had developed under Sloan and Avery, Gottlieb never adopted a *trompe l'oeil* style. Nonetheless, from Surrealism he adopted a more symbolic approach to subject matter. Instead of painting an entire landscape, he uses fragments of desert life in these works to represent the desert as a whole. In particular, he focuses on the detritus of the arid land—petrified wood, dried cacti, and parched bones—to evoke a sense of the desert's mysterious age.

The influence of Avery is still felt in several of Gottlieb's Arizona works, such as *The Swimming Hole, Untitled (Portrait—Blue Bandana)*, and *Untitled (Self-Portrait in Mirror)* (1937–38, Illustrations 16, 18, and 19). But it was the isolation of painting in Arizona that gave him the freedom to develop a new direction, away from the example of Avery. In the Arizona still lifes Gottlieb develops a method of working in a series, establishing a basic compositional format and exploring variations on it in related pictures. This method is important since Gottlieb continued to employ it throughout his later work in the Pictographs, the Imaginary Landscapes, the Unstill Lifes, and the Bursts.

In March 1938, Gottlieb stopped working on still life and turned to landscape and figural compositions. Such works as *Circus Girl* and *Circus Performers* (Illustrations 24 and 25) were inspired by a visiting carnival; however, these are also imaginary scenes in the tradition of his earlier works, *The Wasteland* and *Man with Pigeons*. These pictures display a similarly haunting, inward mood, expressed in the figures' frozen poses and self-absorbed expressions.

While Gottlieb enjoyed living in the desert, he felt culturally isolated there. The only art of interest to him in Arizona was the ancient Southwest Indian art in the State Museum in Tucson.[49] Although Gottlieb did not reflect his interest in Indian art in his painting in Arizona, he did acquire a knowledge of its forms and colors, which he later recalled in the Pictographs.

New York, 1939–1940

Gottlieb and Esther had planned to stay in Arizona through the summer, but they missed New York and so returned early. In June they drove back to East Gloucester, Massachusetts, where they spent the rest of the summer by the sea. In the fall they returned to New York, settling in Brooklyn Heights. They moved into an historic townhouse at 121 Joralemon Street, formerly the home of Hamilton Fish, where they set up both an apartment and a studio.

Gottlieb resumed his life in New York, but things had changed. He was no longer Avery's young admirer, but an artist with ideas of his own. Although Avery disapproved, he continued to be interested in Surrealism—especially the art of Dali, which he surely saw exhibited in the spring of 1939 at the Julien Levy Gallery. He knew that Verist Surrealism contradicted the painterly tradition Avery stood for and to which he also belonged, but he understood that to oppose Avery was the only way to find himself.

By 1940 Gottlieb no doubt also sensed that the times were different. The artists' organizations he had known during the Depression were no longer viable: the small Artists' Union had been swallowed by big labor—the AFL and the CIO—and the WPA had been cut back by a reactionary Congress attempting to purge what it perceived as dangerous leftist elements. In the spring of 1940 these forces of change were focused in Gottlieb's own life as he was pulled into the breakup of the Artists' Congress.

Initially Gottlieb had been enthusiastic about the democratic ideals of the Congress, but like other artists, over the years he had lost interest in the Congress because it did not further his career. Yet it was a series of events in 1939, at the beginning of World War II, that eventually led to the dissolution of the Congress. Many artists who had been sympathetic to the left were disillusioned by reports of the purge trials in the Soviet Union and were shocked by the Hitler-Stalin nonaggression pact of August 23, 1939. The Russian invasion of Finland in December, however, finally revealed the aggressive, totalitarian character of the Stalinist regime, destroying whatever interest these artists had in "the Russian experiment."[50] These events, which rocked the world, moved Gottlieb from political indifference to conviction.

The invasion of Finland caused a deep rift in the Congress between members who wanted to protest it and those who did not. Gottlieb, who was against the invasion, joined a dissident group centered around art historian Meyer Schapiro. In a petition read by member Ralph Pearson at the April 4 meeting, Schapiro's group

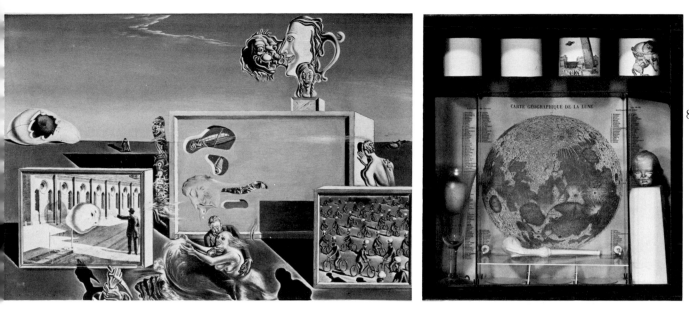

8. Salvador Dali,
 THE ILLUMINED
 PLEASURES, 1929
 oil & collage on
 composition board
 9⅜ x 13¾"
 Collection: The
 Museum of Modern
 Art, New York.

9. Joseph Cornell,
 SOAP BUBBLE
 SET, 1936 Wadsworth
 Atheneum, Hartford.

challenged the Congress "to make clear to the world whether the Congress is a remnant of the cultural front of the Communist Party or an independent artists organization."[51] Gottlieb signed this statement along with Milton Avery, Peggy Bacon, George Biddle, Ilya Bolotowsky, Jose de Creeft, Morris Davidson, Dorothy Eisner, Paula Elisoph, Hans Foy, Louis Harris, Renee Lahm, Paul Mommer, Lewis Mumford, Ralph Rosenborg, and Mark Rothko. At this meeting, Schapiro spoke out against the Lynd Ward report that did not condemn the Russian invasion of Finland, but he was unable to garner enough votes to defeat it. As a result, Schapiro encouraged artists to protest by resigning from the Congress.[52]

Gottlieb and the Schapiro group publicly resigned from the Congress on April 17, 1940. Although the Congress officially lasted until 1942, the secession of this group effectively destroyed it. The disintegration of this artists' organization marked the end of an era of idealism which had begun in the early days of the Depression. By 1940, the situation of the artist had not changed, but the world had. The humanitarian ideals of Socialism had been replaced by the totalitarian reality of Communism.

Reaffirming the need for a non-political alliance of artists, Gottlieb and the dissident group around Schapiro formed a new organization entitled The Federation of Modern Painters and Sculptors. Unlike the Congress, the Federation was solely devoted to exhibiting the work of its members. Gottlieb helped found this group and served subsequently as a Vice-President in 1942 and as its President in 1944–45. With 62 members by 1942, the Federation was dedicated to promoting "the welfare of free progressive art in America."[53]

During 1939–40 Gottlieb's circle of friends in Brooklyn Heights also broke up. In 1940 David Smith and Dorothy Dehner moved to Bolton Landing, where they had been spending part of the year since buying a farm there in 1929. About the same time, Graham formed a new circle of friends, including Pollock, Newman, Hedda Sterne, Fritz Bultman, Corrado Marcarelli, and Theodoros Stamos. Gottlieb stayed in Brooklyn Heights and did not join this circle. Of these artists, he was friendly only with Newman; he did not meet Pollock until the mid-forties.

At the same time Gottlieb drifted away from The Ten, exhibiting with them for the last time at the Bonestell Gallery in 1939. The Ten had served its purpose in providing regular exhibitions; now galleries were approaching several of its members for individual shows. In April 1940, during the same days as the Artists' Congress crisis, Gottlieb had a one-man show at Hugh Stix's Artists' Gallery. When friends in The Ten saw the Arizona pictures he exhibited there, they were perplexed by the new, more abstract direction he had taken in his art.

23

The Influence of Surrealism, 1939–40

In New York Gottlieb continued to paint still lifes, such as *Still Life-Alarm Clock* (1938, Illustration 26) and *Untitled (Cactus Still Life, New York)* (1939, Illustration 27), in the flattened style of his Arizona works. But beginning in the summer of 1939 in East Gloucester he focused on still lifes of sea objects in a more illusionistic style influenced by Verist Surrealism. It is not surprising that during this time of escalating world war, Gottlieb was drawn to the irrationality of the Surrealist dream world. As the German *wehrmacht* swept across Europe, spreading violence and death, Surrealism's dark view of man's psyche made more sense than Avery's serene outlook on the world. The reality of the war was brought home when, between 1939 and 1941, the Surrealists themselves, including Breton, Dali, Matta, Masson, and Seligmann, fled Europe to live in exile in the United States. Their presence in New York brought Surrealism to the forefront of the art world.

Although Gottlieb had been interested in Surrealism for several years, it was in 1939–40 that he clearly incorporated it in his work. He was first impressed by the work of de Chirico and Dali, which were then being exhibited in New York.[54] In *Picnic (Box and Figure)* (1939–40, Illustration 28) Gottlieb recalls de Chirico's metaphysical painting in his creation of an unreal space with a rectangular box in an empty landscape. Gottlieb's mannikin figures derive directly from de Chirico's work of 1915–17, such as *The Duo* (1915, fig. 7). The ghostly bridge in the background of Gottlieb's picture echoes his earlier imaginary scene, *Brooklyn Bridge*. But here it is the structure of the box rather than the bridge that creates a sense of psychological tension. Yet Gottlieb's contrast of this compressed space with the open vista of the background remains unresolved.

In *Untitled (Boxes on Beach and Figure)* (1939–40, Illustration 29) Gottlieb avoids this spatial dilemma by emphasizing a deep space in which forms gradually diminish toward the horizon. Again he uses the box motif in a bleak landscape, but he transforms the box, inspired by fishing crates near the beach,[60] into sinister, coffinlike containers. His allusion to death, enhanced by the mysterious figure at the right and the dark palette of browns and grays, perhaps reflects his feelings during this time of widening war.

Gottlieb pursues the theme of spatial dichotomy in *Untitled (Box and Sea Objects)* (1939–40, Illustration 30), again contrasting forms seen at close vantage point with a faraway horizon. He omits the figure, however, and fills the compartmented box with objects from the sea—shells, seaweed, and driftwood. As he had used pieces of cacti to suggest the desert in his Arizona still lifes, here he employs these oceanic fragments to evoke the sea. The wide-open space of the sea reminded him of the desert, as the desert had earlier recalled the sea. His arrangement of the box against a remote sea and sky suggests the example of Dali's *Illumined Pleasures* (1929, fig. 8), which was exhibited in 1936 at the Museum of Modern Art.[55] Like Dali, Gottlieb creates a sense of mystery through the disjunction of the illogical, irregular shapes of its contents. But Gottlieb does not fill his box with frenetic nightmare scenes; instead he uses solitary objects from nature whose forms are in themselves evocative. His style is also more painterly than Dali's and his space is flatter.

To reduce a sense of recession Gottlieb also paints the box frontally and buries its interior perspective lines in shadow. For the first time he simplifies the composition to one box with multiple compartments, which was suggested by a slotted, wooden bottle crate he had seen on the beach in Gloucester. This kind of box also points to Gottlieb's awareness of Joseph Cornell's works, such as *Soap Bubble Set* (1936, fig. 9), which in 1936 had been exhibited in *Fantastic Art, Dada and Surrealism* and illustrated in Julien Levy's book, *Surrealism*. But Gottlieb takes a different approach to the box than Cornell, working in two instead of three dimensions. Whereas Cornell evokes a magical mood through the recurrence of similar motifs among dissimilar objects, Gottlieb creates a sense of mystery through the contrast of disparate, strange shapes among related, familiar objects.

In *Box and Sea Objects* Gottlieb creates Surrealist-inspired metamorphic images, making the driftwood at the top of the box look like a human hand. He also gives objects sexual innuendos: whereas the shape of the open, oval shell at the upper left appears vaginal, that of the sharp, pointed shell at the lower right is phallic. This sexual imagery, revealing his interest in the later thirties in Freud, resurfaces in more abstract form in his Pictographs of the forties.

Notes

This essay is based on a section of my 1980 dissertation, presented to Columbia University, entitled "The Painting of Adolph Gottlieb, 1903–1971." I would like to thank deeply Mrs. Adolph Gottlieb and Mr. Sanford Hirsch, Administrator of the Adolph and Esther Gottlieb Foundation, for their generous assistance. Thanks also go to Professor Theodore Reff for his encouragement of this project.

I would like to say a word about the general terms used in this essay. None of the labels traditionally applied to the art of Gottlieb and his colleagues is wholly satisfactory. "Abstract Expressionism," coined in 1951 by critic Robert Coates, is the best known stylistic label. Though it correctly suggests the dual influences of abstraction and Expressionism, it does not acknowledge Surrealism, which exerted an equally powerful force on their art. Another stylistic label is "Action Painting," invented in 1952 by critic Harold Rosenberg, who adapted the vocabulary of Existentialism to stress the process over the form or content of this art. "Action Painting" was used broadly by writers, but it correctly applies only to painting in which the artist's gesture is primary. Even then the term overemphasizes the spontaneity of this art and undervalues its thoughtful elements and subjective content. "American-Type Painting," proposed in 1955 by critic Clement Greenberg, does not as a label distinguish this art from any other American painting. A more specific geographical term is "The New York School," suggested by Robert Motherwell in 1951. "The New York School" identifies the center of these artists' activities, but it says nothing of their styles, nor does it separate them from those of younger artists who also rose to prominence in New York. Clearly, "Abstract Expressionism" and "The New York School" are inaccurate labels, but they have been adopted commonly by historians and critics, so they will be used in this essay.

Part I: Student Years and Early Work

1 Letter from Mrs. Edwin London (Rhoda Gottlieb), March 4, 1977.

2 Registrar's records at The Art Students' League, New York, list Gottlieb's address in 1920–21 as 1228 Grand Concourse; in 1923–24 as 2295 Grand Concourse; and in 1926 as 285 Riverside Drive, New York City.

3 Gottlieb, quoted in John Gruen, *The Party's Over Now: Reminiscences of the Fifties* (New York: The Viking Press, 1967), p. 254. Because of his birthplace, Gottlieb called himself "the original Tenth Street artist" (*Ibid.*) He refers to Tenth Street during the fifties, which was a center of artists' studios, cooperative galleries, the Club and the Cedar Tavern, where artists gathered. Actually, though Gottlieb frequented the Club, he remained aloof from this community where many younger artists followed the style of Willem de Kooning.

4 Dorothy Seckler, Interview with Adolph Gottlieb, New York, October 25, 1967, Archives of American Art, Smithsonian Institution, Washington, D.C., p. 2.

5 Registrar's records, The Art Students' League, Parsons School of Design, and Cooper Union, New York.

6 Hamilton Easter Field, *The Technique of Oil Painting and Other Essays* (Brooklyn, New York: Ardsley, 1913). During the twenties Field was editor and publisher of *The Arts* magazine.

7 Seckler, Interview, p. 9.

8 John Sloan, *Gist of Art: Principles and Practice Expounded in the Classroom and Studio* (New York: American Artists Group, 1939), p. 83.

9 Seckler, Interview, p. 4. "I went to the Louvre every day almost for six straight months," Gottlieb said. "And this was very valuable." Martin Friedman, An Interview with Adolph Gottlieb, New York, August, 1962 (unpublished typescript), Tape 1B, p. 4.

10 Gottlieb recalled, "I was tremendously impressed; I took it all like a duck to water." Seckler, Interview, p. 4.

11 *Ibid.*, p. 5. Although Thornton Wilder was also staying at Gottlieb's pension, he did not make his acquaintance.

12 *Ibid.* In Vienna and Munich Gottlieb was drawn to the art of Titian, Tintoretto, and El Greco. He was also fascinated by German Expressionism, which he would continue to see in New York in the 1930s in exhibitions at the J.B. Neumann Gallery.

13 In 1959 William Rubin noted Gottlieb's identification with the modern tradition: "Here is a painter in whom the assimilation of the most viable qualities of the European tradition is immediately evident. The sophistication of Gottlieb's art, his transformation of the means of European painting to serve the purposes of his own personal vision—rather than needlessly jettisoning this inheritance out of fear of seeming less American or, on the other hand, retaining its more seductive aspects when they would have compromised his goals—these point to an unself-conscious independence that impresses one in the man and his work." "Adolph Gottlieb," *Art International*, 3, Nos. 3–4 (March 1959), p. 35.

14 Conversation with Annalee Newman, New York, July 29, 1976. Mrs. Newman said, "Barnett met Adolph when he was seventeen, in 1922. Adolph considered himself an artist, wheras Barnett was still a young kid."

15 *Portrait* and *Nude Model* were dated 1921 in Miriam Robert, *Adolph Gottlieb: Paintings, 1921–56*, exhib. cat. (The Joslyn Art Museum, Omaha, Nebraska, 1978). Since Gottlieb had taken only Sloan's Illustration class by 1921, he probably painted these in 1923 when he had enrolled in the painting class.

 All works before 1941 not dated in Gottlieb's hand are given "circa" dates. These dates were assigned by Esther Gottlieb, Sanford Hirsch, and me on the basis of stylistic considerations. Some dates were also taken from exhibition listings and catalogues of the period. Works from 1941–74 are dated according to consecutive records Adolph and Esther Gottlieb kept at the time he produced the works.

16 Seckler, Interview, p. 3. "When you draw, your intuition is a sort of guide," Sloan advised. "You must have a preconception in your mind and your hand puts down this concept as if guided invisibly." *Gist of Art*, p. 56.

17 Miriam Roberts in *Adolph Gottlieb: Paintings 1921–56* briefly discusses Gottlieb's early work. Other literature does not analyze his pictures of the twenties and thirties, except for isolated examples. See Martin Friedman, *Adolph Gottlieb*, exhib. cat. (The Walker Art Center, Minneapolis, 1963), Robert Doty and Diane Waldman, *Adolph Gottlieb*, exhib. cat. (The Whitney Museum of American Art, and the Solomon R. Guggenheim Museum, New York, 1968), Harry Rand, "Adolph Gottlieb in Context," *Art Magazine*, 51, No. 5 (February 1977), pp. 112–136, and Karen Wilkin, *Adolph Gottlieb: Pictographs*, exhib. cat. (The Edmonton Art Gallery, Edmonton, Alberta, 1977).

18 Seckler, Interview, p. 6.

19 Alfred H. Barr, Jr., *Cézanne, Gaugin, Seurat, Van Gogh* (New York: The Museum of Modern Art, 1929), Aaron Siskind, a close friend of Gottlieb, said "when we were in school, Gottlieb's god was Cézanne." Telephone conversation with Aaron Siskind, March 24, 1977.

20 Anon. Review, *The New York Times*, January 20, 1929.

21 John Jones, Interview with Adolph Gottlieb, November 3, 1965. New York, Archives of American Art, Smithsonian Institution, p. 6. Gottlieb shared an interest in modern literature with Newman, Siskind, Max Margolis (whose portrait he painted in c. 1935, Illustration 14), and Leo Yamin, who together formed a literary society at City College in New York entitled *Clionia*. Though Gottlieb was never an official member of this group, he often discussed books with these friends.

22 *Ibid.*, p. 5.

23 Sanford Hirsch brought my attention to Gottlieb's technique of haloing forms in his early works.

24 Conversation with Esther Gottlieb, September 16, 1976.

25 Conversation with Esther Gottlieb, New York, February 22, 1978.

26 This circle of friendship is documented in an etching of 1933 entitled *Portraits of Adolph Gottlieb, Esther Dick Gottlieb, Edgar Levy, Lucille Corcos Levy, David Smith, and Dorothy Dehner Smith* (Private Collection). For this group portrait, made one evening in the fall of 1933 in the Levy's apartment, each of the six drew lots to choose their subject, then etched a section of the plate. Gottlieb printed a proof on his etching press.

27 Conversation with Sally Avery, Woodstock, New York, June 26, 1976. Gottlieb, Rothko and Newman also participated in a sketching group that met in the mid-thirties in Avery's studio.

28 Interview with Joe Solman, New York, July 9, 1976.

29 Gottlieb, statement in Charlotte Willard, "In the Art Galleries," *New York Post*, January 10, 1965, p. 20.

30 Interview with Solman, July 9, 1976. My discussion of The Ten is based on Joe Solman's account of the group in "The Easel Division of the WPA Federal Art Project," in *New Deal Art Projects: An Anthology of Memoirs*, ed., Francis V. O'Connor (Washington, D.C. Smithsonian Institution Press, 1972), pp. 115–130, in addition to an interview with Ilya Bolotowsky, New York, May 4, 1977.

31 Jerome Klein, "Ten Who Are Nine Return for Second Annual Exhibition," *New York Sun, December 19, 1936.*

32 Interview with Solman, July 9, 1976.

33 Anon. Review, *The New York Times*, December 22, 1935.

34 Earl Sparling, "Workmen See Little Art in the Municipal Gallery," *New York World Telegram*, January 6, 1936. Sparling said, "Workmen bustled today to get the temporary Municipal Art Gallery at 62 West 53rd ready for official inspection by Mayor La Guardia and other city officials . . . What seemed to attract the chief attention of the workmen was a "Sitting Nude" by Adolph Gottlieb . . . "No, we don't like it," said one of the workmen. "Why couldn't he paint a good looking dame?"

35 Edward Alden Jewell, "Review," *The New York Times*, December 20, 1936, p. 11. "I do not believe I understand the American 'expressionists' so very well."

36 Solman, "The Easel Division," p. 128.

37 Foreward to *The Ten: Whitney Dissenters*, exhib. cat. (Mercury Galleries, New York, 1938), n. pag.

38 For an account of the formation and activities of the American Abstract Artists, see Susan C. Larsen, "The American Abstract Artists: Documentary History, 1936–1941," *The Archives of American Art Journal*, 14, No. 1 (1974), pp. 2–7.

39 Gottlieb, statement in "Questions for Artists Employed on the WPA Federal Art Project in New York City and State," New Deal Research Project (Director: Francis V. O'Connor), March 5, 1968, Archives of American Art, Smithsonian Institution, p. 3.

40 For a history of the Congress, see Gerald Monroe, "The American Artists' Congress and the Invasion of Finland," *Archives of American Art Journal*, 15, No. 1 (1975), p. 16. Gottlieb was one of the signers of the original call for the Congress. See American Artists' Congress Papers, Archives of American Art, Smithsonian Institution, Washington, D.C.

41 In a letter to Harold Baumbach from Arizona, March 3, 1938, Gottlieb objected: "I thought the Union policy was to adopt no aesthetic platform. Yet as a Union organ the *Art Front* seems to reproduce only a certain type of painting, that with a so-called social slant."

42 Dorothy Dehner recalled that Gottlieb "was less politically involved than Smith, Levy, Graham and other artists we knew at that time." Letter from Dorothy Dehner, November 25, 1979. Esther Gottlieb also said that Gottlieb was not "very active politically" during the thirties. Conversation, February 22, 1978.

43 John Graham, *System and Dialectics of Art* (New York: Delphic Studios, 1937). Inscribed: "To Esther and Adolphe, *Graham*." On p. 75 Graham added Gottlieb's name in pen in the margin to his list of "outstanding American painters: Matulka, Avery, (Adolph Gottlieb 'amended by the author'), Stuart Davis, Max Weber, David Smith, Willem de Kooning, Edgar Levy . . . Some are just as good and some are better than the leading artists of the same generation in Europe."

44 Conversation with Esther Gottlieb, September 25, 1976. Graham also introduced David Smith and Dorothy Dehner to African Art dealers during their trip to Paris in the fall of 1935. Conversation with Dorothy Dehner, March 10, 1977.

45 Graham, *System and Dialectics* (1937), p. 51. Gottlieb also read *Cahiers d'Art*. He said, "Before the war, the French periodical *Cahiers d'Art* was the dominant source of European influence," quoted in Francis Celentano, "The Origins and Development of Abstract Expressionism in the United States, unpublished Master's Thesis, New York University, 1957, appendix.

46 Friedman, Interview with Adolph Gottlieb, Tape 1B, p. 14.

47 Gottlieb, Letter to Harold Baumbach, December 12, 1937, January 3, 1938. Gottlieb's correspondence to Baumbach and to Paul Bodin during his eight-month stay in Tucson provides the 1937–38 dates for Gottlieb's Arizona works.

48 Gottlieb, Letter to Baumbach, January 18, 1938.

49 Gottlieb, Letter to Paul Bodin, March 3, 1938.

50 Gerald Monroe, "The American Artists' Congress and the Invasion of Finland, p. 14. My account of the breakup of the Congress is based on Monroe's history and the American Artists' Congress papers, Archives of American Art, Smithsonian Institution, Washington, D.C.

51 *Ibid.*, p. 17. The executive board of the Congress did not respond to an appeal for help from the Houver Commette for Finnish Relief. Ralph Pearson, a founding member of the Congress, who objected to the Communists' control of the board, pressured Stuart Davis to have the board vote on the issue of Finland. After delaying as long as possible, the board finally had Lynd Ward prepare a report, not binding on the board, for presentation at the April 4, 1940 membership meeting. Under the guise of

advocating neutrality, the Ward report did not criticize Russia's take-over of Finland.

52 *Ibid.*, p. 18. Stuart Davis announced his resignation in the New York newspapers on April 8, 1940, followed by Lewis Mumford. In *The New Republic* of April 29, 1940, Mumford criticized liberals, who had previously supported the Communist Party's "popular front" against fascism, for maintaining a silence on Russia's non-aggressive pact with Germany. Mumford saw this as a "covert defense of Hiterlism."

53 *Ibid.*, p. 19. Gottlieb was present at the organizational meeting of the Federation on November 1, 1940 at Morris Davidson's studio. Gottlieb was active on several Federation committees from 1940 to 1953, when he resigned. See Federation of Modern Painters and Sculptors, Papers, Archives of American Art, Smithsonian Institution.

54 De Chirico's work was exhibited in New York at the Julien Levy Gallery in *De Chirico, Paintings and Gouaches* (October 29–November 17, 1936) and at the Pierre Matisse Gallery in *De Chirico* (October 22–November 23, 1940) and (December 1, 1940–January 25, 1941).

55 *Illumined Pleasures* (1929) appeared in *Fantastic Art, Dada,* and Surrealism (1936), no. 310. Harry Rand illustrates *Illumined Pleasures* in his article on Gottlieb, but he denies Dali's influence on him. Rand said Dali's "depictive enervation of reality would have been abhorrent to many American artists. Certainly Gottlieb was not attracted to such manipulations." ("Adolph Gottlieb in Context," *Arts*, p. 113). But Gottlieb was definitely influenced by Dali in his still lifes of 1939–40, which echo Dali's contrast of an emotionally charged imagery with a neutral setting.

Lawrence Alloway acknowledged the impact of Verist Surrealism on Gottlieb's works of this period, comparing them with "object pictures like Pierre Roy's." (See Melpomene and Graffiti, *Art International*, 12 (April 1968), p. 21. Pierre Roy's *Electrification of the Country* (Wadsworth Atheneum, Hartford), which Gottlieb could have remembered from *Fantastic Art, Dada, and Surrealism* (no. 574), similarly focuses on compartmentalized objects on a beach.

Part II: The Pictographs, 1941-1953

"A Wedding of Abstraction and Surrealism"

In 1939-40 Gottlieb found himself at an impasse in his career. Disturbed by the growing World War and unsure of what direction to pursue in his art, he fell into a period of deep introspection and doubt. Later he said of this time, "there was some sense of crisis. I felt I had to dig into myself, find out what it was I wanted to express."[1] Gottlieb was sure only that existing styles were not viable for him. Long opposed to both American Scene Painting and Social Realism he felt now more than ever that these forms of expression were outdated in a radically altered world.

Gottlieb was attracted to the irrational content of Surrealism, which reflected the darkness of the time, but he was not comfortable with the illusionism of Dali. Unlike Baziotes, Gorky, Motherwell, and Pollock, he did not associate with the Surrealists in exile in New York in 1940-41. Living in Brooklyn, Gottlieb was to some extent cut off from their activities in the city, but he also deliberately kept his distance from them because, as he said, "I didn't feel that Surrealism was really an answer, a complete answer to what I was looking for."[2] During this time Gottlieb was also drawn to the two-dimensional space of abstraction, but he did not like non-objective abstraction's heavy dependence on Cubism. He was not interested in joining the group of purely abstract painters who exhibited as the American Abstract Artists. Years later Gottlieb said of this dilemma: "the whole problem seemed to be how to get out of these traps—Picasso, Surrealism—and how to stay clear of American provincialism, regionalism, and Social Realism."[3]

Since Gottlieb could not identify fully with either abstraction or Surrealism, he began to formulate a style in which he combined only those aspects of each tradition that appealed to him. In 1941, in a new series of works which he entitled Pictographs, Gottlieb combined a flat, abstract space with a subjective, Surrealist-derived content—elements with which he had begun to work in his Arizona still lifes, but which he now further explored. Although in some respects these aspects of abstraction and Surrealism were esthetically opposed, in merging them Gottlieb arrived at a new expression. He later alluded to this fusion in his 1951 introduction to a memorial exhibition of paintings by Arshile Gorky at the Kootz Gallery in New York. In paying tribute to Gorky, he also spoke about himself:

> For him, as for a few others, the vital task was a wedding of abstraction and surrealism. Out of these opposites something new could emerge, and Gorky's work is part of the evidence that this is true.[4]

Gottlieb's belief in the creative possibilities produced by the marriage of esthetic opposites was itself a Surrealist concept, derived ultimately from Lautréamont's famous image of the casual meeting on a dissection table of a sewing machine and an umbrella. André Breton, Surrealism's principal esthetician, said he believed in "the future resolution of the states of dream and reality, in appearance so contradictory, in a sort of absolute reality, or *surrealité*."[5] By 1940, when Surrealism dominated the art scene in New York, Gottlieb was no doubt familiar with this concept. In the Pictographs, however, he interpreted it in his own way, combining disaparate styles as well as images. Indeed, in these works Gottlieb fuses a wealth of diverse artistic sources from ancient, Renaissance, modern, and primitive art, as well as other sources in Freud, Jung, and Surrealist literature to forge his own expression.

Although other Abstract Expressionists also combined aspects of abstraction and Surrealism in their painting of the mid-forties, Gottlieb's Pictographs of 1941 place him with Gorky and Pollock in the vanguard of this trend. Moreover, in these early works Gottlieb was one of the first of his generation to incorporate the major themes of Surrealism—biomorphism, automatism, primitivism, and myth. The Pictographs are also important in terms of the development of Gottlieb's pictorial ideas, for in them he first formulates the theme of polarity, pairing an ordered space

29

with a subjective content. This dualism, which Martin Friedman notes as "the pervasive theme of Gottlieb's art,"[6] achieves its distillation in the polar images of the Bursts of the fifties and later paintings, but it first appears in the Pictographs.

While the grid compositions of the 1941 pictures *Oedipus* and *Eyes of Oedipus* (Illustrations 34 and 35) have been assumed to mark the beginning of the Pictographs,[7] other paintings of that year, which were possibly completed before the Oedipus works, indicate that Gottlieb was also working in another direction. There are in fact two kinds of compositions in the first Pictographs of 1941: one with a centralized format, including *Untitled (Still Life)*, *Female Forms*, and *Pictograph-Tablet Form* (Illustrations 31, 32, and 33); and the other with an all-over grid design, exemplified by *Oedipus* and *Eyes of Oedipus*. From 1941 to 1943 Gottlieb worked in both modes before concentrating on grid compositions for the remainder of the forties. While the centralized compositions seem to be a minor theme in the Pictographs, they are important because they reappear in different form in his later art, in the Pictographs of 1950, the Unstill Lifes of 1949-56, and finally the Bursts of 1956-60.

Sources for the centralized and grid varieties of composition in the Pictographs are found in Gottlieb's own work. In *Untitled (Still Life)* the horizontally divided background echoes his Arizona still lifes; however, the table and wall of these earlier works have been transformed into two flat color bands. And in place of desert cacti is an abstract, ameboid shape. In a similar way, the two-dimensional grid in *Oedipus* and *Eyes of Oedipus* can be seen as the logical extension of the slotted box in his sea still lifes of 1939-40.[8] But the two-dimensional space in these works suggests that Gottlieb changed his interest at this time from Verist Surrealism to abstract styles.

Centered Compositions, 1941: Biomorphism and Automatism

Surrealist biomorphism was the most important source for Gottlieb's centralized formats. Lawrence Alloway has identified two types of biomorphism: planar "one-cell biomorphs" and "groups of such forms."[9] In these works of 1941 Gottlieb was clearly influenced by the former, although in Pictographs of 1944-46 he also experimented with the latter. While Alloway noted the influence of biomorphism on Abstract Expressionism of the mid-forties, Gottlieb's first Pictographs indicate that he had absorbed this aspect of Surrealism by 1941. Gottlieb, as well as Baziotes and Pollock, may have become interested in abstract biomorphic images through seeing illustratings of the microbic world revealed by the electron microscope, which was commercially developed in 1940.[10] This minute realm, which exists but cannot be seen, parallels the real but invisible imagination.

For Gottlieb, biomorphism was a way to freely express his unconscious, in which he had become fascinated via Graham, Freud, and Surrealism. And automatism—the painterly technique for Freudian free-association—was the method Gottlieb used to generate biomorphic shapes, which were forms spontaneously conceived in his unconscious.[11] Joan Miró's art was the primary example of biomorphism for Gottlieb's painting of this time. He knew Miró's art through exhibitions in New York during the thirties. Before beginning the Pictographs Gottlieb also may have seen the 1940 Miró show at the Pierre Matisse Gallery and the 1941 retrospective at The Museum of Modern Art.[12] Gottlieb's *Untitled (Still Life)* of 1941 (Illustration 31), which displays a large organic shape against flat color planes, resembles certain Miró abstractions of the early thirties. In *Female Forms* and *Pictograph-Tablet Form* (Illustrations 32 and 33) Gottlieb expands this amoeboid shape into a rounded rectancle, suspended against an undivided background. This central form also owes a debt to the single biomorphs of other European artists, Jean Arp and Wassily Kandinsky.

Gottlieb's interest in 1941 in biomorphism and automatism was shared by Baziotes, Gorky, Motherwell, and Pollock. In the fall of 1942 these artists, along with Peter Busa and Gerome Kamrowski, met in the Ninth Street studio of the Chilean Surrealist Roberto Matta Echaurren to experiment with automatism.[13] Gottlieb was not part of this group, but he surely was aware of automatism through

10. Paul Klee, ARAB SONG, 1932
The Phillips Collection, Washington,
D.C.

11. Pablo Picasso, GIRL BEFORE A MIRROR,
1932 oil on canvas 64 x 51¼"
Collection: The Museum of Modern
Art, New York.

looking at Surrealist painting and reading Surrealist theory in John Graham's book *System and Dialectics of Art*. According to Graham, automatism was a direct means of expressing feelings: "Gesture, like voice, reflects different emotions. . . The handwriting must be authentic, and not faked . . . (not) conscientious but honest and free."[14]

Like those in the Matta circle, Gottlieb understood automatism as a way to transmit the contents of his unconscious onto the canvas. He said his method of painting the Pictographs was "akin to the automatic writing of the Surrealists."[15] To achieve an immediate expression, Gottlieb worked directly on the canvas. Given his training with Henri and Sloan—who advocated painting quickly—Gottlieb easily adopted this technique, applying it to Pictographs in both oil and gouache. He painted these works without preparatory sketches in order to capture, as he explained, "the direct, improvised, fresh sort of feeling." After laying out his free-associated images, there was "very little editing or revision."[16]

But Gottlieb utilized automatism in a more limited way than other Abstract Expressionists. Although to a large extent he moved his hand freely as he painted, at the same time he checked this tendency in the grid, carefully adjusting his images to the frames of their compartments. In contrast to the apparent swiftness of Pollock's and Rothko's calligraphy in their works of the mid-forties, Gottlieb's fluid but considered lines seem controlled. "It wasn't just picture writing. . . . I was involved with the painting ideas and making things painterly,"[17] Gottlieb said. Instead of a device to indulge the unwilled movement of his hand, automatism was primarily a means of releasing his imagination to generate images from his unconscious. He adopted Graham's approach to *ecriture automatique* as "free-association based on memories of the racial past."[18] Through Graham, Gottlieb believed he could tap not only his personal unconscious but also the collective unconscious in his free-associated images.

Jung and the Collective Unconscious

Several writers have noted the Jungian theme of the collective unconscious in the Pictographs, though none have documented Gottlieb's interest in Jung.[19] Before he began these works, Gottlieb was indeed fascinated with Jung's thought. In 1967 he said, "I was reading Jung at the time . . . it was Jung who came up with the idea of the collective unconscious."[20] Jung's theory of the expression of the collective unconscious in archetypes and myths was available in 1939 in English translation in Jung's *The Integration of the Personality*.[21] But Gottlieb did not have to read this book because Graham was an immediate source of Jung's ideas. Both Graham's 1937 article in *Magazine of Art*, "Primitive Art and Picasso," and his book *System and Dialectics of Art* are infused with Jungian references to the collective unconscious.

31

With Graham as his source, Gottlieb absorbed various aspects of both Freudian and Jungian thought in his work. In the Pictographs, for example, there are certain images which are distinctly sexual: oval shapes seem breastlike and serpentine forms appear phallic. While in Freudian terms these originate from the personal unconscious, in Jungian terms they are universal, thus products of the collective unconscious.

There is no doubt that Jung had a special impact on Gottlieb's painting of the forties. In fact, Esther recalled that when Gottlieb began the Pictographs, he was more interested in Jung than Freud.[22] Gottlieb adopted in the titles of several Pictographs Jungian themes of myth and alchemy, which will be discussed later. But like Pollock, who was also influenced by Jung,[23] Gottlieb did not reflect Jung's concepts in any programmatic way. His pictographic images do not have specific meanings; rather, in the spirit of Jungian symbols they are deliberately ambiguous. Moreover, Jung was only one among many sources that Gottlieb assimilated in his works of the forties.

The Grid

In his Pictographs at the beginning of the war, Gottlieb sought to balance the irrational images of his unconscious with a clear formal structure. The defined limits of the grid, presaged in the comparmented boxes of the sea still lifes, first appear in *Pictograph-Tablet Form* of 1941 (Illustration 33). The grid in conjunction with automatism satisfied his interest in both rational and subjective expression. While the grid communicates a sense of order, the images convey randomness. Gottlieb's actual use of these two elements, however, was more complex: He spontaneously invented the images, but carefully placed them in the composition. In addition, he used the grid to create pictorial structure, but he drew it freely. Thus he emphasized the grid's inherent ambiguity: Although he organized images with the grid, he did not give them logical sequence. Therefore, the pictographic signs cannot be read as a rebus, but form multiple associations in vertical, horizontal, and diagonal directions.

The system of intersecting lines in the interior of *Pictograph-Tablet Form*, as well as its palette of browns and grays, point to the example of Cubism. But in contrast to the fractured planes of analytical Cubism, Gottlieb creates definite shapes derived from synthetic Cubism. The merger of the grid and organic shapes in this painting is a pictorial device also found in the work of the late thirties by American Abstract Artists George L. K. Morris, George McNeil, and Vaclav Vytlacil, who reinterpreted the esthetic doctrines of the European Abstract-Creation movement of 1931-37. Though like these artists Gottlieb combined curvilinear and rectilinear synthetic Cubist forms, unlike these non-objective painters he was interested in a subjective content. Gottlieb's expressionist outlook, formed under Avery, gave him the belief that forms were carriers of feeling.

John Graham and Arshile Gorky did influence Gottlieb's work at this time. As a friend of Graham's since the twenties, Gottlieb was certainly familiar with his work. He later described Graham's art as "very influential."[24] During the thirties, Gottlieb met Gorky through Graham. Gottlieb admired Gorky's abstract painting, especially because it was not non-objective. "Gorky was one of the first good abstract painters in America. He was never a non-objective painter, because his work was always about something, and non-objective painting is about nothing," Gottlieb said.[25] The biomorphic Cubism in Graham's and Gorky's works of the thirties are precedents for Gottlieb's semi-abstract style in *Pictograph-Tablet Form*.

Another example for Gottlieb at this time was Paul Klee's art, which he could have seen in a 1941 retrospective at The Museum of Modern Art. Klee's influence on the Abstract Expressionists in general and on Gottlieb in particular is clear. Andrew Kagan has said that Klee's impact on these artists was "precisely formal."[26] In other words, Klee's automatic drawing and flat space were more important to them than the whimsical content of his art. Klee's paintings of the thirties, which bring these pictorial elements together, had a significant effect on Gottlieb's work of the forties. Indeed, in *Pictograph-Tablet Form* the fusion of abstraction and representation is reminiscent of Klee's *Arab Song* of 1932 (fig. 10).

12. Piet Mondrian,
COMPOSITION WITH
RED, 1936
Philadelphia Museum
of Art: A.E.
Gallatin Collection

13. Joacquin Torres-Garcia,
COMPOSITION, 1929
Philadelphia Museum
of Art: A.E.
Gallatin Collection

But the major source for Gottlieb's *Female Forms* (Illustration 32) was Picasso's synthetic Cubist style of the late twenties and early thirties. Picasso's *Girl Before a Mirror* of 1932 (fig. 11), which The Museum of Modern Art had acquired in 1938, was the probable model for Gottlieb's fusion of grid and circular forms. His title confirms that he was thinking of the feminine shape; his biomorphic, oval forms bear some resemblance to the girl's breast and torso in Picasso's picture. Here Freudian sexual imagery, which had first appeared in the magic realist style of the sea still lifes of 1939-40, reemerges in 1941 in more abstract form.

Primitivism

In addition to biomorphism and automatism, Gottlieb introduced the theme of primitivism in these 1941 Pictographs with centralized formats. Although he had collected primitive art since 1935, he never reflected it in his art of that period. But in 1941 Gottlieb was drawn to the idea of primitivism as a means of expressing his feelings about man's primeval nature, which the horrors of World War II were revealing. Most of all, he was attracted to the unconscious expression he sensed in primitive art. Gottlieb inherited this Surrealist idea from Graham, who in 1937 said, "the art of primitive races has a highly evocative quality which allows it to bring to our unconscious mind, stored with all the individual and collective wisdom of past generations and forms." According to Graham, this unconscious expression is also found in Picasso's art: "Picasso's painting has the same ease of access to the unconscious as have primitive artists—plus a conscious intelligence."[27] Graham illustrated his article "Primitive Art and Picasso" with examples of African and Eskimo art, as well as Picasso's *Girl Before a Mirror*.

Given Gottlieb's association with Graham, it is not surprising that he alluded to both primitive art and Picasso in *Pictograph-Tablet Form*. To begin with, he adopted the term "Pictograph," referring to archaic wall art whose meaning is lost to modern man. Gottlieb had seen Pictographs in 1937 at The Museum of Modern Art in *Prehistoric Rock Pictures of Europe and Africa*, in 1938 in Arizona, and again in 1941 in another show in New York, *American Indian Art*.[28] This last exhibition, which stressed the mystery of Pictographs, impressed Gottlieb. He imbues *Pictograph-Tablet Form* with a similar sense of enigma. His ambiguous shapes, such as the dark circle in the center, recall both the breast forms in *Girl Before a Mirror* and the eye signs in Southwest Pictographs. In addition, the short, parallel lines at the upper right echo the bear claw design often found in these Pictographs.

Yet Gottlieb did not borrow primitive styles, but like Picasso, alluded to them in isolated forms. Robert Goldwater's description in *Primitivism and Modern Painting* (1939) of the connection between Picasso and primitive art also applies to Gottlieb: "the relation is . . . that of an admiration which, through the

33

reproduction of certain details . . . creates a reminiscence of primitive art in the mind of the beholder imbued with a similar knowledge and admiration."[29]

To evoke a sense of the archaic Gottlieb placed his images between configuration and abstraction, like inscrutable markings on an ancient stone. He also used a sand-toned palette and added paint skins to the surface to produce a time-worn effect. Further, he applied paint in multiple layers, suggesting time's strata. This technique is best seen at the edges of the Pictographs, where Gottlieb left layer upon layer of paint visible. Because he felt that he could no longer "visualize a whole man on canvas," Gottlieb fragmented the figure, employing a method found in both primitive art and Picasso's painting. To reformulate the figure in his art, Gottlieb used the part as a metaphor of the whole. He said,

> When I say I am reaching for a totality of vision, I mean that I take the things I know— hand, nose, arm—and use them in my paintings after separating them from their associations as anatomy. I use them as a primitive method, and a primitive necessity of expressing, without learning how to do so by conventional ways. It puts us at the beginning of seeing.[30]

The Oedipus Pictographs, 1941: The All-Over Composition

Gottlieb's centralized compositions of 1941, with their sources in American Indian art, Picasso, Klee, and Miró, are the predecessors of later works, such as *Persephone* of 1942 (Illustration 38) and *Rape of Persephone* of 1943 (Private Collection, New York). But the grid within *Pictograph-Tablet Form* also points to the other kind of Pictograph Gottlieb developed in 1941. The works in this second group, represented by *Oedipus* and *Eyes of Oedipus* (Illustrations 34 and 35), have an overall design, which Gottlieb devised by stretching the grid in four directions to the picture's edge.

According to Gottlieb this method had two purposes. The first was to create an "all-over sort of image in which there was no single focal point."[31] Thus Gottlieb, along with Pollock, was one of the first in The New York School to develop a composition which dispersed the viewer's attention over the entire field instead of concentrating it in one area. But unlike Pollock, who evenly distributed linear rhythms to create no single focus, Gottlieb produced multiple focal points. The second purpose of the grid was to create the illusion that it had "no beginning and no end."[32] But in doing this, Gottlieb revealed the grid's dual nature: By extending the lines to all four edges, he suggested that the picture was a fragment of a larger, unlimited whole. At the same time, he stated the grid's definite limitations in the repetition of discrete compartments.

The grids in *Oedipus* and *Eyes of Oedipus*, in contrast to the boxes of the sea still lifes, produce no illusion of three dimensional space, but are flat frameworks. There are several sources in older and modern art for Gottlieb's combination of continuous, two-dimensional grids and fields in the Pictographs. He claimed that his initial source of inspiration was early Italian panel painting, which he had admired since his first trip to Europe in 1921-22. In 1941, as he was searching for a new means of expression, Gottlieb again thought of this kind of painting, with its flat space and compartmented but interrelated scenes. Indeed, in 1943 Gottlieb compared his Pictographs to this late Medieval art:

> Like those early painters who placed their images on the gold grounds of rectangular compartments, I juxtapose my pictographic images, each self-contained within the painter's rectangle, to be ultimately fused within the mind of the beholder.[33]

Unlike these painters, however, Gottlieb does not create a hierarchy of images or arrange them in a narrative sequence.

Gottlieb was aware of the grid in modern art through Cubism. But the most important and obvious source for *Oedipus* and *Eyes of Oedipus* of 1941 was the art of Mondrian. "I admired Mondrian and was very much aware of what he was doing," Gottlieb said in 1962.[34] During the thirties he probably saw Mondrian's paintings, such as *Composition with Red* of 1936 (fig. 12) at the A. E. Gallatin Museum of Living Art, then on view at New York University. In 1941 Gottlieb

14. Mark Rothko, UNTITLED, ca. 1939-1940
 Estate of Mark Rothko

15. Pablo Picasso, STUDIO WITH PLASTER HEAD, 1925 oil on canvas 38⅝ x 51⅝" Collection: The Museum of Modern Art, New York.

would have been especially aware of Mondrian, whose arrival in New York in October 1940 had been publicized. Gottlieb, in his search for an ordered compositional format, was drawn naturally to Mondrian's rational grids. Like Mondrian, he employed empty spaces in his Pictographs to balance occupied compartments. But Gottlieb inhabited these sections with images instead of pure color planes. And in contrast to Mondrian, he invented irregular, painterly grids.

Another possible source for the Pictographs is the painting of the Uruguayan artist Joaquin Torres-Garcia. "The fact is that I didn't know too much about Torres-Garcia," Gottlieb said in 1962. "I had just seen one of his paintings in the Gallatin collection many years ago."[35] This picture was *Composition* of 1929 (fig. 13) which, like the Pictographs, displays a grid containing representational and abstract signs. Gottlieb said, "I wasn't influenced by him [Torres-Garcia]. I think he was a kind of mechanical cubist."[36] But Torres-Garcia surely reinforced Gottlieb's interest in the grid; indeed, he admitted that the impact of Torres-Garcia on his work may have been "unconscious."[37] Yet whereas the Uruguayan painter used an analytical Cubist linear scaffolding and shallow space, Gottlieb utilized a totally flat grid derived from synthetic Cubism and Mondrian.

The Meaning of Myth

Gottlieb introduced mythological themes in the Pictographs in the titles of *Oedipus* and *Eyes of Oedipus*. Though Gottlieb has been described as "only one of the advanced artists to seize eagerly upon archaic themes,"[38] he along with Rothko, was in the vanguard of this direction in the early forties. Gottlieb recalled that he and Rothko adopted mythological themes in their painting after discussions they had together in 1941. Gottlieb viewed myth as an alternative to realism, which he wanted to avoid. He recalled saying to Rothko, "'How about some classical subject matter like mythological themes?' And we agreed . . . Mark chose to do some themes from the plays of Aeschylus, and I played around with the Oedipus myth, which was both a classical theme and a Freudian theme."[39]

Gottlieb arrived at myth in 1941 in various ways. He may have noticed Graham's mythological titles like "Zeus" on paintings in a one-man show in the spring of 1941 at the Artists Gallery.[44] But it was undoubtedly through reading Freud that he focused specifically on the Oedipus myth, to which he alluded in several works of the early forties, including *Oedipus* and *Eyes of Oedipus* of 1941 (Illustrations 34 and 35), *Oedipus Pictograph Totem* of 1942, *Hands of Oedipus* of 1943 (Illustration 39), and *Eyes of Oedipus* of 1945. In 1941, as America plunged into war, Gottlieb was pulled toward the Oedipus myth because he found in it a powerful statement of man's tragic nature. Through Freud he saw Oedipus as a symbol of man's eternal conflict within himself and against society. He also may

35

have seen Oedipus's quest for truth through the personal unconscious as a metaphor for his own search for meaning during this world crisis.

Through Jung, however, Gottlieb viewed Oedipus in a broader context, as a symbol of not only man's personal but also his collective unconscious. He learned from Jung that the archaic thinking in myth and dream still survives today in childlike and non-directed thinking. Modern and archaic man, therefore, though separated by time, are related psychologically. And Oedipus, Jung suggested, is the symbol of this basic connection:

> If we can succeed in discriminating between objective knowledge and emotional value judgments, then the gulf that separates our age from antiquity is bridged over, and we realize with astonishment that Oedipus is still alive for us. The importance of this realization should not be underestimated, for it teaches us that there is an identity of fundamental human conflicts which is independent of time and place. What aroused a feeling of horror in the ancient Greeks still remains true, but it is true for us only if we give up the vain illusion that we are *different*, i.e., morally better than the ancients. We have merely succeeded in forgetting that an indissoluble link binds us to the men of antiquity.[40]

Since the truth of the Oedipus myth was timeless, Gottlieb could use it as the basis for his own modern expression. "I think anyone who looks carefully at my portrait of Oedipus or at Mr. Rothko's *Leda* will see that this is not mythology out of Bullfinch. The implications have direct application to life,"[41] Gottlieb said in 1943. For him, the Oedipus myth, with its themes of incest and patricide, was a compelling expression of man's basic savagery, confirmed again in war.

Around 1941 Gottlieb also may have come across the Oedipus theme in Surrealist literature. Feeling isolated in his search for a personal style, he would have identified with Parker Tyler's discussion in the American Surrealist magazine *View* of Oedipus as a tragic hero, alienated from society. As an artist concerned with his own inner vision, Gottlieb also would have been drawn to Hilary Arm's description of Oedipus as a seer of truth, wrongly punished by the gods.[42]

In *Oedipus* and *Eyes of Oedipus* Gottlieb reflects this theme of tragic self-knowledge in Oedipus's blind visages. By turning Oedipus's eyes in upon themselves and using the image of the single eye, as in the upper right of *Oedipus* (Illustration 34), Gottlieb adopts the Surrealist theme of inner vision.[43] The isolated dream eye is present in Surrealist paintings, such as Miró's *The Family* (1924) and René Magritte's *The False Mirror*, both of which Gottlieb could have seen at The Museum of Modern Art. The pair of mysteriously staring eyes at the left of *Oedipus* also recall those in Klee's *Arab Song* (1932, fig. 10).

In addition, Gottlieb could have found images of the single eye in both Egyptian and Coptic art—The former he knew from visits to The Metropolitan Museum, and in 1941 he may well have seen an exhibition of late Egyptian and Coptic art at The Brooklyn Museum.[44] The image of the solitary eye that appears on the one-dollar bill is a Coptic symbol, while in other Egyptian art the single eye is prevalent as a symbol of the sun. Gottlieb's arrangement of images in vertical tiers in *Oedipus* and *Eyes of Oedipus* recalls hieroglyphics. The faded brown and mauve tones in these works and their textured surfaces—scraped with a palette knife and roughened with paint skins—also creates an effect of antiquity.

In addition to choosing classical and mythological themes, Gottlieb and Rothko naturally looked to ancient art to evoke a sense of the archaic in their own art. But they drew on different sources. Whereas Gottlieb's flat space and schematic drawing in the 1941 Pictographs indicate his interest in Egyptian art, Rothko's shallow space and series of modelled forms in works such as *Untitled* (fig. 14) suggest the example of ancient relief.[45] In *Untitled* Rothko further echoes Near Eastern relief sculpture in his stratified horizontal composition, his decorative architectural patterns, and the stylized human features with tightly curled hair. Yet the two artists also shared a fascination with certain motifs. Like Gottlieb, Rothko repeats the eye and the double face in several of his works of the early forties, also alluding to the inner dream world.

16. Tlingit Fringed Blanket, Chilkat
 Collection: Esther Gottlieb, New York.

17. Joan Miró, HEAD OF A MAN, 1937
 Richard S. Zeisler Collection, New
 York.

Signs of the Artist: The Eye and the Hand

The eye, the hand and the head frequently appear in the early Pictographs. By removing these fragments from the whole body and isolating them in a strange setting, Gottlieb invests them with a disturbing sense of mystery. Precedents for this detached treatment of the human form are found in Surrealism, which often combined human parts in odd relationships with other objects and their setting. Picasso employed the solitary head and hand in works such as *Studio with Plaster Head* of 1925 (fig. 15), which Gottlieb could have seen at The Museum of Modern Art. The single eye in *Oedipus* may have been partially inspired by the staring eye in this picture. In addition, Gottlieb's tendency to thickly layer paint to create an emphatically tactile surface may have been reinforced by seeing Picasso's impasto, evident here. Yet Gottlieb went beyond Picasso in creating an imaginary composition. Whereas *Studio with Plaster Head*—despite its synthetic Cubist stylizations—is a recognizable still life, the Pictographs belong to no conventional category of painting. Rather than still lifes, they seem like cryptic records of some ancient ritual.

Gottlieb employed all the images in these works—the eye, the hand, the head, the curtain and the crown—not as specific symbols but as ambiguous signs. For example, the detached eyes refer to both Oedipus's blindness and his prophetic vision, suggested in *Eyes of Oedipus* by the multiple face, looking forward and backward. The curtain implies simultaneously concealment and revelation, and the hand suggests at once the gods' judgment and Oedipus's punishment of self-inflicted blindness.

Ultimately, these signs refer to Gottlieb's own artistic powers. The crown, symbol of kingship, has special powers of creation. As Freud noted, the artist is capable of turning reality into fantasy and identifying with these inventions of his imagination: "With his [the artist's] special gifts he molds his fantasies into a new kind of reality. . . . Thus by a certain path he actually becomes the hero, king, creator, favorite he desired to be."[46] As the War deepened in 1941, Gottlieb probably felt a strong affinity with the troubled, many-faceted figure of Oedipus. But Gottlieb imbued the signs in his Pictographs with a mystery that defies logical explanation. His focus on an enigmatic imagery at this time may have been encouraged by Kurt Seligmann, who in *View* advised: "In an iconoclastic era such as our own, we shall speak the language of hints. We shall shiftingly identify ourselves with our cryptic images . . . And the leitmotiv will be so intricate that its interpreters, now and forever more, will break their teeth on it."[47]

Soon after Gottlieb began his Oedipus Pictographs, myth became a topic of debate among the Surrealists. "At that time a great many writers more than painters," Gottlieb later said, "were absorbed in the idea of myth in relation to

37

art."[48] Chief among these writers was André Breton, who advocated myth in an April 1942 article[49] in which he stated, "I cannot grant you that mythology is only the recital of the acts of the dead. . . . Have we not known for a long time that the riddle of the Sphinx says much more than it seems to say?"[50] Yet Breton's efforts to promote myth were resented by European Surrealists, who had already developed their own subject matter. In April 1943, an editorial in *View* criticized Breton; the writer said he was "against myths . . . be they pagan or Christian" and was in favor of a "more human interpretation of motivations which Freud has given us."[51]

In this debate among the Surrealists, the unnamed protagonists were Freud and Jung. Freud, whose psychoanalytical technique of free-association was the basis of automatism, dominated Surrealist psychology. Jung, on the other hand, who emphasized myth over dream and the collective over the personal unconscious, was not equally recognized. The Surrealists' silence on Jung is odd because, as John Golding has observed, "the strong neo-romantic flavour of his thought was in many ways more congenial to the Surrealist climate than that of his master, Freud, to whom the Surrealists paid greater honour."[52]

Unlike the Surrealists, however, Gottlieb had no strong allegiance to either Freud or Jung, but following Graham's example, drew freely from both sources. Ironically, Breton's prediciton that myth would be the subject of a new art was fulfilled not by his European Surrealist colleagues, but by the American artists, Gottlieb and Rothko.

Variations on the Pictograph, 1942-1943

Having formulated two kinds of Pictographs—the centralized format and the grid design—in 1942-43 Gottlieb explored variations on these. He followed the path he had begun in Arizona, developing his ideas methodically in a series of related works. In this process he drew from eclectic sources in primitive and modern art to invent his own imagery of mystery and ambiguity.

The first compositional variation is seen in *Pictograph* (1942, Illustration 37), in which Gottlieb combines the curvilinear shapes from *Pictograph Tablet Form* with the overall grid design of *Oedipus*. Instead of an archaic mood, however, Gottlieb evokes a primitive expression. The banded oval eyes in the center of this work echo the pattern of Northwest Coast Chilkat Blankets, which Gottlieb had seen in the 1941 show *Indian Art of the United States*. He liked this art so much that in the mid-forties he added a Chilkat Blanket to his own collection (fig. 16). The vertical columns of faces in *Pictograph* and *Pictograph-Symbol* (Illustration 36), in which human forms seem abstract and abstract shapes assume human form, evoke the Haida totem pole sculpture, which Gottlieb also could have seen at The Brooklyn Museum and in the 1941 show at The Museum of Modern Art.

Though Gottlieb recalled primitive art in these Pictographs of 1942, he invented his own imagery. Through Jung he believed that certain signs, such as the snake and the egg shape, are universal products of the collective unconscious. Therefore, these signs were as much his as the primitive artist's,[53] Gottlieb's assorted images have meaning, but their meaning is deliberately open-ended. "I wanted to use ambiguous symbols for my own purposes, to prevent people giving them interpretations I didn't mean," Gottlieb said.[54] For example, Gottlieb dropped the image of the fish, which he used in *Expectation of Evil* (1945, Illustration 46), when he realized the sign's obvious Christian symbolism.

But unlike the Surrealists, Gottlieb may have initially used the fish, who swims in uncharted waters, to suggest the unconscious. As a creature of the sea, itself a Freudian and Surrealist image of the unconscious, the fish was a means of alluding to this mysterious realm. Thus, the image of the fish, like the eyes of Oedipus, suggests the unconscious and, in a poetic way, Gottlieb himself.

The second compositional variation in Pictographs of this period appears in *Persephone* of 1942 (Illustration 38), which displays a single, centralized shape. Here the form is not classical but is biomorphic. It is at once head and body, and its free-floating eyes and mouths, which look like cellular components, recall Miró's 1937 *Head of a Man* (fig. 17). Gottlieb evidently liked this kind of image by Miró,

18. Joan Miró, UNTITLED, 1944 lithograph
28 x 21"
Collection: Esther Gottlieb, New York.

19. Pablo Picasso, ILLUSTRATIONS FOR PAUL
ELUARD'S ARTICLE "LA BARRE d'appui",
Paris, 1936 aquatint plate: 12⁷⁄₁₆ x 8½"
Collection: The Museum of Modern
Art, New York.

since in the late forties he collected a similar one in a 1944 lithograph (fig. 18). Like
Miró, Gottlieb mutilates the human form, violently rearranging its features. In
1942, as the war worsened, Gottlieb was naturally attracted to Miró's grotesque
tableaux sauvages, which evoke the anguish of the Spanish Civil War. It is not
surprising that during the war Gottlieb focused on mythological themes such as the
blinding of Oedipus and the rape of Persephone, since they expressed man's violent
nature.

In 1943 Gottlieb returned to the grid format and the Oedipus theme in two
closely related works, *Hands of Oedipus* and *Pictograph #4* (Illustrations 39 and
40). He composes the two pictures in the same way, adding a register of images at
the bottom of *Pictograph #4*. He also includes the same images—crowns, faces,
eyes, hands, and birds—but he defines them differently. Whereas in *Hands of
Oedipus* he makes shapes uniformly flat, in *Pictograph* he contrasts two-
dimensional profiles with modelled ones. As in his sea still lifes, he continued to
invent metamorphic images. At the upper left in both works he rhymes eyes and
bird wings, merging them to the right in the poetic image of "bird wings." He
reiterates this visual pun in the series of hands below, which also echo the wings of
a bird.

Gottlieb also introduces new images in these works, suggested by diverse
sources. For the first time he groups the eye and the hand with the image of a bird,
recalling Max Ernst's interpretation of the Oedipus theme in *Oedipus Rex* of 1922.
Like Ernst, Gottlieb suggests in the bird image the flight of the unconscious,
confined by the mind's structures represented by the grid. But Gottlieb rejects
Ernst's deep space for a flat background reminiscent of early Italian painting and
Mondrian.[55] The primitive profile at the lower left of *Hands of Oedipus* and
Pictograph #4, however, recalls Nayarit pottery, which Gottlieb had probably seen
in the 1940 show *Twenty Centuries of Mexican Art*. During the forties Gottlieb
added a piece of this pottery to his own collection. In *Pictograph #4*, he evokes the
color and texture of this art in his clay-toned palette and rough impasto.

In *Black Hand* of 1943 (Illustration 41) Gottlieb produces another enigmatic
image, drawing on Surrealism and primitive art. Gottlieb's impressions of his hand
throughout the picture may have been inspired by his memory of handprints in
Miró's art[56] or by Picasso's illustration for Paul Eluard's *La Barre d'appui* (fig. 19).
In addition, Gottlieb may have seen the handprint in prehistoric art. Robert Hobbs
noted that in *Black Hand* Gottlieb parallels "Cro-Magnon man who at times, as in
Altamira, affixed his identity to the walls of a cave with handprints."[57]

Critics noted the primitive expression in Gottlieb's work when he first began
exhibiting his Pictographs in 1942. Of *Symbol*, the first Pictograph shown, which
appeared in May 1942 in the Second Annual Exhibition of the Federation of

Modern Painters and Sculptors, Carlyle Burrows of *The New York Herald Tribune* said it was "richest in symbolic invention, suggesting American Indian culture."[58] *The New York Times* critic Edward Alden Jewell strongly reacted against the primitive aspect of the Pictographs. In June 1943, in his review of the third Federation show, Jewell criticized Gottlieb, saying he was not prepared to "shed the slightest enlightenment when it comes to Adolph Gottlieb's 'Rape of Persephone.'"Jewell similarly derided Rothko's work: "You will have to make of Marcus Rothko's 'The Syrian Bull' what you can."[59]. Angered by Jewell's antagonism toward their art, Gottlieb decided to respond and enlisted the aid of Rothko. In a now-famous letter to *The New York Times* of June 7, 1943, Gottlieb and Rothko (with the assistance of Barnett Newman) answered Jewell by stating their own views on their art.

Letter to the New York Times, 1943

In retrospect, this letter to the *Times* is historically significant because in it Gottlieb and Rothko first articulate the themes of myth and primitivism, which later became identified with The New York School. But the letter does not express a group credo. At this point Gottlieb and Rothko speak only for themselves in announcing their belief in subject matter and two-dimensional space and their fascination with myth and primitive art. What is important is that Gottlieb and Rothko were the first Abstract Expressionists to stand up to critical opposition and publicly assert their own position. Their willingness to do this is not surprising in view of their earlier protest in *The Whitney Dissenters*. Gottlieb's and Rothko's vigorous defense of their art helped build the confident attitude of The New York School, which was later reflected in the historic artists' panels of 1948–50 in New York and Provincetown, Massachusetts, where artists presented their views to critics, museum directors, and the public.

It is important to examine the letter to the *Times* and a subsequent radio broadcast in 1943, as in these Gottlieb and Rothko set forth the themes of myth and primitivism, which they had been exploring in their painting since 1941. (See Appendix for full texts of the letter and broadcast.) In these statements Gottlieb and Rothko articulate the esthetic issues of their time. It was Gottlieb who initiated the letter to the *Times*, phoning Jewell to ask if he would accept a written response to his review of their art. Jewell agreed, so Gottlieb met with Rothko, drafted a statement with him, then went to Newman, who edited it for them and added an introduction. According to Gottlieb, Newman conceived the letter's first section, Gottlieb wrote the first four points in the letter's second part, and Rothko contributed the last proposition.[60] Jewell printed the letter in the *Times* on June 13, 1943, in an article entitled, "The Realm of Art: A New Platform and Other Matters; Globalism Pops Into View." Predictably, Jewell's derisive comments about their letter succeeded only in drawing attention to Gottlieb's and Rothko's art.

In the first part of the letter the artists criticized Jewell's inability to understand their paintings: "Your failure to dismiss or disparage them is *prima facie* evidence that they carry some communicative power." They continued, "The point at issue . . . is not an 'explanation' of the paintings but whether the intrinsic ideas carried within the frames of these pictures have significance."[61] These ideas are: 1) their interest in "a poetic expression of the essence of myth," not its narrative aspect; and 2) their belief (reflecting the influence of Jung) in the modern relevance of archaic expression. "Since art is timeless, the significant rendition of a symbol, no matter how archaic, has as full validity today as the archaic symbol had then."[62]

In the second part of the letter Gottlieb and Rothko outlined their views. The assertive tone and content of the first four points, written by Gottlieb, recall the style of Graham's *System and Dialectics of Art*. First, their emphasis on art as "an adventure into an unknown world"[63] echoes Graham's belief that the "purpose of art in particular is to re-establish lost contact with the unconscious."[64] Second, their statement that the "world of the imagination is fancy-free and violently opposed to common sense"[65] parallels Graham's idea that the imagination operates "irrespective of reality."[66] Third, their advocacy of the "simple expression of the complex

20. Joan Miró, PAINTING, 1933 oil on canvas 68 ½" x 6' 5 ¼" Collection: The Museum of Modern Art, New York.

21. Pablo Picasso, PAINTER AND MODEL, 1928 oil on canvas 51⅛ x 64¼" Collection: The Museum of Modern Art, New York.

thought"[67] recalls Graham's conviction that artists should transpose observed phenomena into simple, clearer terms."[68] Finally, their "wish to reassert the picture plane"[69] follows Graham's idea that a painter abstracts three-dimensional phenomena on a two-dimensional plane."[70]

The last point, written by Rothko, criticizes non-objective abstraction for its exclusive concern with formal issues, saying, "there is no such thing as good painting about nothing." They also allude to their interest in myth, asserting that "only that subject matter is valid which is tragic and timeless." For that reason, they "profess spiritual kinship with primitive and archaic art."[71]

Radio Broadcast, 1943

In October 1943, Gottlieb and Rothko again presented their views in a radio broadcast on Hugh Stix's "Art in New York" program on WNYC. In this broadcast they answered questions from an anonymous correspondent who had seen their paintings with mythological subjects in an exhibition of portraits by Federation members. In response to the question, "Why do you as modern artists use mythological characters?" Gottlieb asserted the modern meaning of his mythological subjects: "The implications have direct application to life, and if the presentation seems strange, one could without exaggeration make a similar comment on the life of our time."[72]

Gottlieb believed, however, that his own and Rothko's imagery would be understood by only those aware of the universality of art. "The artistically literate person has no difficulty grasping the meaning of Chinese, Egyptian, African, Eskimo. Early Christian, Archaic Greek or even prehistoric art, even though he has but a slight acquaintance with the religious or superstitious beliefs of any of these people."[73] What Gottlieb thought all of these arts shared with his own was an unconscious expression. He believed that "all genuine art forms utilize images that can be readily apprehended by anyone acquainted with the global language of art,"[74] an idea he inherited from Graham. But those who do not perceive this unconscious expression will not understand. "That is why we use images that are directly communicable to all who accept art as the language of the spirit, but which appear as private symbols to those who wish to be provided with information or commentary,"[75] Gottlieb said.

In answer to the question, "Are you not denying modern art when you put so much emphasis on subject matter?" Gottlieb replied that the formalist concerns, which have dominated modern art, are not sufficient for them: "this emphasis on the mechanics of picture making has been carried far enough."[76] Like the Surrealists, they were committed to subject matter, but they were critical of magic realism. "To us it is not enough to illustrate dreams," Gottlieb advised.[77]

41

22. Pablo Picasso, GUERNICA (Detail of Mural), 1937 oil on canvas 11'5½" x 25'5¾" On extended loan to the Museum of Modern Art, New York, from the Estate of the Artist.

23. Antelope Headpiece (Tji Wara), Bambara, Collection: Esther Gottlieb, New York

They were instead drawn to primitive art, not only for its formal beauty but also for its spiritual content. "While modern art got its first impetus through discovering the forms of primitive art, we feel that its true significance lies not merely in formal arrangements, but in the spiritual meaning underlying all archaic works."[78] Like the primitive artist, Gottlieb and Rothko painted in a direct fashion dark themes evoking a violent time: "If we profess a kinship to the art of primitive man, it is because the feelings they expressed have pertinence today. In times of violence, personal predilections for niceties of color and form seem irrelevant."[79]

Gottlieb's and Rothko's emphasis on subject matter, seen in these statements of 1943, was soon after echoed by others in The New York School. In 1944, Motherwell, in a lecture entitled "The Modern Painter's World," said that "the function of the artist is to express reality as felt."[80] Around 1944 Newman also discussed the issue of content in an unpublished essay entitled "The Problem of Subject Matter."[81] In 1948 Newman drew attention to subject matter again in titling the informal art school—founded in 1948 by Baziotes, Hare, Motherwell, and Rothko, and joined in 1949 by Newman—"The Subjects of the Artist."

Aside from collaborating with Rothko and Newman in 1943, Gottlieb followed his own course in the early forties. A leading member of artists' exhibition groups, he was one of the founders of the Federation of Modern Painters and Sculptors and served on several of its committees. In 1942–43 he became one of its Vice-Presidents and from 1944–45 he acted as President of the Federation. Gottlieb also helped organize a smaller exhibiting group, The New York Artist-Painters, which included George Constant, Morris Davidson, John Graham, Louis Harris, George L.K. Morris, Rothko, Louis Schanker, and Vaclav Vytlacil.

During this period, however, Gottlieb was not part of Peggy Guggenheim's Art of This Century Gallery, where other Abstract Expressionists were gathering. Between 1943 and 1945 Baziotes, Hofmann, Motherwell, Pollock, and Rothko were given one-man shows by Guggenheim. With the exception of Hofmann, all of these artists were predominantly influenced by Surrealism at this time. In fact, Baziotes and Motherwell, who were both experimenting with Matta in 1942 with automatism, were included in the 1942 Surrealist exhibition organized by Breton, *First Papers of Surrealism*. But Gottlieb, who did not associate with the Surrealists, was only peripherally involved in the Guggenheim gallery, exhibiting there only in the Autumn Salon of 1945.

But in 1944, Howard Putzel—formerly Peggy Guggenheim's assistant, who had opened his own "Gallery 67"—showed Gottlieb's work in his inaugural exhibition *Forty American Moderns*, along with pictures by Baziotes, Graves, Hofmann, Motherwell, Pollock, Pousette-Dart, Rothko, and Tobey. Gottlieb had a

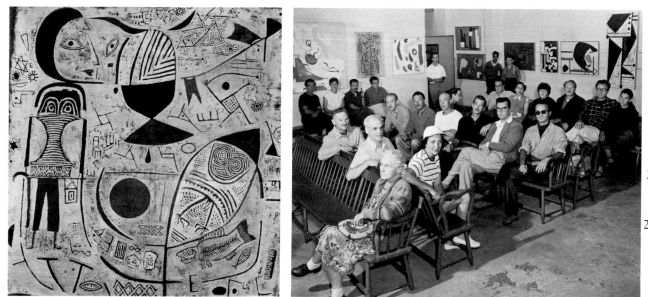

24. Paul Klee, SHEET OF PICTURES, 1937 The Phillips Collection, Washington, D.C.

25. "Forum 49" Group Photo, Gottlieb, center bench, second from left. © Photograph by Bill Witt

one-man show at Putzel's gallery in 1945 and was included in the group exhibition, *A Problem for Critics*, in which Putzel challenged critics to confront the recent development in contemporary painting, which he called a "new metamorphism." Putzel found the sources of this style in the art of Arp, Masson, Miró, and Picasso, which he exhibited with pictures by Gottlieb, Gorky, Hofmann, Pollock and Rothko. At the same time, Putzel stressed the originality of the Americans.

The critic Clement Greenberg rejected Putzel's "new metamorphism." As Irving Sandler has noted, since Greenberg held Cubism in the highest regard, he was reluctant to accept the influence of Surrealism on American painting. He admitted that a few "have accepted just enough Surrealist cross-fertilization to free themselves from the strangling personal influence of Cubist and post-Cubist masters. Yet they have not abandoned the direction these masters charted. . . . They advance their art by painterly means without relaxing the concentration and high impassiveness of true modern style."[82] With his preference for rational expression, Greenberg naturally did not like the unconscious content of Surrealism. He discounted the influence of Arp and Miró as Surrealists by viewing them as part of the "flattening out, abstracting, purifying process of Cubism."[83]

Abstract Surrealism: The Influence of Miró and Picasso

But abstract Surrealism, and especially the art of Miró, which had been featured in 1942 at The Museum of Modern Art, definitely influenced the work of the early and mid-forties by Gottlieb and other Abstract Expressionists. Whereas from 1941 to 1943 Gottlieb had created single biomorphs in his painting, from 1944 to 1946 he experimented with groups of organic shapes, as seen in *Alchemist (Red Portrait)* of 1945 (Illustration 46). The visceral shapes in this work owe a debt to such Miró paintings as *Painting* of 1933 (fig. 20), which he could have seen at The Museum of Modern Art.[84]

More than Miró, Picasso's Surrealist style had the largest impact on Gottlieb's Pictographs of the mid-forties, both in style and content. As he had done earlier in *Pictograph Tablet Form*, in *Red Bird* of 1944 (Illustration 44) Gottlieb combined figurative and abstract elements evoking *Girl Before a Mirror*. In the red and blue circles in the middle of *Red Bird* he suggests a breast, and in the black outline and dots and stripes below he recalls the patterns of the wallpaper and the girl's dress in Picasso's picture. Again, like Picasso, Gottlieb paints in disparate styles. For example, the red bird head, which is a gaping mouth of teeth, is reminiscent of primitive images by Picasso. On the other hand, the classical head above this beast brings to mind the calm profile on the left of *Girl Before a Mirror*. Like Picasso, Gottlieb splits the head into two sides, expressing both the outer and the inner persona.

43

Gottlieb continues to contrast these different styles in other works of this period. In *Nostalgia for Atlantis* of 1944 (Illustration 43) the classical head at the left recalls the profile on the easel in Picasso's *Painter and Model* of 1928 (fig. 21), while the Cyclopian form to the right resembles Picasso's distorted head of the artist. Similarly, in *Expectation of Evil* of 1945 (Illustration 46) Gottlieb combines the grotesque mouth at the upper right, whose vertical tilt recalls the primitive head in *Painter and Model*, with the graceful head to its left, whose sweeping contour line echoes certain heads in Picasso's *Guernica* of 1937 (fig. 22), which Gottlieb had seen in New York.

In addition to stylistic similarities, there are also thematic relationships between Gottlieb's and Picasso's art. Much as Picasso had projected Surrealism's dark view of man in *Guernica*, Gottlieb also incorporated the theme of evil in several works of the mid-forties: *Expectation of Evil* (1945), *Premonition of Evil* (1946), *Evil Omen* (1946), and *Evil Eye* (1946). Clearly, at the end of World War II, as the depths of human depravity were revealed in the horrors of Auschwitz, "evil" had special meaning. In 1947, in the magazine *Tiger's Eye*, Gottlieb explained how his imagery fit the tenor of the time:

> The role of the artist, of course, has always been that of image maker. Different times require different images. Today when our aspirations have been reduced to a desperate attempt to escape from evil, and times are out of joint, our obsessive, subterranean and pictographic images are the expression of the neurosis which is our reality.[85]

Subjects of the Unconscious

During the war Gottlieb gradually turned away from mythical themes. "I just dropped the whole idea of classical mythology as subject matter and decided that the proper subject for me was subjective free-association of images and symbols which I couldn't explain," he said.[86] Nevertheless, Gottlieb continued to explore Surrealist-derived themes alluding to the unconscious.

For example, the titles of several 1945 Pictographs refer to alchemy, a side interest of Surrealism: *Alchemist (Red Portrait)*, *The Alchemist*, *Alchemist's Crucible*, and *The Alkahest of Paracelsus*. Perhaps Gottlieb saw alchemy—the occult science for transforming base metal into gold—as a metaphor of man's emergence after the war from barbarism to civilization. Gottlieb probably became aware of alchemy through Graham, who was deeply interested in magic.[87] It is also possible that Gottlieb came upon alchemy through reading Jung. In the essay "The Idea of Redemption in Alchemy," published in 1939, Jung interpreted alchemy as an analogy for the self's psychic regeneration. Jung also suggested that alchemy's obscure methods—which formed in Egypt, flourished in the Middle Ages and the Renaissance, and withered in the Englightenment—are akin to the mysterious process of the psyche's development from chaos to order.

In addition, Gottlieb may have absorbed the idea that alchemy was a metaphor for not only the psychic process but also artistic creation.[88] Perhaps Gottlieb saw a parallel between the alchemist's trance and his own free-associative process in painting the Pictographs. As the alchemist began with the dark *materia prima*, so Gottlieb drew images from the obscurity of his unconscious. Gottlieb may have seen the term "alkahest," which is a universal solvent invented by the 14th-century physician Paracelsus, as a metaphor for the magic of his own imagination. "The creative work of the artist is perhaps also a magic act,"[89] Kurt Seligmann said. Indeed, Gottlieb alluded to magic and prophecy in the titles of other works at this time, including *Augury* (1945), *Recurrent Apparition* (1946), *The Spectre* (1946), *Oracle* (1947, Illustration 51), and *Sorcerer* (1948).

In other Pictographs Gottlieb suggested the unconscious in themes of the journey, the sea and the night. The Surrealists compared their journeys into the unconscious with the legendary tasks of mythical heros, as Motherwell noted in 1944.[90] In particular, Surrealists saw Theseus's venture into the Labyrinth to confront the Minotaur as an analogy to the artist's search within his own mind for the unknown. Gottlieb alluded to this mythical journey in *Minotaur* (1942) and *Threads of Theseus* (1948), as well as Odysseus's travels in *Mariner's Dream, Return*

of the Mariner, and *Voyager's Return* of 1946. Gottlieb suggested the sea in these and later works, such as *Weirs at Dawn* and *Low Tide* of 1949. Thomas Hess noted that Gottlieb referred to the sea in his art because he "found renewal and assurance in a contemplation of the sea."[91] But in the late forties Gottlieb also may have interpreted the ocean's dark waters as the depths of the unconscious. He also alludes to the unconscious through images of the night and the dream in the titles of *Nocturne* and *Sleepmask* of 1945 and *Black Enigma* of 1946.

At the same time, Gottlieb further explored his unconscious expression through primitive themes. In contrast to the American Indian motifs of earlier works, in *Masquerade* of 1945 (Illustration 48) and *Evil Omen* of 1946 (Illustration 49) Gottlieb recalls African art. In the staring faces of *Masquerade*, which seem to shield exotic presences, he evokes the enigma of African masks, which he had collected since 1935. He enhances this sense of mystery in the buried oval mask at the right, whose partially visible outline and color haunt the surface. Gottlieb also echoes African sculpture in his wooden-toned palette and textures.

In *Evil Omen* Gottlieb's stark contrast of dark shapes against a cream-colored background brings to mind Bambara antelope sculpture, which was part of his collection (fig. 23). While the arcing forms at the upper left resemble the elegant curving horn of the antelope, the series of triangles at the lower right of *Evil Omen* suggest the geometric pattern on the animal's neck. The primitive mood and emphasis on linear design in this picture suggests the possible influence of Paul Klee's *Sheet of Pictures* of 1937 (fig. 24).[92] But whereas Klee borrows from the decorated staffs from the Marquesas Islands, Gottlieb draws on African masks. But Gottlieb felt that he was "not in any sense borrowing from the form of primitive art. The form of my paintings is distinctly a modern notion."[93] Indeed, as we have seen, many motifs in works of the mid-forties are closer to Picasso than to primitive art.

Gottlieb continued to create textural variety in works of this period. In fact, his fascination with the disparate qualities of paint led him to combine different media. One of the earliest examples of this technique appears in *Masquerade* (Illustration 47), in which Gottlieb layers lighter shades over darker, drier brushstrokes over wetter, and tempera over oil to achieve a surface of subtle transparencies and contrasts of mat and glossy paint. In *Sounds at Night* of 1948 (Illustration 53) Gottlieb used oil and charcoal together, while in *Letter to a Friend* of the same year (Illustration 54) and *Figurations of Clangor* of 1951 (Illustration 57) he combined oil, tempera, and gouache.

In 1947 Gottlieb joined the Samuel Kootz Gallery, which in the late forties and early fifties was a major showplace for several Abstract Expressionists. When the Art of This Century Gallery broke up at the end of the war with Peggy Guggenheim's return to Europe, her American stable dispersed. Pollock and Rothko went with Betty Parsons, and Baziotes and Motherwell signed with Kootz. Hofmann, like Gottlieb, joined Kootz in 1947. Although Gottlieb had participated in group exhibitions with these artists, he did not associate with them until he joined the Kootz gallery.

In the Pictographs Gottlieb was the first among this group to paint a major series of related works in which were explored variations on a basic compositional mode. The Pictographs, begun in 1941, were well formed before the appearance of Rothko's color-form abstractions in 1946–47, Pollock's poured paintings in 1947, Motherwell's Spanish Elegies in 1949, and de Kooning's Women paintings in 1950–52. It was during the fifties and sixties that the series became the dominant method of working for his generation and later artists such as Morris Louis and Kenneth Noland.

But Gottlieb's pioneering role has not been stressed because most critics have concentrated on the late forties as the period when Abstract Expressionism came into its own. Clement Greenberg referred to 1947–48 as "the turning point . . . when there was a great stride forward in quality."[94] "It was only during the period 1947–50 that they [the Abstract Expressionists] realized their more personal styles and painted what in some cases remain their best pictures," William Rubin said of de Kooning, Motherwell, Pollock, and Rothko.[95] Irving Sandler noted that the

move towards more abstract styles by these artists corresponded to the waning influence of Surrealism, which came at the end of the war with the return to Europe of the artists in exile.[96]

Yet the Abstract Expressionists did not reject Surrealism as much as re-evaluate it, turning away, as Rubin has said, from "Freudian mythological symbolism" while maintaining an interest in automatism.[97] The most obvious transformation of this kind occurs in Pollock's poured paintings, in which he did not abandon the unconscious content he had inhereted from Surrealism, but gave it greater abstract expression in his interwoven skeins of color. The other major stylistic change appears in the work of Rothko, who in 1946–47 transformed his Surrealist biomorphic images into abstract blocks of color.

Perhaps because Gottlieb's paintings of the late forties did not undergo such a dramatic metamorphosis, Greenberg did not include them in the so-called "turning point" of 1947–48. During this period Gottlieb continued to be fascinated with the all-over composition of the grid and the free association of subjective images, which he had initiated in his work of the early forties. Unlike Pollock and Rothko, he did not adopt a purely abstract style. In works such as *Pictograph—Heavy White Lines* of 1947 (Illustration 52) and *Letter to a Friend* of 1948 (Illustration 54) Gottlieb's geometric configurations and meandering lines still allude in places to the figure. Indeed, his imagery at this time was often sexual. Phallic shapes and breastlike forms appear in *Letter to a Friend* (1948, Illustration 54), and Gottlieb continued to evoke figural fragments in his last Pictographs, *Figurations of Clangor* (Illustration 57) and *Sentinel* (Illustration 63) of 1951.

Because of the unconscious content of Gottlieb's art, the figure was a natural part of his imagery, and it reappeared in isolated forms throughout his abstract styles of the early fifties—in his Imaginary Landscapes, Unstill Lifes, and Labyrinths. Gottlieb was not alone in this regard. In their works of the late forties Baziotes and Motherwell also evoke the figure, although they distort it freely. And Pollock and de Kooning, who gave up the figure in the late forties, reintroduced it in their painting of the next decade.

In 1948 Gottlieb began experimenting with a new kind of composition by decomposing the grid, scattering its pieces and images over the canvas, as seen in *Sounds at Night* (1948, Illustration 53). Gottlieb was probably prompted to move in this direction by seeing Pollock's poured paintings, which were exhibited in January 1948 at the Betty Parsons Gallery. In contrast to Pollock, however, Gottlieb distributes throughout his composition discrete shapes instead of interconnected lines.

The dispersed, floating forms of *Sounds at Night* suggest the influence of Paul Klee's late works. Gottlieb incorporates the dot and the arrow, which are major components of Klee's vocabulary. But Gottlieb was most affected by the basic theme of Klee's art: the pictorial interaction between moving and static forms. Gottlieb no doubt sensed in Klee a similar interest in uniting disparate modes of expression.[98]

In his last Pictographs Gottlieb continues to draw on Klee's late paintings, which he could have seen in the 1949 Klee retrospective at The Museum of Modern Art. For example, in *Figurations of Clangor* of 1951 (Illustration 57) Gottlieb's combination of oil, gouache, and tempera on unsized burlap may have been inspired by Klee's mixture of various media on burlap in several of his works of the thirties. The leglike forms at the upper left of *Sentinel* of 1951 (Illustration 62) look like Klee's image of a line "taking a walk." Hilton Kramer noted the impact of Klee on Gottlieb's art: "The Pictographs of the forties, with their increasingly larger and more graphic grids and their alternation of symbolic and abstract shapes, are essentially a projection of Klee onto a monumental scale."[99] But it is precisely the monumental scale of Gottlieb's works that separates them from Klee's easel-sized art.

Gottlieb's ultimate Pictographs are remarkable for the sheer beauty of their color. In *Figurations of Clangor*, Gottlieb creates a dramatic contrast between still black and percussive yellow, offset by minor chords of white and isolated notes of blue and red. *Sentinel* displays a palette of softer harmonies: On a salmon-colored field Gottlieb juxtaposes dark orange, cream and rust tones.

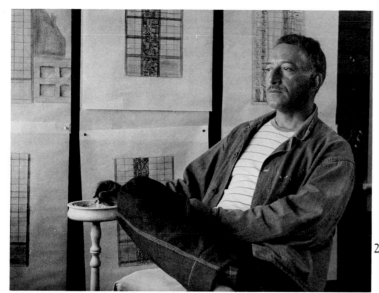

26. Adolph Gottlieb in his Provincetown
studio, 1952.

These late Pictographs look ahead to Gottlieb's works of the fifties: The black shapes and bands of *Figurations of Clangor* anticipate the structure of his Unstill Lifes, and the floating oval in *Sentinel* suggests the suspended discs of his Imaginary Landscapes and Bursts. The most prophetic work of this time, however, is *Night Flight* of 1951 (Illustration 58), which contains not only these elements but also linear networks foreshadowing the Labyrinths. The carefully layered surfaces of these works reward close viewing, revealing a plethora of subtle textures and hidden colors, and demonstrating Gottlieb's abilities as a painter.[100]

Gottlieb's Contribution to the Emergence of The New York School

Not only was Gottlieb a virtuoso painter, he was also one of the most active artists of his generation in bringing the painting of The New York School to the attention of critics and the public. He regularly participated in artists' forums, organized in the late forties by the Art Students' League, the Federation of Modern Painters and Sculptors and The Museum of Modern Art. In 1949 Gottlieb helped start the famous Forum 49 Provincetown, Massachusetts, a series of panel discussions among artists and writers, begun by poet and painter Weldon Kees, writer Cecil Hemley (Gottlieb's cousin), and painter Fritz Bultmann. Other major participants in these weekly forums on Thursday evenings at Gallery 200, which drew large audiences in the summer of 1949, were Karl Knaths and Hans Hofmann (see fig. 25).

Yet Gottlieb did not associate himself closely with other Abstract Expressionists. In Provincetown he did not join the Hofmann circle, preferring instead the company of Kees and Hemley. Rather than going to the beach with the art crowd, Gottlieb followed his own unvarying schedule. In the morning he painted in his studio at 353 Commercial Street (fig. 26), working in gouache or on his designs for the stained glass panels for the Steinberg Memorial. Gottlieb also led an independent life in New York, living in Brooklyn, away from his old friends Newman and Rothko and the art scene in the city. At the Kootz Gallery Gottlieb came to know Motherwell and Hofmann. "My friends in the fifties were Hans Hofmann, Rothko, and Baziotes," Gottlieb said.[101] But Gottlieb did not take part in the art school Baziotes, Hare, Motherwell, and Rothko founded in 1948, which Newman titled "Subjects of the Artist." Gottlieb seems to have been uninterested in this school, which lasted only a semester, because he did not enjoy teaching.

Gottlieb did participate, however, in other important group activities of the Abstract Expressionists. He joined the artists' discussions growing out of the Subjects of the Artist School which, held in their loft at 35 East Eighth Street, came to be known as Studio 35. Gottlieb was a speaker during Studio 35's first two seasons, along with writers Nicolas Calas, Kees, Harold Rosenberg, and artists Jean Arp, Baziotes, Jimmy Ernst, Herbert Ferber, Fritz Glarner, Harry Holtzman, de

47

Kooning, Motherwell, Newman, Reinhardt, and Rothko. During 1951–52 Gottlieb was also active in The Club at 39 East Eighth Street which, though it grew out of Studio 35, was limited to artists and others in the art world, such as collectors, dealers, curators, and critics. In January 1952 he participated in the second of three sessions on "Abstract Expressionism." As Robert Goldwater noted, the "positive spirit" of The Club fostered a feeling of self-confidence among The New York School. The self-assertive attitude of these artists owes much to Gottlieb and Rothko, who set the precedent for this group in forcefully presenting their views in their public statements of 1943.

Gottlieb continued to express his esthetic beliefs in the early fifties. He took part in Studio 35's three-day closed panel discussion among artists from April 21–23, 1950, organized by artist Robert Goodnough, then a graduate student at New York University, and moderated by artists Richard Lippold and Motherwell, as well as Alfred H. Barr, Jr., from The Museum of Modern Art. In these sessions, summarizing the issues discussed at Studio 35, Gottlieb reiterated his belief in subject matter in abstract painting, which he and Rothko had first announced in their 1943 letter to the *Times*. For Gottlieb, formal values were not the sum of art; there was an emotional content as well.

More important, Gottlieb was the principal organizer of the famous "Irascibles" protest of May 1950, which perhaps more than any other single event of the period focused attention on the Abstract Expressionists. Gottlieb planted the seed for this action at the end of the closed session of Studio 35, at which time he suggested that the assembled artists protest the conservative bias of the jury for the upcoming competition in modern art at The Metropolitan Museum. It was Gottlieb who initiated the group's decision to send an open letter expressing their views to the president of The Metropolitan Museum, as B.H. Friedman noted in his article on The Irascibles.[102] For nearly three weeks Gottlieb worked on a statement for the group, conferring with other artists, as he had done on the 1943 letter. He was advised principally by Newman and Reinhardt, but he also cleared the letter with other artists by letter or telephone. Gottlieb also prepared the final version of the statement and sent it to each artist to be signed. Of the twenty-eight who supported the letter, most had participated in the Studio 35 panel, but others were painters Bultman, Pollock, Rothko, and Still, and sculptors Mary Callery, Theodore Roszak, and Day Schnabel.

Newman took the signed statement, titled "Open Letter to Roland Redmond, President of The Metropolitan Museum of Art," to the City Editor of *The New York Times* on Sunday, May 21st. The letter said the "undersigned painters reject the monster national exhibition to be held at The Metropolitan Museum of Art next December, and will not submit work to its jury."[103] The letter succeeded in stirring controversy, appearing on the front page of the *Times* on Monday, May 22, 1950, in an article entitled "18 Painters Boycott Metropolitan: Charge 'Hostility to Advanced Art.'" On the next day, the charges in the letter were answered in *The Herald Tribune*, not in the *Times*. This unsigned editorial, titled "The Irascible Eighteen," attacked the painters for their "distortion of fact" in saying that The Metropolitan Museum had "contempt" for modern painting.

Gottlieb immediately drafted a reply to this editorial, again aided by Newman and Reinhardt. After getting twelve painters and three sculptors to sign his reply, Gottlieb sent it to the Editor at *The Herald Tribune*. Though his rebuttal was not published, the original letter in the *Times* had already attracted *Time* magazine, which featured the protest in an article entitled "The Revolt of the Pelicans."[104] This article in turn prompted *Life* magazine to cover the protest for December 1950, when the results of the competition at The Metropolitan Museum were announced.

Again, it was Gottlieb who was acted as spokesman for the group, making arrangements with Dorothy Seiberling, *Life's* art editor, for a photograph session with the artists. Gottlieb later said that *Life*

wanted us to come to the steps of The Metropolitan Museum with paintings under our arms and to stand there and be photographed. So we said, we don't mind being

photographed, but we're not going to be photographed that way . . . because that would look as if we were trying to get into The Metropolitan and we were being turned down on the steps. So they were very surprised at this, because nobody refuses anything to *Life*.[105]

It was agreed to photograph the artists in *Life*'s west side studio on 44th Street. On November 24 they assembled there, with the exception of Kees, who was in San Francisco; Bultman, who was in Rome; and Hofmann, who was in Provincetown. They all dressed in suits or sportcoats, which gave them a serious, professional image. Nina Leen, *Life*'s photographer, took them to a high-ceilinged studio, where the artists arranged themselves for the portrait.

Life's picture does not document a cohesive group: "Despite their subsequent labels as Abstract Expressionists, action painters, and so forth, this is a picture of a group that never was a group, a picture of fifteen individuals, unified only by the click of a camera at a particular time and place,"[106] as B.H. Friedman noted. Nevertheless, this photograph is important as a group portrait of artists who formed The New York School. It is ironic that Gottlieb, who was most instrumental in arranging the portrait which identified this group as the avant-garde in American painting, stood in the background of the picture. This surely reflects Gottlieb's basic ambivalence toward public life; although he fought for the acceptance of his own painting and the art of his colleagues, he did not seize the limelight for himself.

Gottlieb was both part of and apart from the Abstract Expressionists. He emerged from the same milieu of the Depression and the WPA and he became an active organizer of artists' groups. But he was an independent artist, developing his pictorial ideas in his own way, which was not always synchronized with the critical history of Abstract Expressionism. Gottlieb's art is not dramatic "gesture" painting, identified with Pollock, de Kooning, and Kline, whose bold styles convey freedom and movement. Nor is his art austere "color field" painting, associated with Newman, Rothko, and Still, whose large color forms evoke order and stasis. Instead, Gottlieb's mature art synthesizes contrasting esthetic modes—both free and controlled—to express both the emotional and rational sides of his inner experience.

In sum, Gottlieb's art was the conscious expression of his unconscious feelings. "The act of painting must be rational . . . and disciplined," he believed.[107] This is evident from his methodical development of his artistic ideas beginning with his Arizona still lifes and continuing in his Pictographs, Unstill lifes, Imaginary Landscapes, Labyrinths, Bursts, and later works. Gottlieb pursued variations on his pictorial concepts until he felt he had exhausted them. But balancing his will toward structure was his need for emotional expression, which nourished all of his art. "The idea that painting is merely an arrangement of lines, colors, and forms is boring,"[108] Gottlieb said in 1955. Later he summarized his esthetic goal: "Subjective imagery is the area which I have been exploring. . . . I reject the outer world—the appearance of the natural world. . . . The subconscious has been my guiding factor in all my work. I deal with inner feeling."[109]

Gottlieb and the Abstract Expressionists made history when they joined the mainstream of the modern tradition and became its avant-garde. In contrast to some of his more iconoclastic colleagues, Gottlieb identified with the great traditions of past art and acknowledged his debts to them. He drew on tradition throughout his career; yet, at the same time, he was also an innovator. In the Pictographs of the early forties he developed an all-over grid composition in a series of related works and in his Bursts of the late fifties he formulated a single-image art of extremely reduced means, exploring these ideas long before they became prominent in painting of the sixties and seventies. It is this dual sense of rootedness in the past and the present that makes Gottlieb's art still compelling today.

Notes

PART II: THE PICTOGRAPHS, 1941-1953

1 Dorothy Seckler, Interview with Adolph Gottlieb, 1967, Archives of American Art, p. 17.

2 John Jones, Interview with Adolph Gottlieb, 1965, Archives of American Art, p. 7.

3 Dore Ashton, Interview with Adolph Gottlieb, New York, February 4, 1972, unpublished typescript, p. 2.

4 Adolph Gottlieb, Introduction to *Selected Paintings by the Late Arshile Gorky*, exhib. cat. (Kootz Gallery, New York, March 28–April 24, 1950), n. pag.

5 Andre Breton, quoted in Julien Levy, *Surrealism* (New York: Black Sun Press, 1936), p. 9. Because this book was in English, it was an important source for American painters of Surrealist theory and art.

6 Martin Friedman, *Adolph Gottlieb*, exhib. cat. (Walker Art Center, Minneapolis, 1963), n. pag.

7 Waldman names *Eyes of Oedipus* as the first Pictograph in *Adolph Gottlieb* (1968), p. 13. Lawrence Alloway also notes that *"Eyes of Oedipus* (was) where it all started,"* in "Melpomene and Graffiti," (1968), p. 29. Alloway said Gottlieb told him in conversation that this picture was the initial Pictograph, but Gottlieb may have thought of it as the beginning of the series of compositionally related works. Actually, Gottlieb's records list the following works of 1941 before *Eyes of Oedipus: Untitled Still Life* (Illustration 31), *Female Forms* (Illustration 32), *Pictograph Tablet Form* (Illustration 33), *Oedipus* (Illustration 34), and *Profile*.

8 Waldman noted, "The division of the pictographic surface suggests that he arrived at this stage by virtue of his own compartmented still lifes of 1939–40." *Adolph Gottlieb*, p. 13.

9 Lawrence Alloway, "The Bimorphic Forties," *Artforum*, 4, No. 1 (September 1965), n. pag.

10 In 1940, Dr. Hillier and Dr. Vladimir K. Zworykin at the RCA labs in Princeton, New Jersey, developed the first commercial electron microscope.

11 Alloway said, "Automatic drawing is a natural begetter of biomorphs, charged with organic life but not descriptive of any single organism. Biomorphic forms enabled artists in the forties to invent freely while avoiding non-objectivity. Their allusive though non-descriptive forms have a strong potential for erotic, pathetic, or aggressive meanings. Introduction, *William Baziotes: A Memorial Exhibition, exhib. cat. (The Solomon R. Guggenheim Museum, New York, 1965), n. pag.

12 Joan Miró's art was exhibited annually at the Pierre Matisse Gallery in New York from 1936–41. It also appeared in the 1936 shows at the Museum of Modern Art, *Cubism and Abstract Art* and *Fantastic Art, Dada, and Surrealism*, as well as in a Miró retrospective there in December 1941–January 1942.

For a discussion of Miró's influence on Abstract Expressionism, see Alloway, "The Biomorphic Forties," pp. 18–22, and Gail Levin, "Miro, Kandinsky, and the Genesis of Abstract Expressionism," *Abstract Expressionism: The Formative Years*, exhib. cat. (The Whitney Museum of American Art, New York, 1978), pp. 27–40.

13 The date of fall of 1942 was given by Peter Busa in Sidney Simon, "An Interview with Peter Busa and Matta," Minneapolis, 1966, quoted in Gerome Kamrowski, exhib. cat. (Monique Knowlton Gallery, New York, 1978), n. pag. See also Max Kozloff, "An Interview with Robert Motherwell," *Artforum*, 4, No. 1 (September 1965), pp. 23–26, 33–38.

14 John Graham, *System and Dialectics of Art*, p. 88.

15 Jones, Interview, p. 1.

16 Seckler, Interview, p. 18.

17 *Ibid.*

18 Graham, *System and Dialectics*, p. 31.

19 Although Gottlieb's interest in Jung has been mentioned by Martin Friedman, Diane Waldman, Irving Sandler, Dore Ashton, and Karen Wilkin, it was not documented by Gottlieb's own statements until my article "The Pictographs of Adolph Gottlieb: A Synthesis of the Subjective and the Rational," *Arts Magazine*, 52, No. 3 (November 1977), pp. 143, 147.

20 Seckler, Interview, p. 17.

21 Carl G. Jung, "Archetypes of the Collective Unconscious," *The Integration of the Personality*, trans. Stanley M. Dell (New York: Farrar and Rinehart, Inc., 1939), pp. 52–53.

22 Conversation with Esther Gottlieb, September 16, 1976.

23 For a discussion of Jung's influence on Pollock, see Judith Wolfe, "Jungian Aspects of Jackson Pollock's Imagery," *Artforum*, 11 No. 3 (November 1972), pp. 65–73, and Elizabeth Langhorne, "Jackson Pollock's *The Moon Woman Cuts the Circle*," *Arts Magazine*, 53, No. 7 (March 1979), pp. 138–141. William Rubin criticizes the tendency among these and other writers to interpret Pollock's works from 1938–46 as literal illustrations of Jungian concepts. See "Pollock as Jungian Illustrator: The Limits of Psychological Criticism," Part I, *Art in America*, 67 (November 1979), pp. 72–92; Part II (December 1979), pp. 104–123. While Rubin's objection is valid, it does not erase the definite impact Jung had on Pollock's work.

24 Andrew Hudson, Dialogue with Adolph Gottlieb, New York, 1968, unpublished typescript, p. 17.

25 Gottlieb, *Selected Paintings by the Late Arshile Gorky* (1950), n. pag.

26 Andrew Kagan, "Paul Klee's Influence on American Painting: New York School." *Arts Magazine*, 49, No. 10 (June 1975), p. 55.

27 John Graham, "Primitivism and Picasso," *Magazine of Art*, 30, No. 4 (April 1937), p. 237.

28 The catalogue for the latter show emphasized the mystery of the Pictographs: "the significance which most pictographs may have had has been lost to us." I noted this earlier in "The Pictographs of Adolph Gottlieb," *Arts Magazine* (1977), p. 147.

29 Robert J. Goldwater, *Primitivism in Modern Painting* (New York: Harper & Brothers, 1938), p. 127.

30 Gottlieb in "New York Exhibitions," *MKR Art Outlook*, No. 6 (December 1945), p. 4.

31 Gottlieb in John Gruen, *The Party's Over Now*, p. 258. The concept of the endless grid is discussed in John Elderfield's "Grids," *Artforum*, 10, No. 9 (May 1972), pp. 52–60, and in Rosalind Krauss, "Grids, You Say," *Grids: Format and Image in 20th Century Art*, exhib. cat. (The Pace Gallery, New York, 1978).

32 *Ibid.*

33 Gottlieb in Sidney Janis, *Abstract and Surrealist Art in America* (New York: Reynal and Hitchcock, 1944), p. 119.

34 Friedman, Interview, Tape 1A, p. 5. Gottlieb also said, "I was always a little bit puzzled the whole time I was doing these (the Pictographs) because nobody ever brought up Mondrian in connection."

35 *Ibid.*, Tape 2B, p. 15. Irving Sandler points to Torres-Garcia's influence on Gottlieb's Pictographs in *The Triumph of American Painting*, p. 193, as does Robert Hobbs in "Early Abstract Expressionism," p. 15.

36 Seckler, Interview, p. 21.

37 Friedman, Interview, Tape 2B, p. 15.

38 Karen Wilkin, *Adolph Gottlieb: Pictographs*, exhib. cat. (Edmonton Art Gallery, Edmonton, Alberta, 1977), n.p.

39 Hudson, Dialogue with Adolph Gottlieb, p. 5. Diane Waldman said that "the form and mythic content of archaic art appeared in Rothko's art as early as 1938." (*Mark Rothko, 1903–70: A Retrospective* (New York: Harry N. Abrams, 1978), p. 38). But this date seems early for Rothko to have changed his style so radically. In 1938 he was still painting urban genre scenes in an expressionist style and he continued to show these works as late as 1941. *Antigone*, the first work with a mythological title dated by Waldman 1938, was not exhibited until January 1942 in a group show at R.H. Macy Department Store, New York. Though Waldman said that Rothko "often continued to work in one style while experimenting with another," she bases this observation on Rothko's dating of early works which she admits is "problematic." (*Rothko*, p. 26).

Whereas Rothko dated most of his works years after painting them—according to Waldman "without records and relying entirely upon his memory"—Gottlieb, beginning in 1941, made records of his works as he produced them. Moreover, Edith Carson, Rothko's wife at the time, said that it was the early forties when Rothko's art changed. (Letter to Waldman, January 5, 1978, in *Rothko*, p. 70).

40 Carl G. Jung, "Symbols of Transformation" (originally published as *Psychology of the Unconscious*, 1916) in *The Basic Writings of C.G. Jung*, ed. V.S. de Laszlo (New York: Modern Library, 1959) p. 8.

41 Gottlieb in Adolph Gottlieb and Mark Rothko, "The Portrait and the Modern Artist," typescript of a radio broadcast on WYNC, October 13, 1943 (see appendix).

42 "Poor blind Oedipus! . . . Theirs (the gods) was the ignorance, his was the knowledge. He solved the riddle of the Sphinx." Arm's phrase "the stupidly mysterious eyes of the gods" seems to be echoed in the Oedipus works. Hilary Arm, "Nostradamus Against the Gods; An Assertion of the Active Principle of Prophecy," *View*, 1, Nos. 7–8 (Fall 1941), p. 5.

43 James Johnson Sweeney said of Miró's art: "The pure eye is the dream eye . . . or the eye subordinated to the workings of the subconscious." ("Joan Miró," *Cahiers d'Art*, 9ᵉ annee (1934), p. 46.)
Several images of the dream eye appeared in the 1936 show *Fantastic Art, Dada, and Surrealism*, including Odilon Redon's *The Eye Like a Strange Balloon* and Rene Magritte's *The Eye*.

44 *Paganism and Christianity in Egypt* (The Brooklyn Museum, Brooklyn, New York, 1941).

45 Waldman, *Rothko*, p. 40.

46 Sigmund Freud, "Formulations Regarding the Two Principles in Mental Functioning" (1911), in John Rickman, ed., *A General Selection From the Works of Sigmund Freud* (originally published by London: Hogarth Press, Ltd., 1937), rev. ed. (Garden City, New York: Doubleday & Co., 1957), p. 44.

47 Kurt Seligmann, "An Eye for a Tooth," *View*, I, Nos. 7–8 (Fall 1941), p. 3.

48 Gottlieb in David Sylvester, "An Interview with Adolph Gottlieb," (first broadcast on the BBC Third Programme, October 1960), *Living Arts*, No. 2 (June 1963), p. 4.

49 André Breton, "The Legendary Life of Max Ernst Preceded by a Brief Discussion on the Need for a New Myth," *View*, No. 1 (April 1942), pp. 5–7. Breton continued to discuss myth in "Prolegomena to a Third Manifesto of Surrealism or Else," *Triple V*, No. 1 (June 1942), pp. 18–26.

Gottlieb had in his library other sources of myth: *Chimera: A Rough Beast*, 5, No. 4 (Spring 1942–43) and Sir James Frazer, *The Golden Bough* (London: S.G. Phillips, 1980).

50 Breton, "The Legendary Life of Max Ernst," p. 5.

51 "The Point of View," *View*, (April 1943), p. 5.

52 John Golding, "Picasso and Surrealism," *Picasso in Retrospect* (New York and Washington, D.C.: Praeger Publishers, 1973), p. 82.

53 Gottlieb said, "It was Jung who came out with the idea of the collective unconscious . . . it just corroborated my idea that . . . if I decided to use certain symbols in my painting, for example, an egg shape, I did this without intending it to be a symbolic reference. Why couldn't I come up with the idea of an egg signifying fertility just as well as some aborigine in Australia? . . . these are symbols which are universal." Seckler, Interview, p. 17.

54 Gottlieb in "American Exhibit Scores," *The American Weekend*, April 18, 1959, p. 12. Alloway also noted whenever Gottlieb "happened to learn of pre-existing meanings attached to any of his pictographs, they became unusable." "Melpomene and Graffiti," p. 26.

55 The hand gesturing toward detached eyes in these pictures resembles a detail from Francesco del Cossa's *The St. Lucy Altar*, illustrated in a June 1942 article by Seligmann in Triple V entitled "The Evil Eye." There is a sense of the evil eye—both as watcher and watched—in these works. Gottlieb also may have seen the isolated head and hand in Stuart Davis's art and in popular advertisements.

56 Gail Levin noted a 1935 Miró gouache of a handprint as a possible source of *Black Hand*, 1943, in "Miro, Kandinsky, and the Genesis of Abstract Expressionism," *Abstract Expressionism*, p. 25, note 3.

57 Robert Hobbs, "Early Abstract Expressionism," p. 10.

58 Carlyle Burrows, "Review," *New York Herald Tribune*, May 31, 1942, p. 12.

59 Edward Alden Jewell, "Modern Painters Open Show Today," *The New York Times*, June 3, 1943, p. 14.

60 Friedman, Interview, Tape 1A, p. 17. Alloway noted this information in "Melpomene and Graffiti," p. 27, as does Sandler in *The Triumph of American Painting*, p. 70, note 2.

61 Adolph Gottlieb and Mark Rothko (with the assistance of Barnett Newman), Letter to Edward Alden Jewell, Art Editor, *The New York Times*, June 7, 1943, printed in Jewell, "The Realm of Art: A Platform and Other Matters; 'Globalism' Pops into View," *The New York Times*, June 13, 1943, p. 9.

62 *Ibid.*

63 *Ibid.*

64 Graham, *System and Dialectics*, p. 15.

65 Gottlieb and Rothko, Letter.

66 Graham, *System*, p. 15.

67 Gottlieb and Rothko, Letter.

68 Graham, *System*, p. 13.

69 Gottlieb and Rothko, Letter.

70 Graham, *System*, p. 13.

71 Gottlieb and Rothko, Letter.

72 Adolph Gottlieb and Mark Rothko, "The Portrait and the Modern Artist," typescript of a broadcast on "Art in New York," WNYC, October 13, 1943, pp. 1–2. (See appendix). Hugh Stix said Gottlieb and Rothko came to him with the idea for the show. Conversation, August 26, 1976.

73 *Ibid.*

74 *Ibid.*

75 *Ibid.*

76 *Ibid.*

77 *Ibid.*

78 *Ibid.*

79 *Ibid.*

80 Robert Motherwell, "The Modern Painter's World," 1944 lecture at Mount Holyoke College, printed in *Dyn*, No. 6 November 1944), p. 9.

81 Barnett Newman, "The Problem of Subject Matter," unpublished essay, c. 1944, quoted in Thomas B. Hess, *Barnett Newman* (New York: Museum of Modern Art, 1971), pp. 39–41. There is an echo of the Pictograph in Newman's title *The Ideographic Picture* for the exhibition he organized at Betty Parsons Gallery, New York, 1947.

82 Clement Greenberg, "Art," *The Nation*, 160, No. 23 (June 1945), p. 657, quoted in Sandler, *the Triumph of American Painting*, p. 81. Sandler traces the development of Greenberg's attitudes towards Cubism and his hesitant acceptance of Surrealism.

83 *Ibid.*

84 In addition, the animal and vegetal forms in *Alchemist (Red Portrait)* and *Birds* of 1945 bear some resemblance to the imagery in André Masson American paintings of 1942–45, which were exhibited at the Museum of Modern Art in 1944.

Gorky, Pollock and Rothko were also influenced by Miró and Masson at this time. Lawrence Alloway has noted a common interest among these artists, Baziotes, and Gottlieb in marine imagery. See "The Biomorphic Forties," *Artforum*, p. 22.

85 Adolph Gottlieb, statement in *The Tiger's Eye*, 1, No. 2 (December 1947), p. 43.

86 Friedman, Interview, Tape 1A, p. 8.

87 Dorothy Dehner recalled that Graham often spoke of magic when she and David Smith knew him in the thirties. Conversation, March 10, 1977. For a discussion of Graham's rejection of modernism and turn to magic, see Hayden Herrera, "John

Graham: Modernist Turns Magus," *Arts Magazine*, 51, No. 2 (October 1976), pp. 7–12.

88 Carl G. Jung, "The Idea of Redemption in Alchemy," *The Integration of the Personality (1939)*, *pp.* 208–9.

89 Kurt Seligmann, "Magic Circles," *View*, I, Nos. 11–12 (February-March 1942), p. 3. The title of *Alkahest of Paracelsus* (1945, Coll'n: Boston Museum of Fine Arts) may have been inspired by Seligmann's article "Prognostication by Paracelsus," *Triple* V, Nos. 2–3 (March 1943), pp. 96–97. Esther Gottlieb said that Gottlieb saw an article on Paracelsus in one of the American Surrealist magazines. Conversation, September 16, 1976.

90 Robert Motherwell, "The Modern Painter's World," *Dyn*, No. 6 (November 1944), p. 13.

91 Thomas B. Hess, "The Artist as Pro," *New York Magazine* (December 4, 1972), p. 97.

92 Theodore Reff suggested Klee's *Sheet of Pictures* as a possible source for *Evil Omen*. *Sheet of Pictures* was exhibited as *Picture Album* (1937), no. 57, in the 1941 Klee retrospective at The Museum of Modern Art and was illustrated in Robert Goldwater's *Primitivism and Modern Painting* (1938), pl. 111.

93 Friedman, Tape 1A, p. 19.

94 Clement Greenberg, "'American-Type' Painting," *Art and Culture: Critical Essays* (Boston: Beacon Press, 1961), p. 219.

95 See William Rubin, "Arshile Gorky, Surrealism, and the New American Painting," *Art International*, 7, No. 3 (February 1963) rpt. in Henry Geldzahler, *New York Painting and Sculpture: 1940–1970* (New York: E.P. Dutton & Co.), p. 375.

96 Sandler, *The Triumph of American Painting*, p. 211.

97 Rubin, "Arshile Gorky," p. 376.

98 Klee was "preoccupied with the idea of a duality of concepts joining to form a unity: movement and countermovement order themelves in meaningful harmony and become functions in pictorial space." Jurg Spiller, ed. *Paul Klee: The Thinking Eye; The Notebooks of Paul Klee* (New York: George Wittenborn, Inc., 1961), p. 26.

99 Hilton Kramer, "Art: Two Periods of Adolph Gottlieb," *The New York Times*, February 15, 1968, p. 48.

100 Gottlieb returned to the all-over grid in three architectural commissions-an ark curtain in 1951 for Congregation B'nai Israel in Millburn, New Jersey, another in 1953 for Congregation Beth El in Springfield, Massachusetts, and a stained glass facade, 1952–55, for the Milton Steinberg Memorial Center in New York. Of these projects, the Steinberg facade is the most important. It marks not only the end of the Pictographs but also the beginning of his work of the fifties, both in terms of its large scale and its more abstract style. Echoes of its stained-glass patterns later appear in his Unstill Lifes of the early fifties.

101 Gottlieb in Gruen, *The Party's Over Now*, p. 256.

102 B.H. Friedman, "'The Irascibles': A Split Second in Art History," *Arts Magazine*, 53, No. 1 (September 1978), pp. 96–102.

103 "Open Letter to Roland L. Redmond, President of The Metropolitan Muscum of Art," May 20, 1950, printed in part in "18 Painters Boycott Metropolitan; Charge 'Hostility to Advanced Art,'" *The New York Times*, May 22, 1950, p. 1, rpt. in B.H. Friedman, p. 98.

104 "The Revolt of the Pelicans," *Time*, June 5, 1950, p. 54.

105 Gottlieb, statement in Hudson, Interview, p. 8.

106 B.H. Friedman, "'The Irascibles,'" p. 102.

107 Gottlieb, in *The New Decade*, exhib. cat. (The Whitney Museum of American Art, New York, 1955), pp. 35–36.

108 *Ibid.*

109 Gottlieb in Gruen, *The Party's Over Now*, p. 258/

Adolph Gottlieb and Abstract Painting

Lawrence Alloway

Abstract painting in the United States was largely separated by the artists of Gottlieb's generation from its geometric base. Mondrian, for instance, was regarded highly, but more as a dedicated or obsessed man than as the exponent of order. This change of focus was symptomatic of an American renewal of the mystique of the artist's vocation and a recovery of confidence in the role of subject matter. The original European abstract painters had been driven towards abstraction by an urge to express great thoughts and mysteries. The artists of Gottlieb's generation were moved by a comparable ambition. It needs to be borne in mind that Gottlieb, for all his professional aplomb, shared this exalted expectation of art. Neither his Pictographs nor the Burst series can be fully grasped outside this context.

Gottlieb's historical position is of the greatest interest. He was the last Abstract Expressionist to arrive at a holistic surface, the whole of which constitutes the visual image, what Clement Greenberg in 1955 called a field.[1] As a result, Gottlieb's paintings after 1957 may seem to lack the prestige of priority as it is built into the theory of the avant garde, but in fact "firstness" is not a stable property of art. Works of art are frequently over-determined in their causes, so that priority becomes a function of which of various contributory factors are being recognized.[2] Thus, there is no reason to think that Gottlieb's historical position put him at a disadvantage to the other artists of his generation. He had their examples to contemplate and to compare with one another; and this, of course, is a critical act. His position in time acted as a vantage point which enabled him to make a special contribution to the mode of field painting. He was able to use in the Burst series (to call them that pragmatically) the lateral expansion of color, as in field paintings, especially Mark Rothko's broad tiers of colors. He was able also to use the cutting edge and directional path of gestural painting and to make a personal version of the revision of the figure-ground relation that preoccupied American abstract painting of the period. Gottlieb's balance of surface and mark, field and gesture, has no parallel among his contemporaries. Irving Sandler was the first to note his connection to "both gesture painters and color-field painters."[3] Gottlieb was sensitive to the spread of color and equally responsive to the inventory of forms revealed by a quick brush. Gesture is essentially the linear route of the brush, and field painting essentially has to do with color's immersive properties: Gottlieb reconciled them.

Gottlieb's connection to Abstract Expressionism had an equivocal effect on his reputation. On one hand, he was associated with a powerful group of artists who, like him, were to receive international attention; but, on the other hand, he received less than his full recognition. He knew Barnett Newman very well, and Rothko; his own early work, defining an American subject-matter in small canvases, is parallel to Rothko's. One reason for the slow growth of his reputation is

the concept of Abstract Expressionism as a breakthrough that occurs around 1947–48, an ideal historical moment in which a group of men made art fresh. However, this is a deceptive notion, replacing stylistic and social complexities with the vision of sudden change. Several Abstract Expressionists did not produce a consequential body of art until the late 40's, and, as a result, they lost nothing by the account of a new start; whereas other artists who reached earlier maturity had their existing work separated from the "new" phase. This happened to Gottlieb, whose Pictographs were never fully integrated into any general view of Abstract Expressionism: ironically their priority isolated them.

This occurred partly because of the emergence of an increasingly formalist reading of Abstract Expressionism which had no use for the myth-raking of the early 40's. Evocative imagery, such as that of the Pictographs, was accordingly undervalued, though it can be seen now as part of the substratum of the later work. Thus, not only did Gottlieb lose his developmental lead over his friends, he was sometimes ranked after them. A contributory factor here is his protracted transitional period between the small, complex Pictographs and the large pictorially simplified paintings of 1957 and after. The works of the interim between the Pictographs and the Burst series constitute, in fact, a period of invention not hesitation, as we shall see. The "magic moment" theory of the birth of Abstract Expressionism has been viewed sceptically recently, making it easier to examine both Gottlieb's continuity and priorities.[4] To discuss his work from the 50's to his death in 1974 therefore involved tracing the logic of the sequence of his work.

Gottlieb's Pictographs explored a broad range of symbolism, but without exceeding the then-traditional small scale of American easel painting. Nonetheless within these limits, he showed an unquenchable inventiveness, accenting the grids and their occupants with a variety closer to Paul Klee's resourcefulness than to Joachim Torres-Garcia's repetitiveness. I visited a warehouse with Gottlieb once and saw the artist standing knee-deep in Pictographs, like the Colossus of Rhodes astride the harbor, and realized that the Pictographs represented a storehouse of culture. He was demonstrating that the world was accessible to the American artist of the 40's, an ambition that was resumed in his later works, as we shall see. The grid, for all its flexibility, ceased to satisfy Gottlieb by the late 40's. Color expanded without linear intervention, as in *Sounds at Night*, 1948, in which there are no walls to hold the scattered pictographs. In *Labyrinth I*, 1950, there is a conspicuous grid, but it is in negative, produced by peeling tape from already painted areas; in retrospect we can see this as a part of Gottlieb's increasing interest in continuous planes of color. In other Pictographs, such as *Tournament*, 1951, paint is thickly impasted; this has the effect of dissolving the signifying function of the visual symbols and stressing their decorative character. The all-over composition of the Pictographs is retained, but the surface no longer implies the past or the unconscious mind and their complicities.

A coloristic, all-over web was developed by Gottlieb in a group of paintings in the early 50's that lead to *Labyrinth III*, 1954, sixteen feet long, close in size to Pollock's half-dozen large drip paintings. However, despite the evocative title, Gottlieb has curbed the mythological atmosphere rigorously. The painting consists of firmly brushed overlying grids that create a shallow space. Another line of Gottlieb's thought at this time fused the image potential of the Pictographs with massive single forms on a large scale. The first of these, *Black Silhouette*, 1949, (Illustration 60) is a single dark form that spans the canvas irregularly, reaching to three edges of the painting. It leads to the Unstill Lifes in which the armature of the grid is, as it were, knotted into a central dark image that implies a hefty volumetric mass. The form, somewhere between a table top and a personnage, is seen on a ground squeezed against the edges of the canvas. This group of paintings picks up the ominous mood of some of the Pictographs and embodies it in monumental form. Thus Gottlieb was maximizing the separate elements of his art by concentrating on specific resources in the painting process.

The centered Unstill Lifes turn Braque's *gueridon* into the Rock of Gibraltar. They were accompanied developmentally by the Imaginary Landscapes. This is a

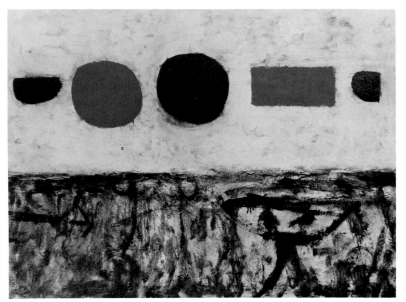

27. THE FROZEN SOUNDS, NO. 1 1951 oil
on canvas 36 x 48″ Whitney Museum of
American Art
Gift of Mr. & Mrs. Samuel M. Kootz

series, properly so-called, whereas the number of Labyrinth and Unstill Life paintings is small. The first realized painting is *The Frozen Sounds*, I, 1951, (Figure 27) in which a procession of five segmented forms are presented above an emphatic horizon line. It is a sign of Gottlieb's persistent curiosity about figure-ground relationships that he alone of the Abstract Expressionists uses the horizon. The Imaginary Landscapes consist of zones of earth and sky, starkly divided by an horizon parallel to the long top and bottom of the picture, at right angles to the sides. These paintings are schematic in form and luxurious in facture. The terrestrial areas are highly brushy and the solar areas, open and spare by contrast. The firmly painted circular forms are never geometrically neat, but are organically varied, like the silhouette of a fruit or the outline of a glans in cross-section.

The Imaginary Landscapes are considerably larger than the Pictographs, and the images depicted, far fewer. Hence the scale of Gottlieb's brushwork is expanded; it has an amplitude and precision that are new. Some of the painting is improvised in the act of working, but this is a situation of informed process, of control not impulsive hunting. The sequences of disks, ellipses, segments, or blocks of color have a freely inventive character. (Incidentally, we could regard *The Frozen Sounds* as the fate of the Music of the Spheres at the temperature of outer space.) Below the straight-line horizon the lower area is often suggestive of water. Even when the zone is black, brown, and warm, as it is in *The Frozen Sounds I*, the imagery has tidal implications, as if the upper forms were affecting the lower plane, which is always sensuous and sometimes turbulent. This reading is supported by titles, such as *Sea and Tide* and *Eclipse*, both 1952. Gottlieb also used technical terms with a navigational or astronomical reference, such as *Azimuth*, *Equinox*, and *Nadir*, as well as color-based titles, *Red Sky* and *Four Red Clouds*, both 1956. A group exhibition at the Whitney Museum of American Art, arranged by John I.H. Baur, "Nature in Abstraction," 1958, fitted these works admirably. As a matter of fact, the exhibition constituted one of the comparatively few occasions when Gottlieb's current practice coincided with art world patterns from which he felt a certain detachment.

There is a significant change in Gottlieb's choice of color in the early 50's: his use of black and red on white has a readymade look, like enamel from the can or printer's ink. This can be compared with the Abstract Expressionist denial of finesse in favor of directness, like Clyfford Still's color straight from the tube or Franz Kline's use of house-painters' brushes. For an artist whose work had shown great variety of color, in the atmospheric, wide-palette Pictographs, this is a pronounced simplification. In the Imaginary Landscapes these readymade colors add tension to the nature reference of the format. The paintings incorporate both the visual clout of found color and the gradation of invented passages. Gottlieb had not lost his coloristic subtlety as many later paintings show. He was an original colorist, ranging

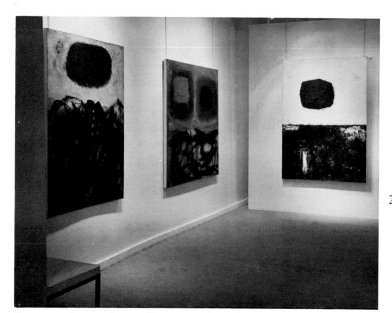

28. l. to r. COMPRESSION, 1957
Courtesy: Mr. Bradford E. Phillips,
Cincinnati
RED, BLACK AND GRAY, 1957
SOLITARY, 1957
Collection: Iola S. Haverstick, New
York

from tender and tonally equivalent hues that conceal their borders to forthright declarations in brown, green, and yellow, colors that are traditionally hard to use on a large scale. We can conclude that black and red were a personal code for the impersonal. It was a knowing, consciously American decision to use vernacular color. It is a crucial part of the series that Gottlieb started in 1957, from the first painting, *Burst*, to a late one like *Crimson Spinning*, 1971.

The multiple heavenly bodies and the textured earth plane, often including sections of broad linear brush work in black, lead to the Burst series. The sequence is clearly traceable and follows from Gottlieb's decision to transfer the landscape motif to a vertical format. A majority of the paintings in this major group are between six and seven-and-a-half feet high and they tend to be broad, not thin, in the horizontal dimension, a size that relates to human scale: Gottlieb's in painting, the spectator's in viewing. The paintings are a subtle and sustained contribution to the investigation of the visual-physical relationships of image and spectator that is central to the Abstract Expressionists' big pictures.

Let us consider some of the steps leading to *Burst*. In *Solitary* (figure 28) there is a single body in the upper zone and a solid earth plane that spans the canvas almost at midpoint. Though this was painted in 1957, Gottlieb had already arrived at the essential scheme of the Bursts in the preceeding year, in *Black, Blue,Red*. The freely painted lower zone more or less spans the canvas but with a solidification of two-thirds of its length which essentially condenses the image on a central axis with two areas, one above another. These two forms relate more to one another in the canvas field than to the edges of the canvas. In the similarly titled *Pink,Blue and Black*, 1957, the forms are aligned on a tighter vertical axis. In both paintings Gottlieb is markedly gestural in handling paint, but the elements imply *Burst*, 1957, (figure 29) the first full statement of the dyadic theme with two freely painted but firmly delimited forms. That this formulation was not easily arrived at is suggested by the fact that in 1958 Gottlieb painted a work like *Argosy*, which can be taken as a version of *Solitary* with its edge-to-edge horizon. He was in possession of the basic format but still experimenting and checking around it: there was nothing facile in the simple-looking image. He confirmed the importance of *Burst* with two other paintings of the same year, *Blast I* (figure 30) and *II* (figure 31). The three works can be discussed together for the light they cast on one another and on the long, fruitful period that they initiated.

The decisive painting *Burst* is eight feet high by three-and-a-half wide, narrower than the norm for what I shall call the dyadic paintings. Other paintings led to it, as we saw, a reminder of the false decisiveness of breakthrough theories that presuppose an absolute break between past and present, old and new. *Burst* is different from its predecessors, however, with two forms, roughly equal in area, one above the other; they do not touch, but it feels as if they were bound together, as by

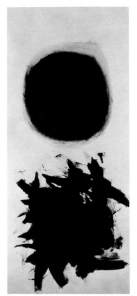

29. BURST, 1957 oil on canvas 96 x 40″
Collection: Mrs. Milton Fischmann

planetary forces. The lower form is black and painted in a choppy gestural way; the upper form, red, is smoother in surface and edge, but not closed or measured. It is the product of another type of gesture: the ellipse is freely brushed and surrounded by a tonally graduated halo. (There are red drips, here and there, in two directions, not conspicuous but adding animation to the more contained forms.) Associational chains are strong, initiated by Gottlieb's choice of title, as in the Blast pair: the fire ball of the A-bomb, remembered from the end of World War II but kept vivid by postwar testing as at Bikini Atoll. Gottlieb was aware of this association, having solicited it, but he commented that it should not exclude other readings. Like all the Abstract Expressionists, he maintained the greatest confidence in the signifying capacity of art: thus, fire and earth, the solar and the tidal, augment the fireball reading. Gottlieb continued to regard meaning as he had in his Pictographs as open-ended and evocative, a value and not a limiting case. Thus *Burst* and the works that followed can be viewed as Pictographs or the scale of field painting.

A field is "an expanse of anything," a "total complex of interdependent factors" (unabridged Random House Dictionary). In painting the term applies to pictures with large areas of monochromatic and spectrally-close color or an all-over linear density. Gottlieb's inventory of disks, ellipses, aureoles, and splashes is paired to characterize the field in ways analogous to human thought patterns.[5] He used the technical means of field painting to visualize a mode of thinking, the dyadic. Dyadic means of or consisting of two parts. Pairs likely to have been in Gottlieb's mind, both as a member of our general culture and as the former painter of Pictographs, include sun and earth, male and female, night and day, life and death, Mediterranean and Northern. It will be seen from just these five dyads that such groupings relate to fundamental ideas of order. They are morphological units basic to human communication: us and them, art and life.

In the 60s, a period of proliferating labels and movements, Gottlieb called himself, jokingly in conversation, a trestle painter, the only one. It is a technical fact that many of his field paintings were begun on a trestle table which provides a horizontal surface at a more convenient level than the floor. The wetness of Gottlieb's paint required a flat plane: it would have leaked or poured downward if the picture had been upright at the start. In the horizontal plane, he was free to stir the paint and find the borders of his forms with brush and squeegee. As the paint dried, the canvas could be moved to the traditional upright position, which provides unbeatable opportunities for visual judgment. This is a long way from gestural art interpreted as the swipe or the splash, but it is a good example of the way in which gesture can be a part of planning and thinking, a constructive part of painting, not the sign of a demonstrative physicality. Gottlieb is thinking with paint, not opposing muscular gesture to the act of thought.

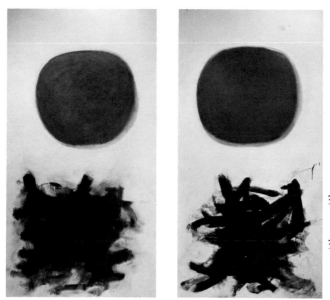

30. BLAST I 1957 oil on canvas 90 x 45″
Collection: Museum of Modern Art,
New York

31. BLAST II 1957 oil on canvas 90 x 45″
Collection: Joseph E. Seagram & Sons,
Inc.

We can summarize Gottlieb's position in 1957 on these lines: the immediate source of the Burst series in his own history is the Imaginary Landscapes and the longer-term source is the Pictographs, drawn on for their semantic resonance. In addition, there is Gottlieb's evaluation of his contemporaries' work, particularly Rothko's: his vertical stacks of horizontal forms are echoed by the Burst series. This is not a matter of simple dependency but arises from a critical appraisal of histoy and abstract art, of Gottlieb's own and his contemporaries' contributions. Robert Motherwell has observed that "the development of the large format" was essential to Abstract Expressionism.[6] To this we can add reduction of the intricacy of the image. It seems clear, looking at *Burst, Blast I,* and *Blast II,* that Gottlieb was exhilarated by the convergence of scale and economy. The pleasures of similitude equalled the beguilement of variety to which he was accustomed. He was an exponent of intricate and subdivided composition who became master of the unified field, a formal shift of enormous range. The first three paintings showed him concerned with the serial image, not as it was to be codified in the 1960s, but in a speculative early form. There is, of course, nuanced differentiation among the paintings, but it occurs behind a screen of identity.

In 1958, Gottlieb broadened the proportion of his canvases in works like *Exclamation,* 90 inches by 72, and *Tan Over Black,* 108 inches by 90. In *Positive,* a lighter and freer version of *Tan Over Black,* the canvas measures 90 inches by 60. Gottlieb's interest in repetition and covert variation persists, as is shown by the relation of *Tan Over Black* and *Positive.* His color expanded beyond black and red, but keyed as it was to two large forms, one of them always black, he became a colorist of large as opposed to compartmented areas. It is not unusual for a third color to be introduced as the tinted ground itself. There is a classic balance to these broad paintings which the agitated edges, pulling apart or merely shifting the weight of the lower form, animate but do not disrupt. The two islands are usually equivalent in area and are characterized as much by their mutuality as their differences. Despite their manual contrast as painted forms, they occupy a continuous spatial plane. The dyadic image should not be interpreted solely in terms of contrasts and opposites. The inter-dependence of the two zones is also important to Gottlieb. Thus he posits a complex exchange between the two parts of the holistic image.

The theme of the Imaginary Landscapes remained in Gottlieb's mind: recurrent horizontal pictures punctuate the verticals of the Burst series. In the Landscapes' development he expanded to a drama of scale that has no equivalent in the upright paintings. Verticality is always keyed to the single human presence in his work, so that the proportionate division of the canvas relates to ourselves. There is a kind of Vitruvian analogy. The later horizontals don't have this intimacy,

the scale of the forms, each clearly articulated disk or cursive mass, stays in the body's range, if they are regarded one at a time. The later Imaginary Landscapes from 1960 are influenced by the Burst series in the abolition of the horizon line: the multiple solar and flowing tidal forms are related in horizontal succession and are no longer attached to the edge of the picture field by the horizon. Gottlieb's sculpture belongs to the same train of thought, as it tends to consist of sequences of flat, cut forms at different heights and angles along a central spine. Though fully three-dimensional, this is emphatically painter's sculpture, as it emphasizes form in terms of segments of color seen in their singleness. Gottlieb, incidentally, was an accomplished sailor, and the spatial effect of the Imaginary Landscapes is akin to the low eye-level from a small boat.

The division of Abstract Expressionism into two main directions after the early period of biomorphism, to which the Pictographs contribute as Mary Davis MacNaughton points out, isolates field and gesture. On one hand, there are painters like Newman and Rothko who, whatever gestural components exist in their work, are concerned with color in large planes; and on the other, painters like Kline and Motherwell whose works emphasize the course of the black-loaded brush. Motherwell possesses a keen sense of surface as well as directional inscription, but the retention of black as his prime means reduced the planar potential of forms that might have become fields. It was Gottlieb in particular who showed that the two modes were not antithetical: that is to say, he reconciled drawing with field painting. The time of his entrance to Abstract Expressionism (the last of the group to paint holistically) put him in a position to align the gestural and coloristic aspects of the movement. His paintings done in 1957 and after make us poignantly aware of the fusion of structural brushwork, from cutting edge to ruffled island, and economical but immersive color, from permeating flood to radiant glow. Gottlieb reconciles color as sensation with form as touch. The pairs in the dyadic paintings act as figures on a ground, but their internal unity and proportion stress the sense of the whole. The holistic image is crucial to the definition of field painting, but Gottlieb is the only painter to achieve it without abandoning the precision of the figure-ground relationships that inhere in gestural handling.

The field painters brought about a change in our expectations of abstract art. The means were simplified, but the content was amplified. Manual emphasis was separated from the decorative and attached to the search for momentous meaning. When Alexander Rodchenko adopted the circle as a canonical form in his paintings of 1918–20, he aimed to reduce the sensuality of easel painting, but, half a century later, Gottlieb's repetition of circular forms became, among other things, a way of preserving manual touch as a positive value. Gottlieb had found a capacious form, a continuous mode, that did not have to be invented every time he painted. It was a shared problem of abstract artists at this time: how to establish an ambitious style within which it was possible to improvise without any slackening of authentic activity. The necessary motif was one that could survive painterly variation without loss of legibility. Gottlieb's early work contributed to his later solution.

Before he approached abstract painting, Gottlieb had painted his Pictographs for ten years and, as this survey explores for the first time, had been a realist for more than fifteen. He was in his late 40s when he entered the new phase of his work. His brush work however is not retentive of the devices of representation: a large scale, gestural directness and color simplification were brilliantly coordinated, as in the Imaginary Landscapes. There is no formal equivocation between the styles. What happened to subject matter when he was ostensibly no longer using it? It was absorbed in the new imagery and transformed. The Pictographic evocation of mythologies, that is, worlds, is transformed into solar and planetary forms, like a world-landscape. In the Imaginary Landscapes the format of an observed place is transformed into the schemata of earth and void. Titles like *The Frozen Sounds*, *Figuration of Clangor*, and *Cadmium Sound* show that Gottlieb did not present his paintings as pure visual objects in isolation from other experiences. On the contrary, he drew attention to the persistence of meaning in the new large, simple forms. The reference here is to synesthesia, as in the French Symbolists'

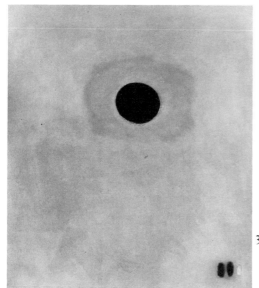

32. ROMAN THREE 1962 oil on canvas 78 x 66"
Private Collection, New York

correspondence of the senses: the visual and the aural, art and music, are linked in *The Frozen Sounds*, an apt term incidentally for the arresting of music's temporal flow by the spatial tableau of visual art. Gottlieb's painting, like that of the other Abstract Expressionists, was never containable by theories of concreteness and purification. On the contrary, the concrete was replaced by process, so that painterliness became an open source of authentication.

The pace and range of Gottlieb's invention in the late 50's has not been sufficiently recognized, partly because his inventiveness concealed itself in apparently deadpan repetitions. In fact it was an extraordinarily fertile period. The close appearance of the various motifs, which were in full use to the end of his life more than twenty years later, demands that we see them all as part of a total pattern. There are the single-image paintings, which in effect consist of the upper form of the dyadic paintings in isolation, as in *Una*, 1959. There is, too, the first statement of color coding, as it might be called, in which short rows of small tabs of color are compared to the expansive colors of disk and field. The dyadic image of *The Form of the Thing*, 1958, for example, has a third zone along the base, a kind of morse code in red, black, and white. This work, though at the scale of painting, is on paper which suggests its experimental status; but by 1962 the motif was fully resolved and integrated into single-image paintings such as *Roman Three* (figure 32). Here three small but decisive rectangles in the lower right seem to summarize the broad yellow field with its high, central, flattened disk. Gottlieb found a way to introduce size-contrast into field painting, much as earlier he had introduced figure-ground relationships into the unified surface. In the work of the 1970s Gottlieb made a sustained, increasingly free play with all these elements—dyads, single images, and color coding—but with a specifically new stress.

The works from 1971 on were increasingly carried out with the help of assistants, owing to a stroke that immobilized Gottlieb. He had used an assistant before, as many artists do, but now he required more than routine assistance with studio chores. These later works, however, show no loss of personal control, because it had never been *touch* that characterized his work. A conceptual program, anticipating, not simply responsive to, process, was normal in his practice, as the serial nature of the Burst image indicates. Thus, his esthetic and technical decisions were communicable to other people acting on his instructions. The field and the discrete forms upon it were as much the result of prior control as discovery through work. The concept of work itself exceeded the cycle of kinesthetic feedback to incorporate decision making.[7]

The later paintings are continuous with the field paintings but move from the monumental to the lyrical. The scale of the field does not diminish in the 70s, but the forms in the field are often smaller in relation to the whole than before. They

convey an impression of mobility, as they flare and fade. Gottlieb's color was always varied and subtle apart from his black-and-red paintings, but it is freshly delicate in the late work. Although the grid is not overt in the Burst format, it is implicitly present in the stability of the motifs bound into the rectangle of the canvsas. Like Rothko and Newman, Gottlieb tended to perpetuate the verticality and horizontality of the canvas edges in what he painted. In the late works, however, the smaller forms seem not to be fixed in the same way: they are shaking loose, floating, flying. The fleetingness of the imagery is enhanced by the occasional turning of the canvas during the process of work. This varies the direction of paint splatter, of course, but it also alters the visual impression of the vector of forces implied by the paint. Gottlieb creates a less serene, less restrained field within which the smaller scale of his touch becomes highly animated. The classicism of the earlier works in the series is dissolved by shimmering color and unpredictable from location.

Gottlieb's use of, his feelings for, color is remarkable. In the black paintings of the early 50's color functions like mosaic chips, sparks that arouse the massive planes. In the interwoven paintings that follow, color is similarly firm-bodied, briefer than the grid lines but laid down in similar directions. My sense is that color is used as a relatable solid, as specific area, with less fusion and gradation than are traditionally practiced in painting. Gottlieb's color in the abstract paintings tends to establish a solid surface, but one that is flexible and resilient. It is a brilliant modification of flat color that avoids both schematic two-dimensionality and the full three-dimensional spatiality that a free manual touch engenders. There are numerous paintings and passages in paintings in which color acts as a dimmed or glowing veil, but Gottlieb also expanded the scale of solid, permeable color to the total field of the canvas. These tranquil planes, carefully mixed by the artist, touch on the evocative power of color without violating an essential restraint. All this is compatible with Gottlieb's continued and resourceful use of black as line and color, as edge and surface. Only in the last paintings does he experiment with an open and expanding range of atmospheric color as a primary means of painting. The changed facture creates a more volatile surface than is usual but retains the essential characteristics of field painting intact. Gottlieb's commitment to this mode of work after 1957 turned out to be deeply satisfactory; its semantic and pictorial possibilities attuned both to his sensibility and his thinking.

Notes

1. Clement Greenberg, "'American Type' Painting," *Art and Culture*, (Boston: Beacon Press, 1961) pp. 208-229. First published in *Partisan Review*, 22, no. 2 (April 1955) pp. 179-196.

2. Lawrence Alloway, "Residual Sign Systems in Abstract Expressionism," *ArtForum*, 12, no. 3 (November 1973) pp. 36-42.

3. Irving Sandler, *The Triumph of American Painting*. (New York: Praeger Publishers, 1970) p. 201.

4. We are indebted to both revisionary art writers, such as Robert Carleton Hobbs (*Abstract Expressionism: The Formative Years*, New York: Herbert F. Johnson Museum of Art and the Whitney Museum of American Art, 1978, pp. 8-26) and graduate departments of art history who rehabilitate neglected pasture by extending the years worth investigating, beyond the artists' first reputations.

5. Field painting is sometimes called Color-field painting, but this over-emphasizes the esthetic and undervalues the semantic potential of the style. We know from statements by Gottlieb, Rothko, and Newman that they were preoccupied with meaning, which suggests that "Color-field" as a term opposes documentation and intention.

6. Max Kozloff, "Interview with Robert Motherwell," ArtForum, 4, no. 1 (September 1965) pp. 33-37.

7. The idea of the creative act as a kinesthetic spectacle was popularized by Hans Namuth's photos of Pollock (Robert Goodnough, "Pollock Paints a Picture," *Art News*, 50 (May 1951) pp. 38-41) which accidentally reinforced the notion of "Action Painting."

Illustrations

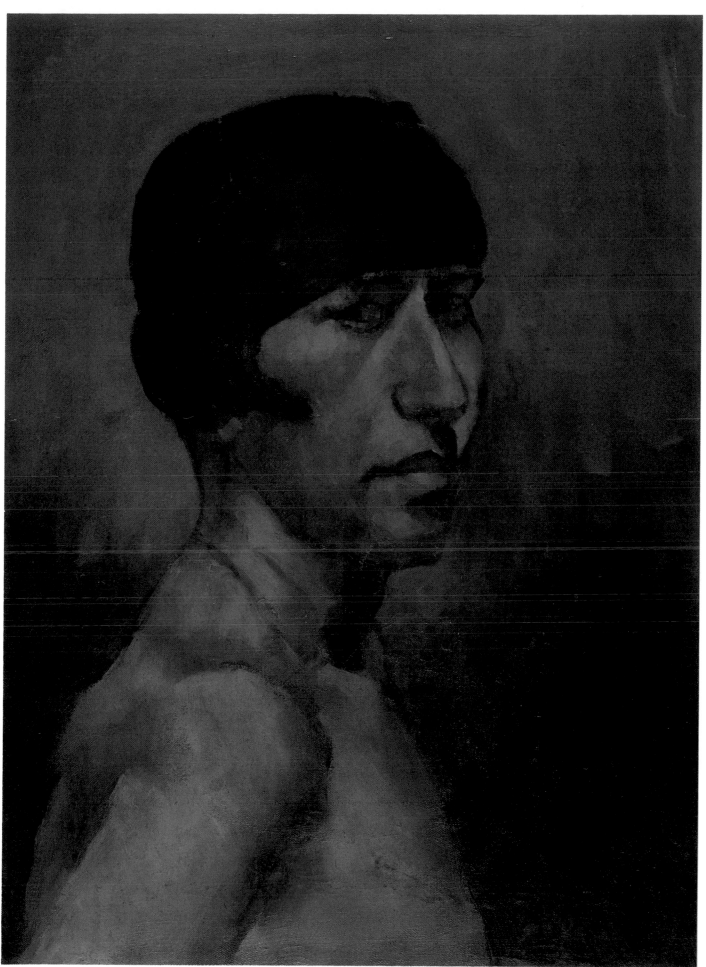

1. PORTRAIT ca. 1923 oil on canvas 23¹⁄₁₆ x 17⅛"

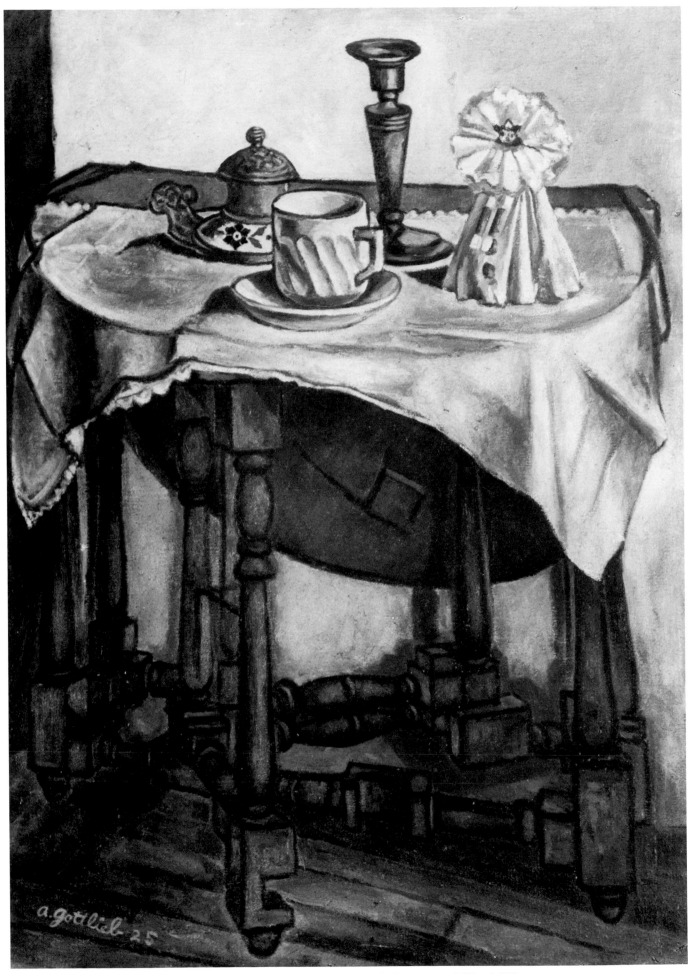

2. STILL LIFE—GATE LEG TABLE 1925 oil on canvas 35⅝ x 24⅞"

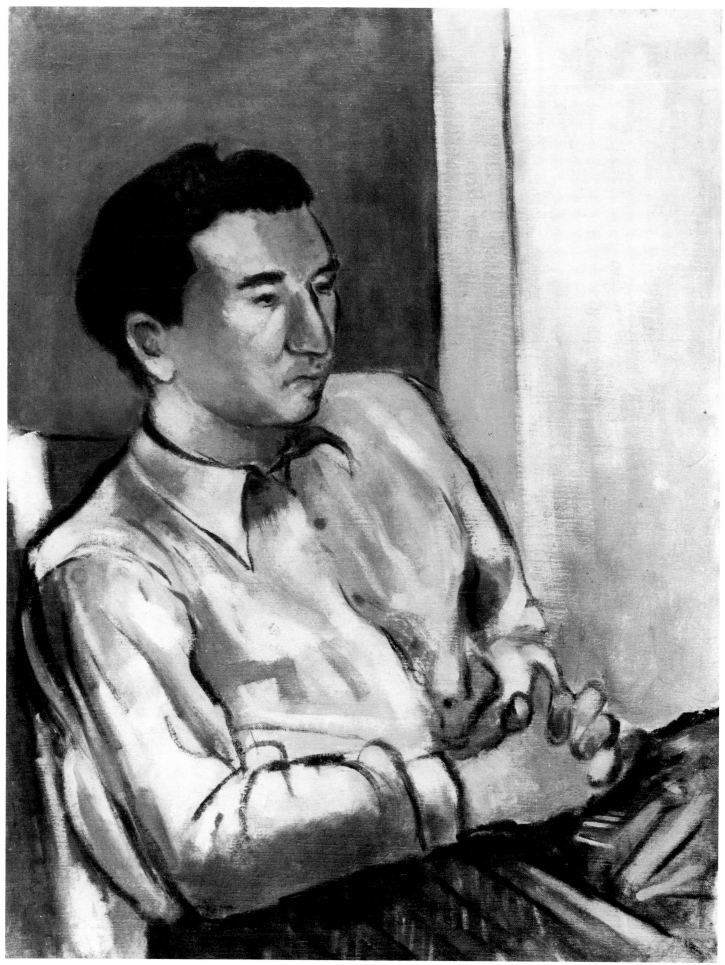

4. AARON SISKIND ca. 1927 oil on canvas 27 1/16 x 19 3/16"

3. GRAND CONCOURSE ca. 1927 oil on canvas 29⅞ x 23⅞"

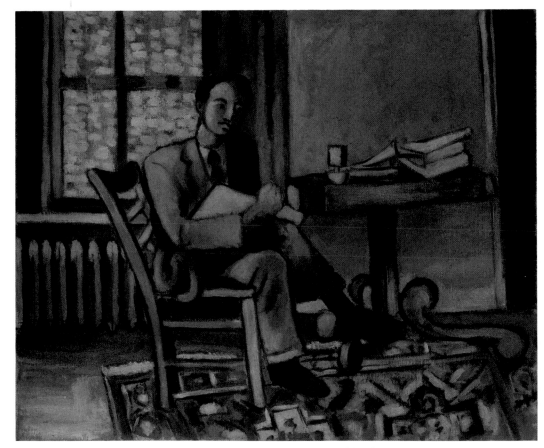

5. INTERIOR ca. 1927 oil on canvas 24 x 30"

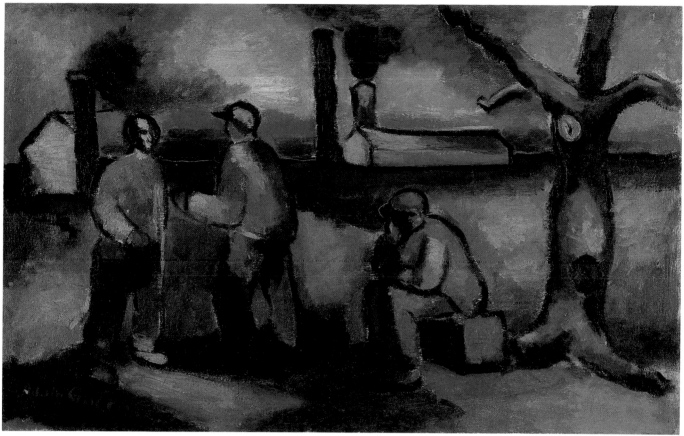

8. THE WASTELAND 1930 oil on canvas 22 x 34"

15. LUXEMBOURG GARDENS ca. 1936 oil on canvas 27¾ x 35⅞"

6. SOUTH FERRY WAITING ROOM ca. 1929 oil on cotton 36 x 45"

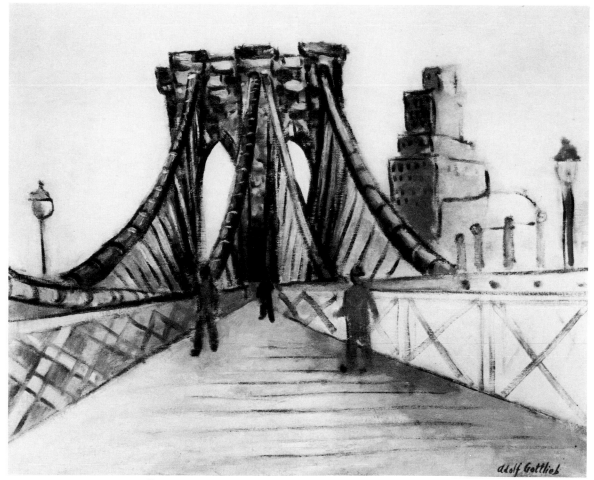

7. BROOKLYN BRIDGE ca. 1930 oil on canvas 25¹⁵/₁₆ x 31¹⁵/₁₆"

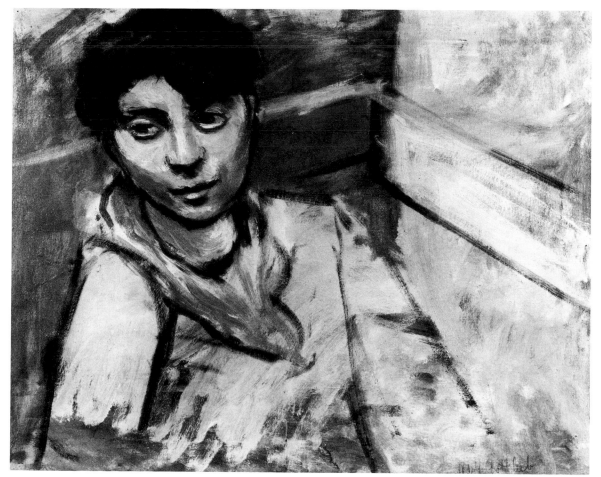

9. ESTHER 1931 oil on canvas 19 x 24"

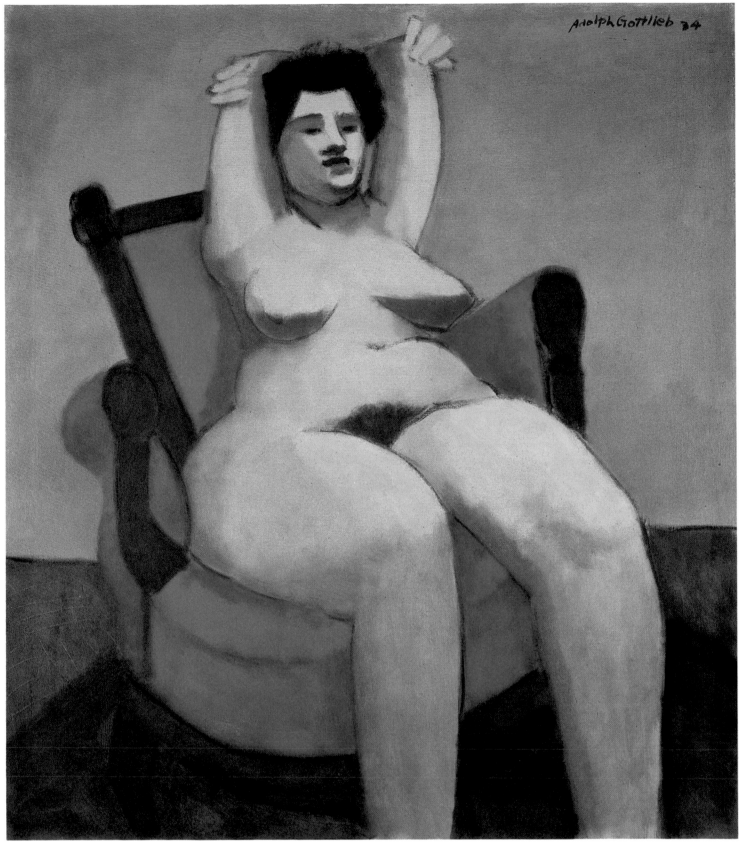

12. SEATED NUDE 1934 oil on canvas 39⁹⁄₁₆ x 35½"

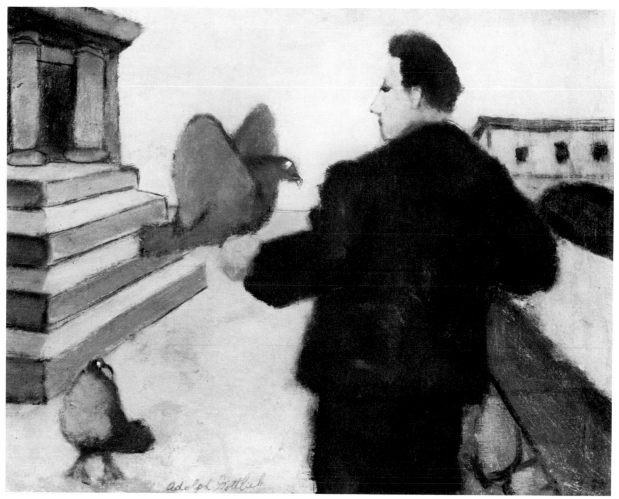

10. MAN WITH PIGEONS 1932 oil on linen 14 x 18"

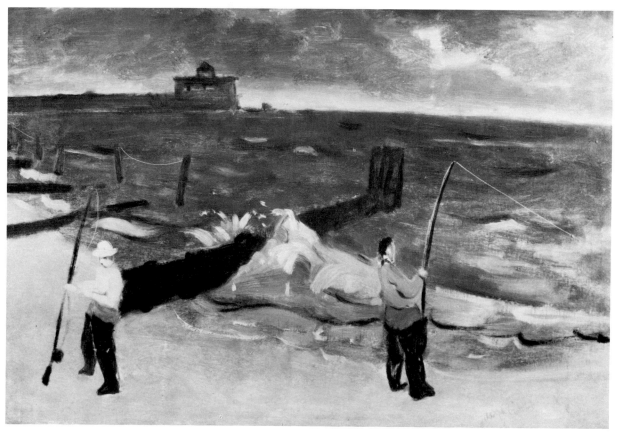

13. SURF CASTING ca. 1935 oil on canvas 19⁷⁄₁₆ x 28⁵⁄₈"

11. UNTITLED (PORTRAIT OF EMIL) ca. 1934 oil on canvas 33⅞ x 25¹³⁄₁₆″

14. UNTITLED (MAX MARGOLIS) ca. 1935 oil on canvas 26⅜ x 19⅜"

16. THE SWIMMING HOLE ca. 1937 oil on canvas 25½ x 34¾"

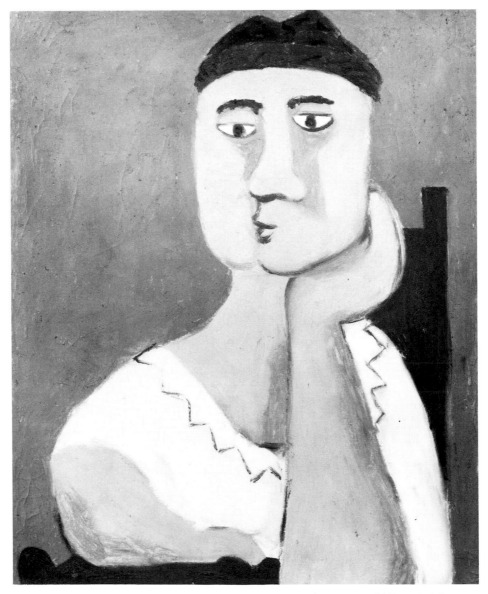

18. UNTITLED (PORTRAIT—BLUE BANDANA) ca. 1937 oil on canvas 29¹⁵⁄₁₆ x 23¾"

19. UNTITLED (SELF-PORTRAIT IN MIRROR) ca. 1938 oil on canvas 39⅞ x 29⅝"

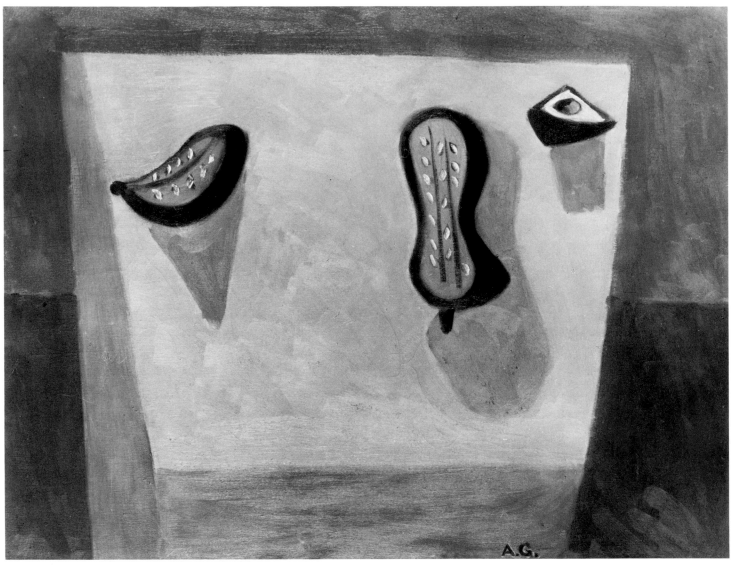

21. UNTITLED (GREEN STILL LIFE—GOURDS) 1938 oil on canvas 29⅞ x 39¾″

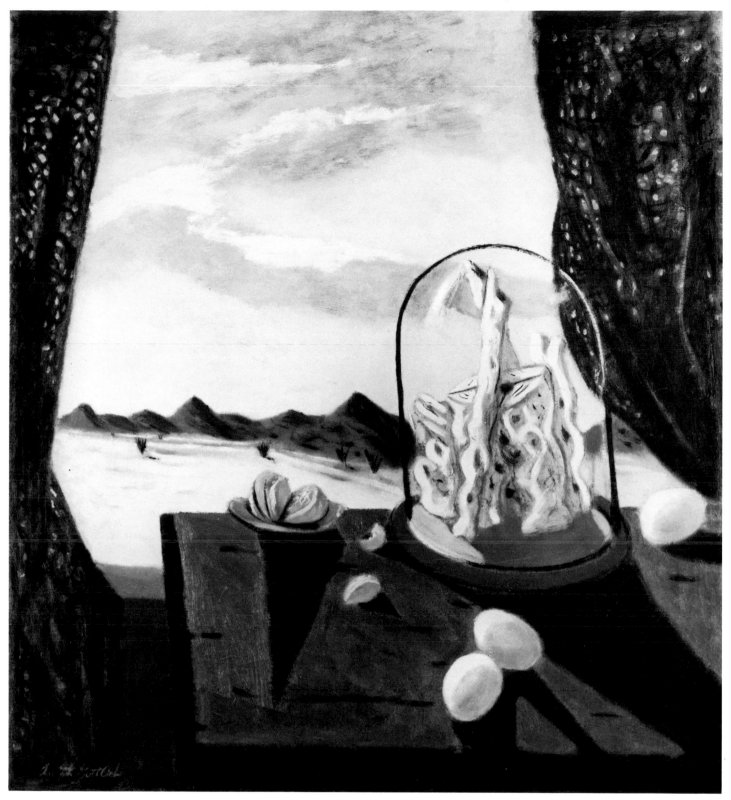

23. SYMBOLS AND THE DESERT 1938 oil on canvas 39¾ x 35⅞″

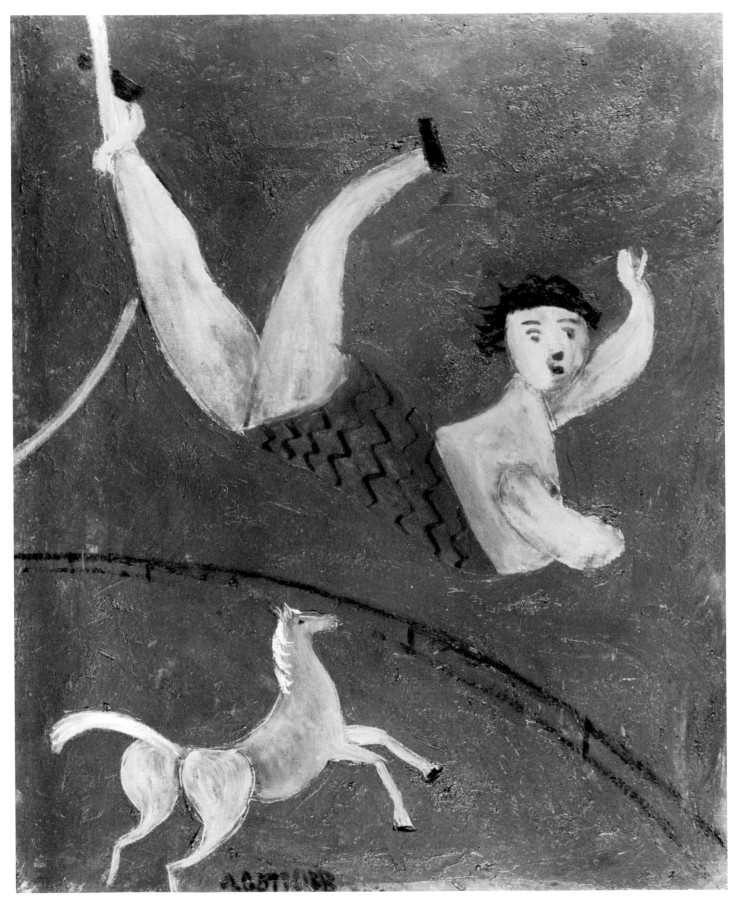

24. CIRCUS GIRL 1938 oil on canvas 23¾ x 29⅞"

17. UNTITLED (ESTHER AT EASEL) 1937 oil on canvas 40 x 36⅛"

22. UNTITLED (STILL LIFE—LANDSCAPE IN WINDOW) 1938 oil on canvas 29⅞ x 39⅞"

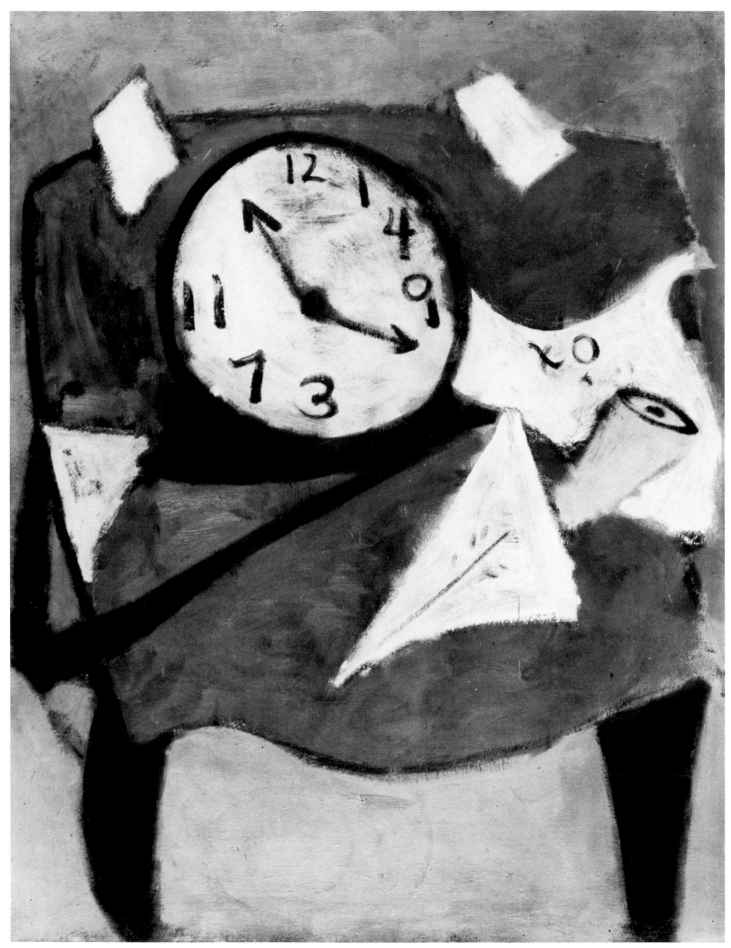

26. STILL LIFE—ALARM CLOCK 1938 oil on canvas 33⅞ x 25¹¹/₁₆″

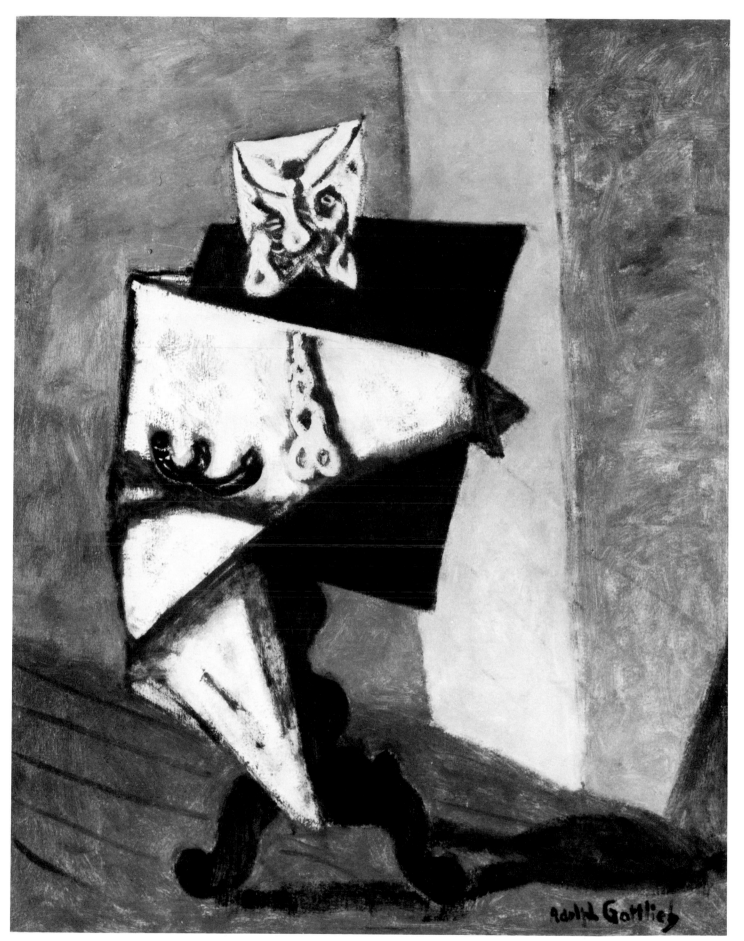

27. UNTITLED (CACTUS STILL LIFE—NEW YORK) 1939 oil on canvas 35¹³⁄₁₆ x 27¹¹⁄₁₆″

83

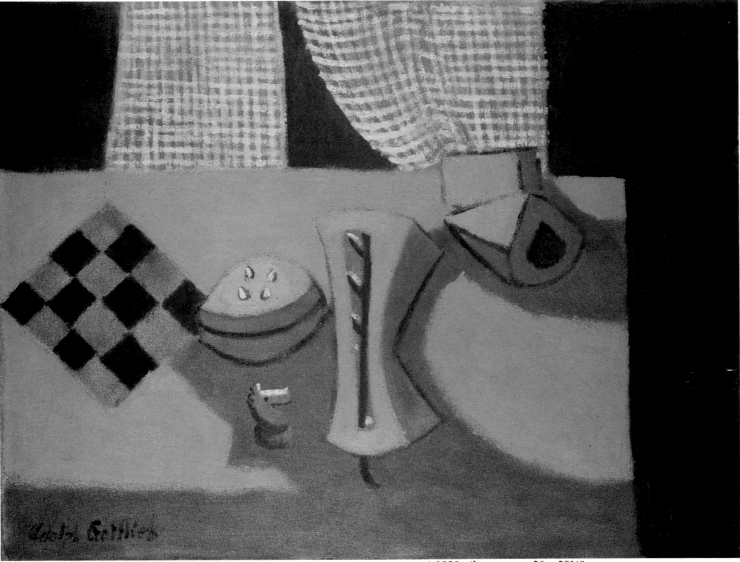

20. UNTITLED (PINK STILL LIFE—CURTAIN AND GOURDS) 1938 oil on canvas 30 x 39¾″

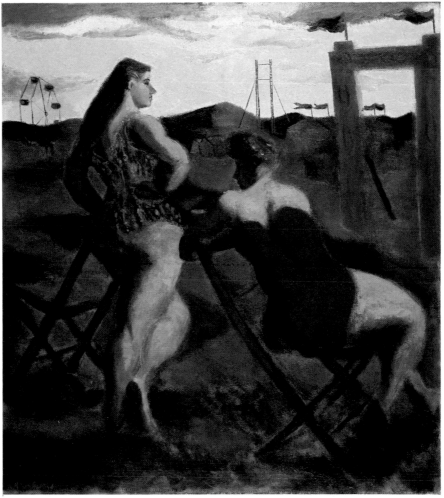

25. CIRCUS PERFORMERS 1938 oil on linen 40 x 36″

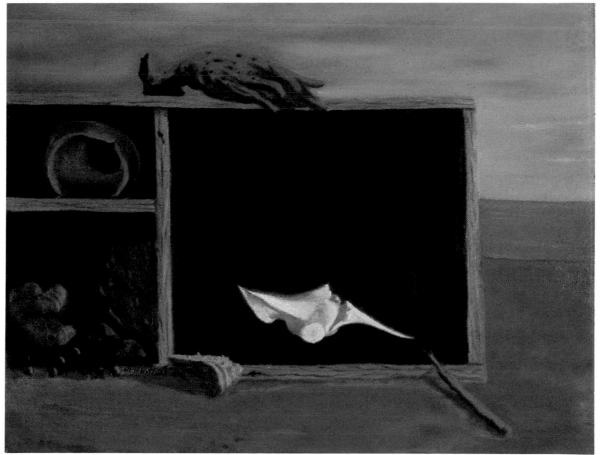

30. UNTITLED (BOX AND SEA OBJECTS) 1940 oil on linen 25 x 31⅞″

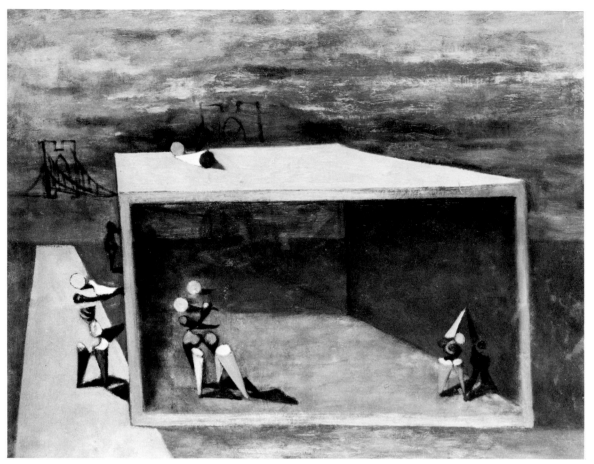

28. PICNIC (BOX AND FIGURES) ca. 1939 oil on linen 25⅞ x 33⅞"

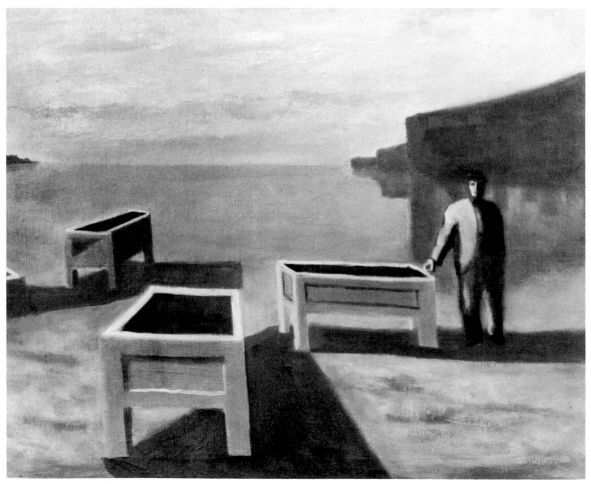

29. UNTITLED (BOXES ON BEACH AND FIGURE) 1940 oil on canvas 25 x 31⅞"

33. PICTOGRAPH—TABLET FORM 1941 oil on canvas 48 x 36"

31. UNTITLED (STILL LIFE) 1941 oil on canvas 25¹³⁄₁₆ x 24″

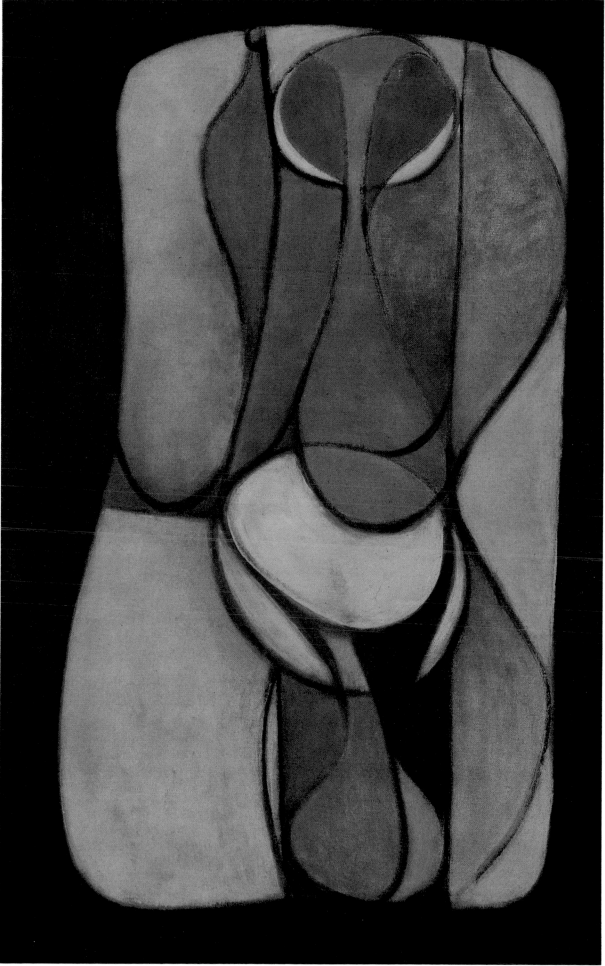

32. FEMALE FORMS 1941 oil on canvas 43 x 27"

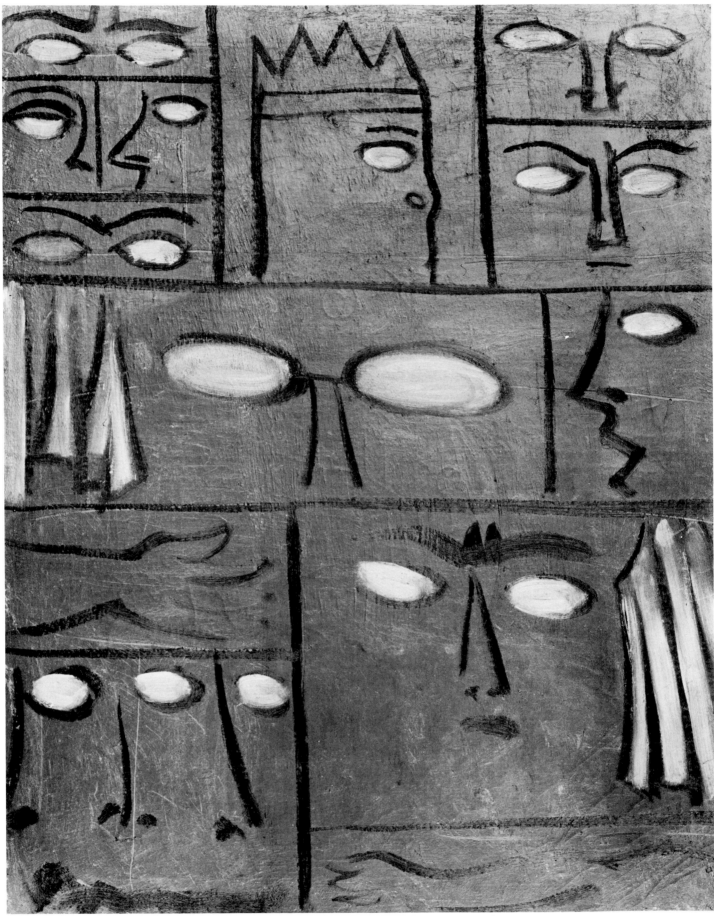

35. EYES OF OEDIPUS 1941 oil on canvas 32¼ x 25"

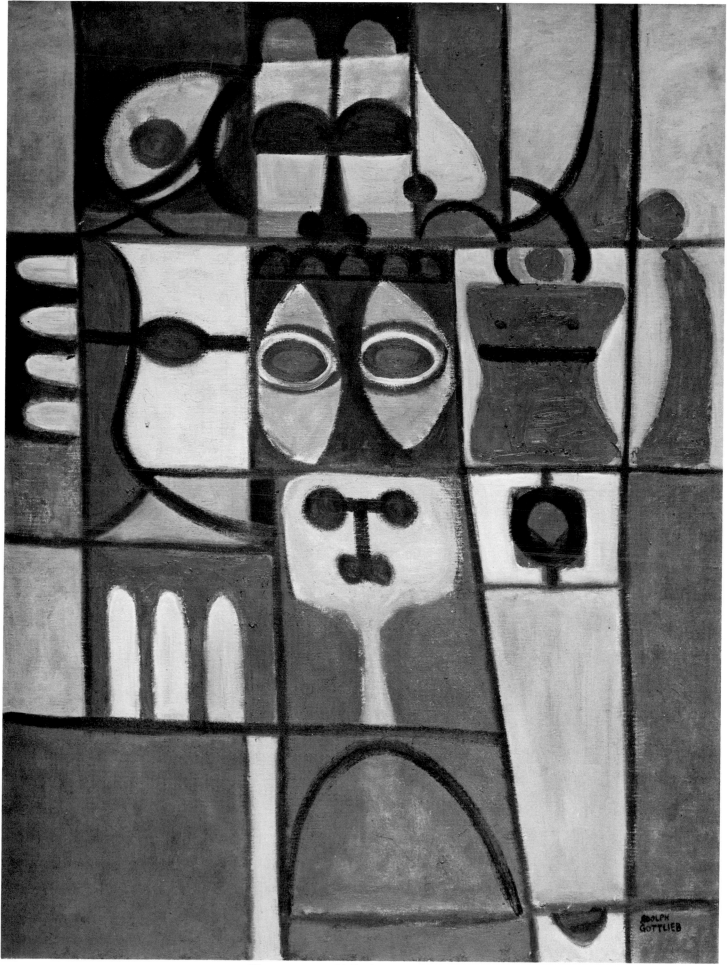

37. PICTOGRAPH 1942 oil on canvas 48 x 36"

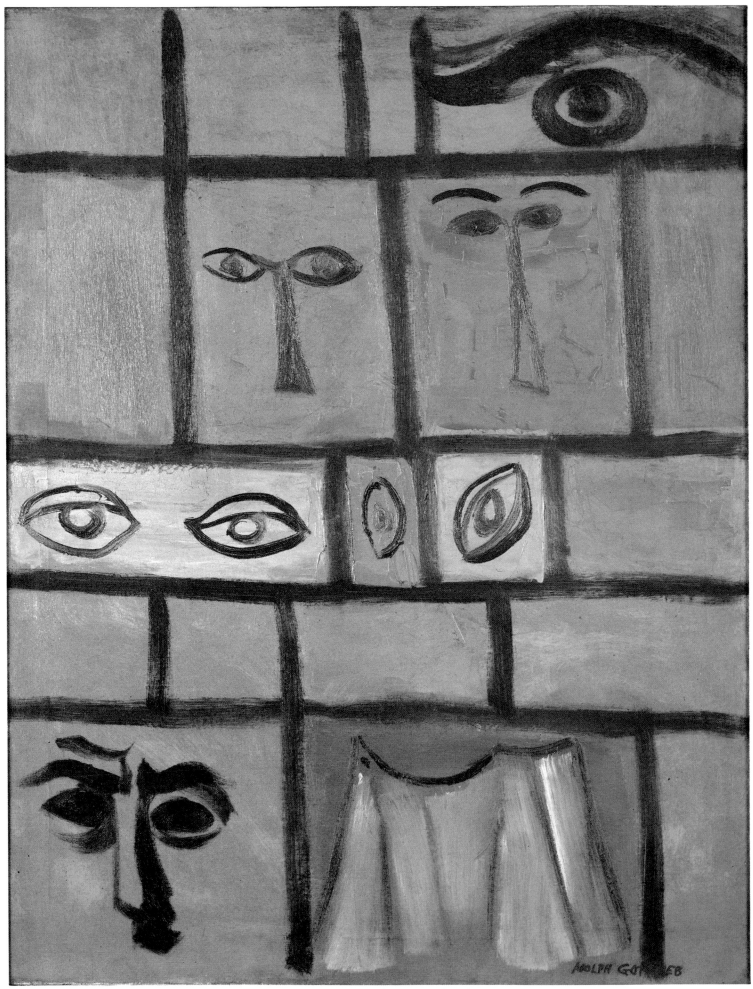

34. OEDIPUS 1941 oil on canvas 34 x 26"

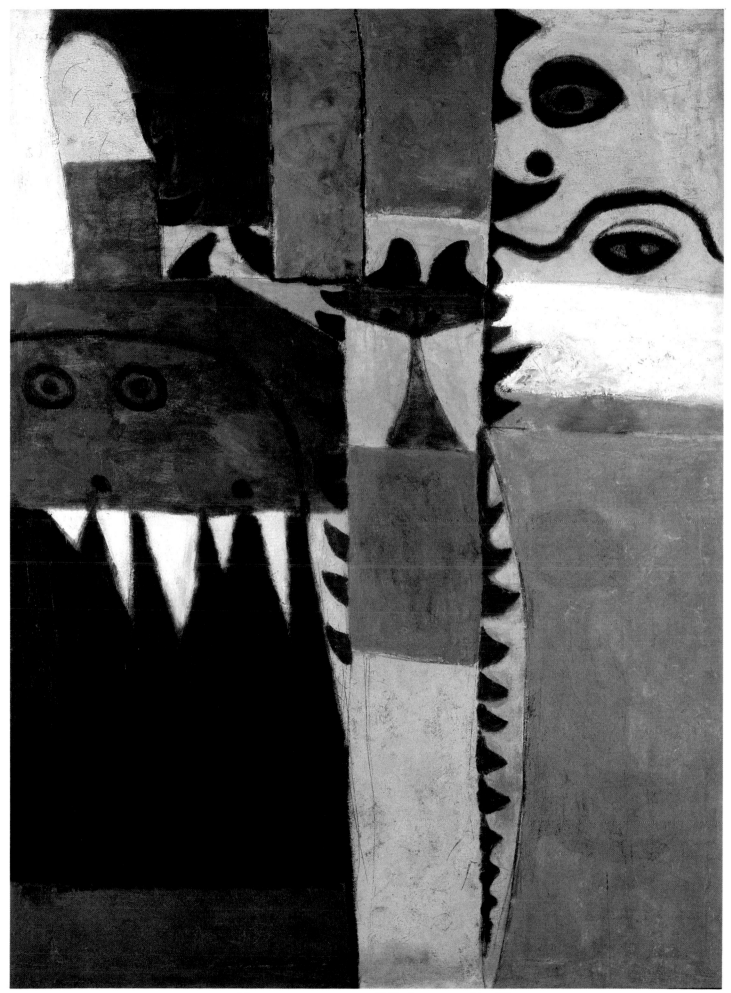

36. PICTOGRAPH—SYMBOL 1942 oil on canvas 54 x 40″

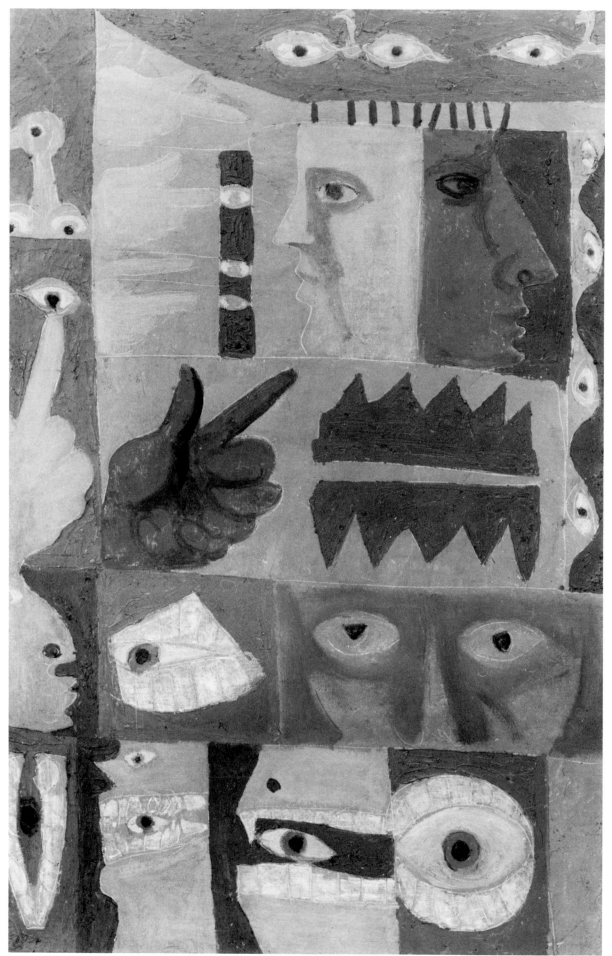

40. PICTOGRAPH #4 1943 oil on canvas 36 x 23"

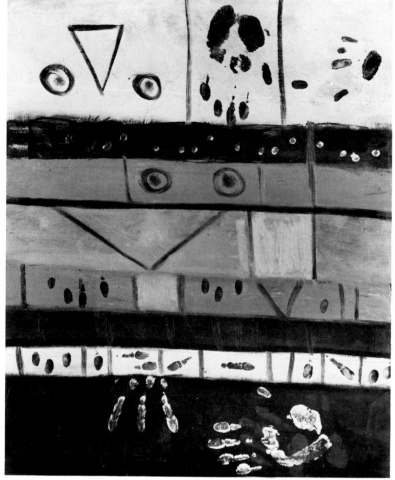

41. BLACK HAND 1943 oil on linen 30 x 26″

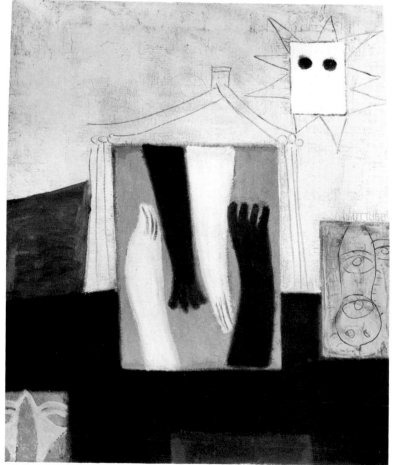

42. HOME 1943 oil & pencil on canvas 23⅞ x 19⅞″

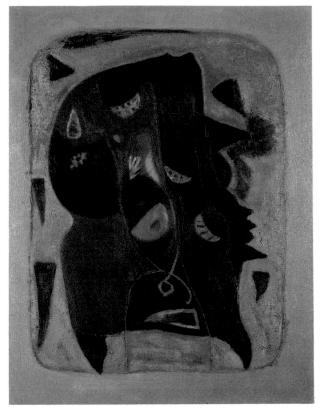

38. PERSEPHONE 1942 oil on canvas 34 x 26″

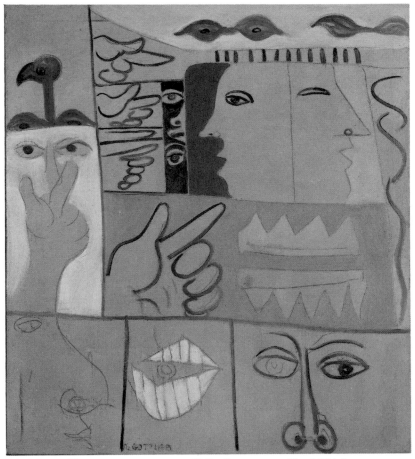

39. HANDS OF OEDIPUS 1943 oil on canvas 48 x 35¹⁵⁄₁₆″

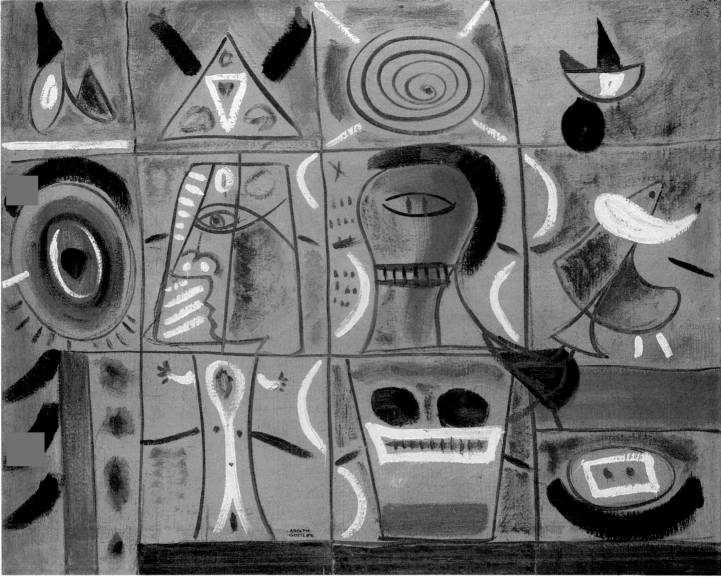

43. NOSTALGIA FOR ATLANTIS 1944 oil on canvas 20 x 25"

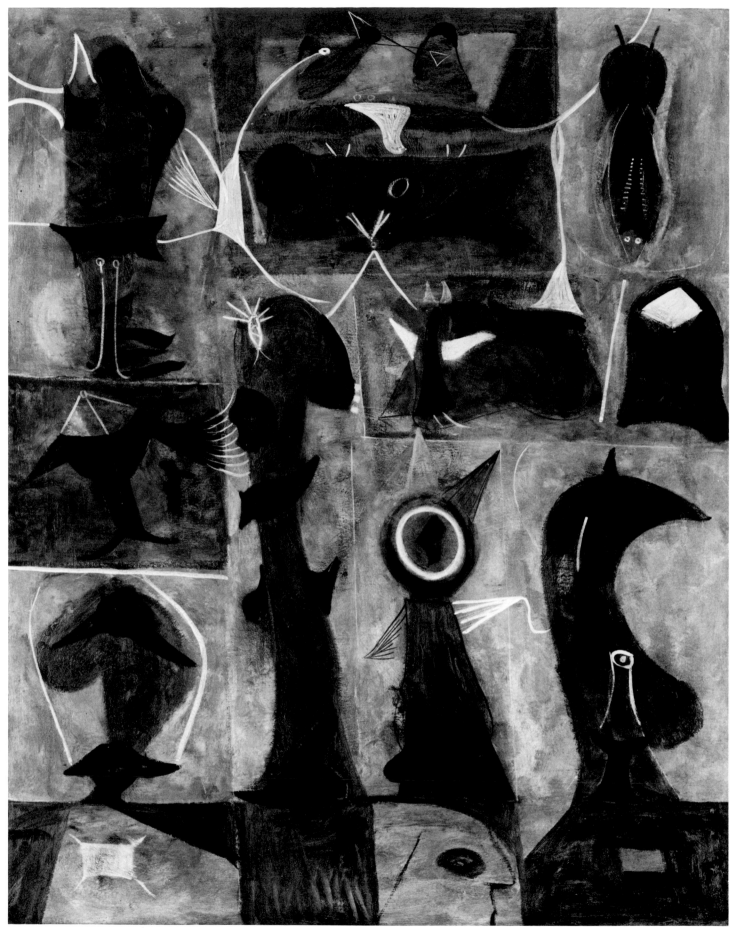

45. BIRDS 1945 oil on canvas 54 x 42″

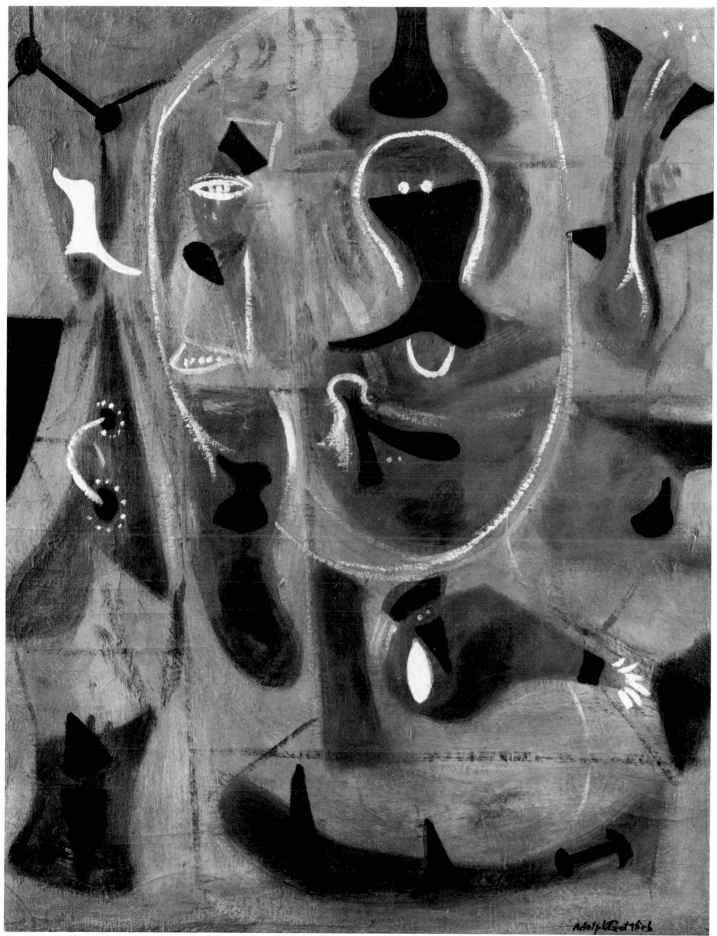

46. ALCHEMIST (RED PORTRAIT) 1945 oil on canvas 34 x 26″

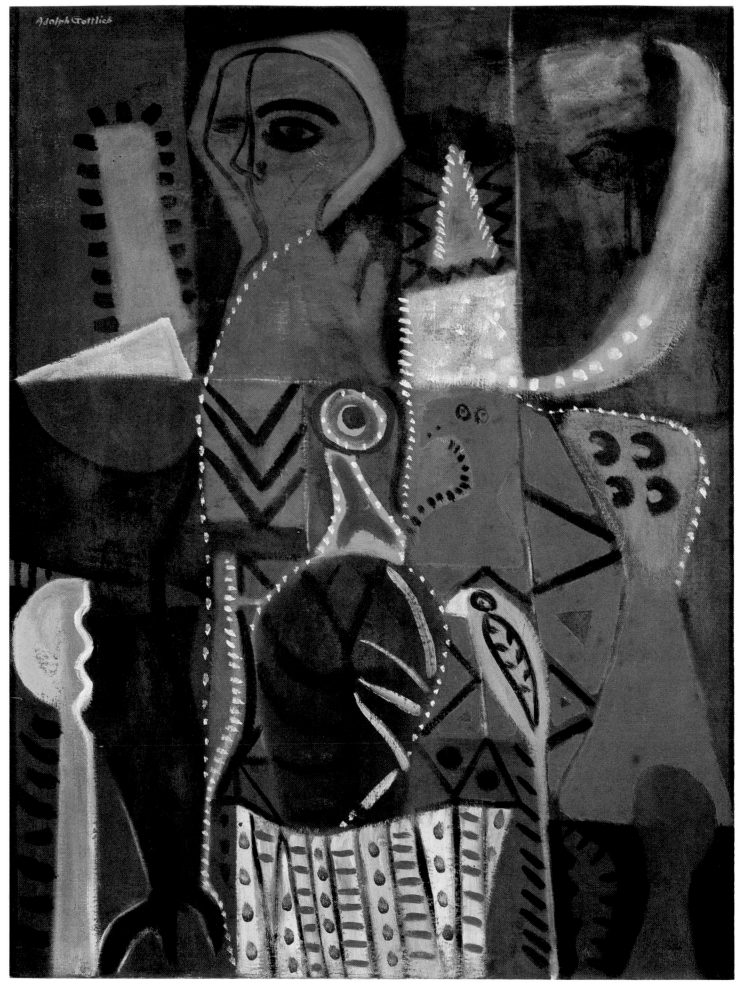

44. THE RED BIRD 1944 oil on canvas 40 x 30″

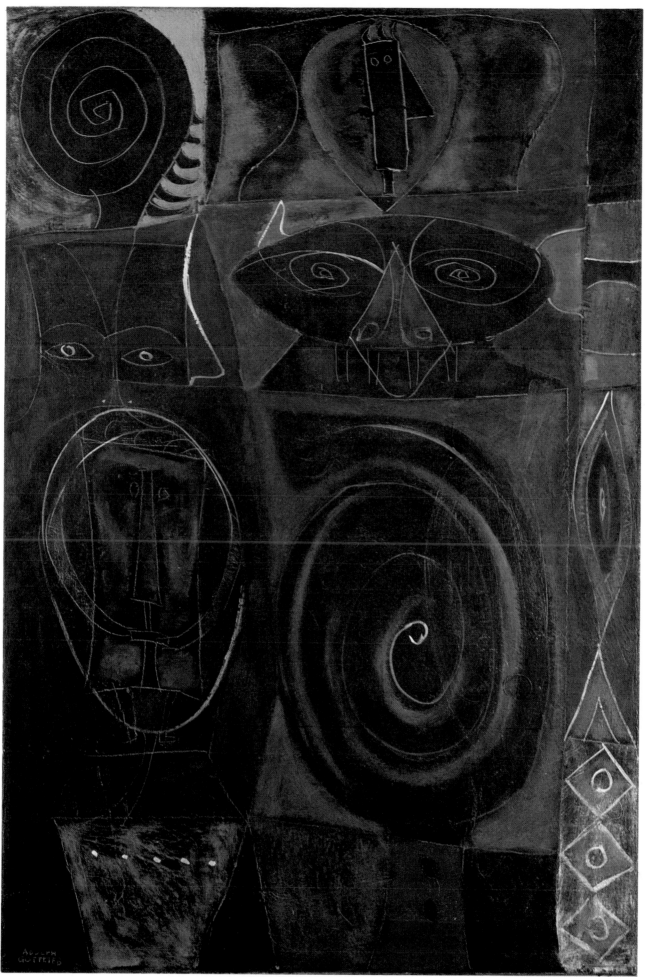

48. MASQUERADE 1945 oil & egg tempera on canvas 36 x 24″

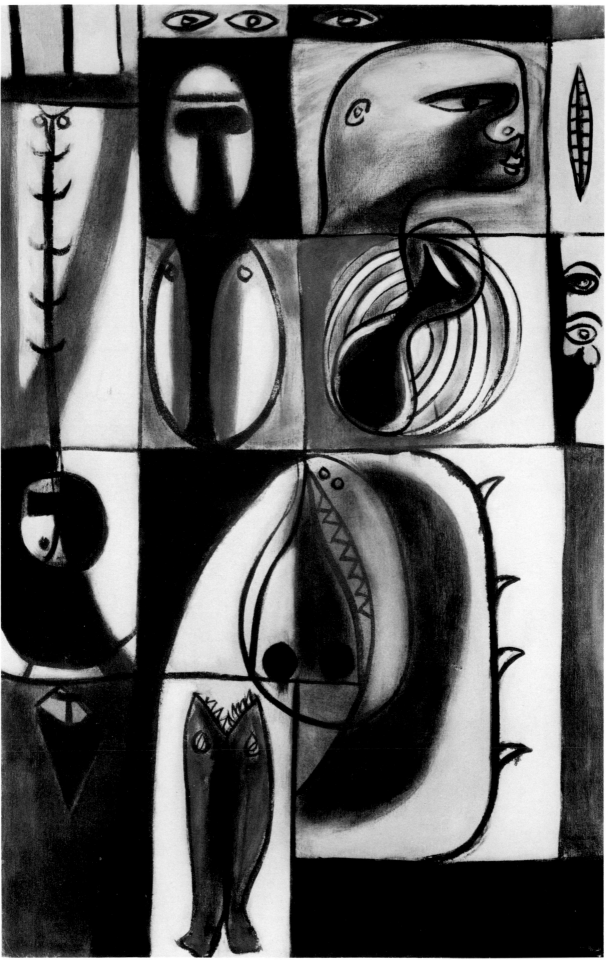

47. EXPECTATION OF EVIL 1945 oil, gouache & tempera on canvas 43 x 27"

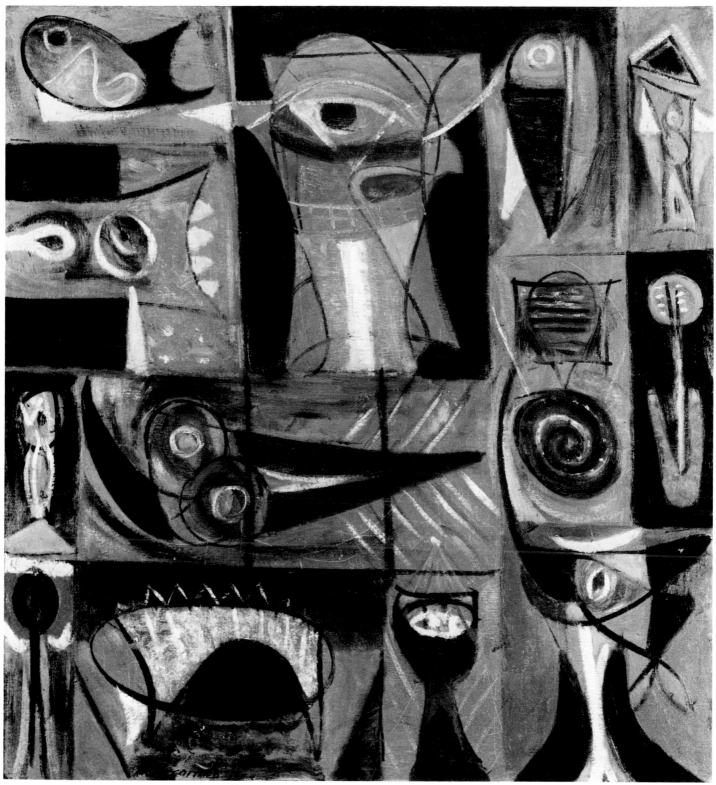

49. GREEN AND BLUE 1945 oil on canvas 39¾ x 35⅞"

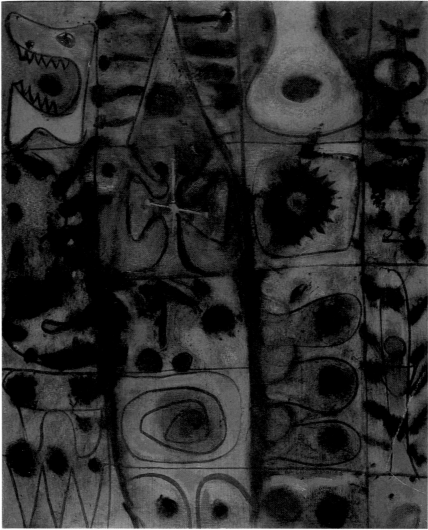

51. WATER, AIR, FIRE 1947 oil on pressed board 30 x 24″

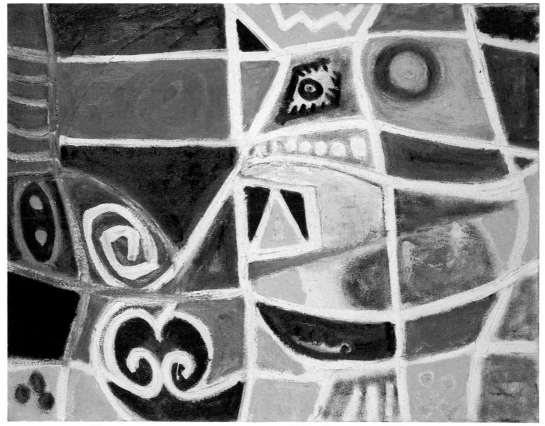

53. PICTOGRAPH—HEAVY WHITE LINES 1947 oil on canvas 24¹¹⁄₁₆ x 31¹¹⁄₁₆″

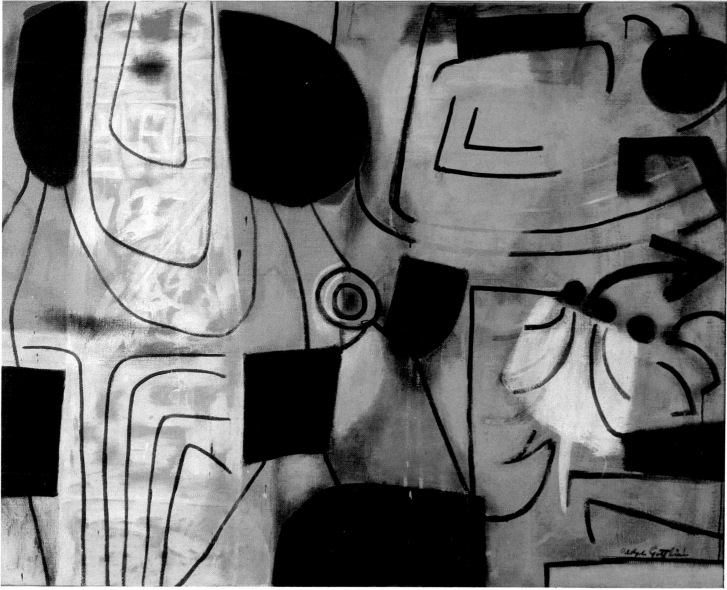

58. FIGURATIONS OF CLANGOR 1951 oil, gouache & tempera on burlap 48¹⁄₁₆ x 60¹⁄₈″

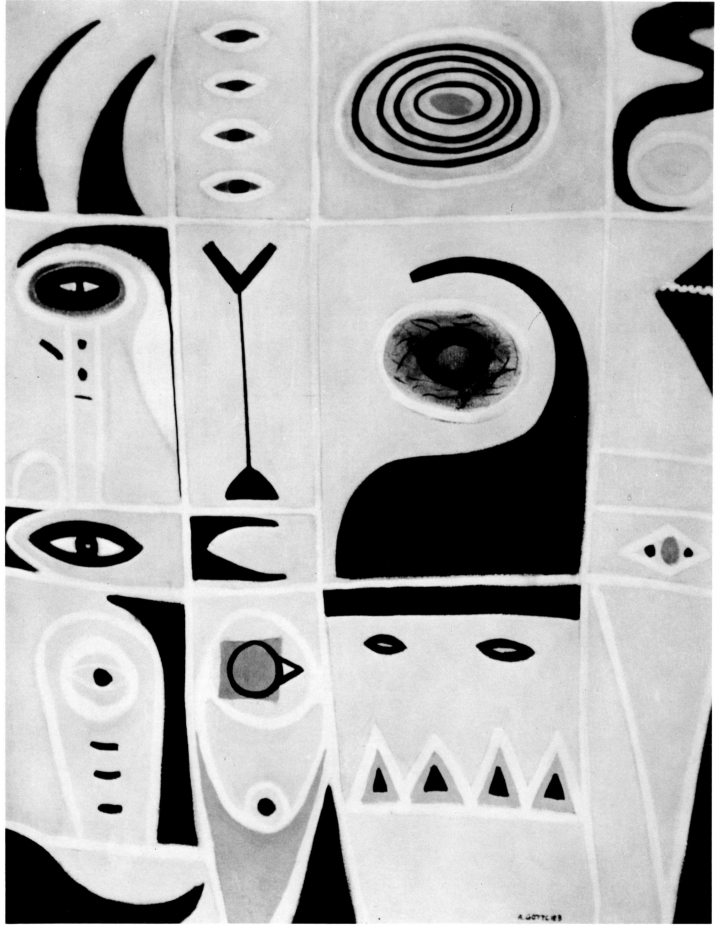

50. EVIL OMEN 1946 oil on canvas 38 x 30"

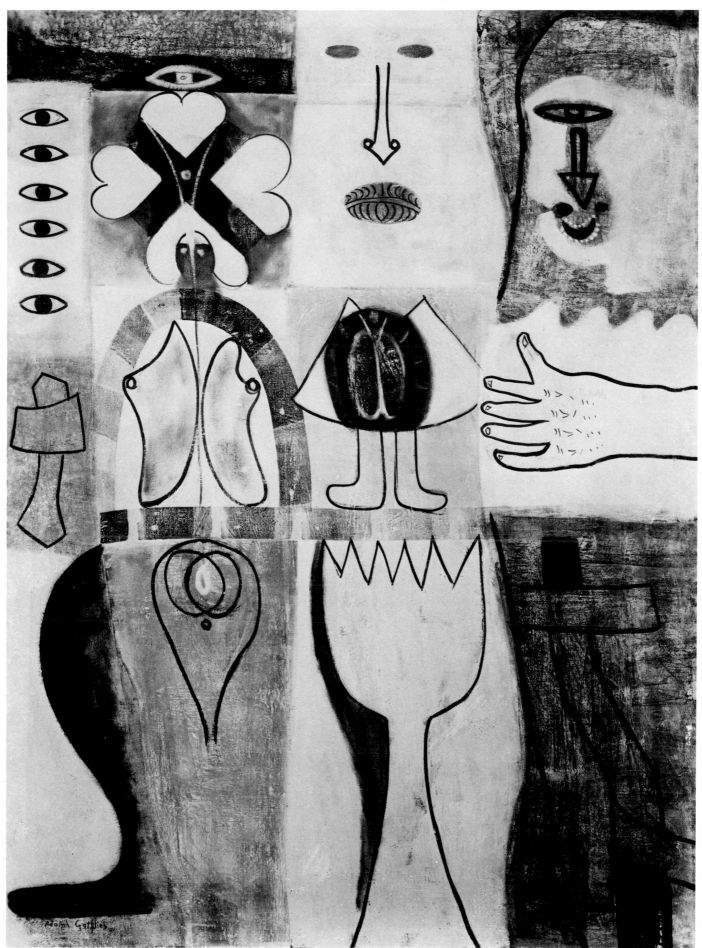

52. ORACLE 1947 oil on canvas 60 x 44″

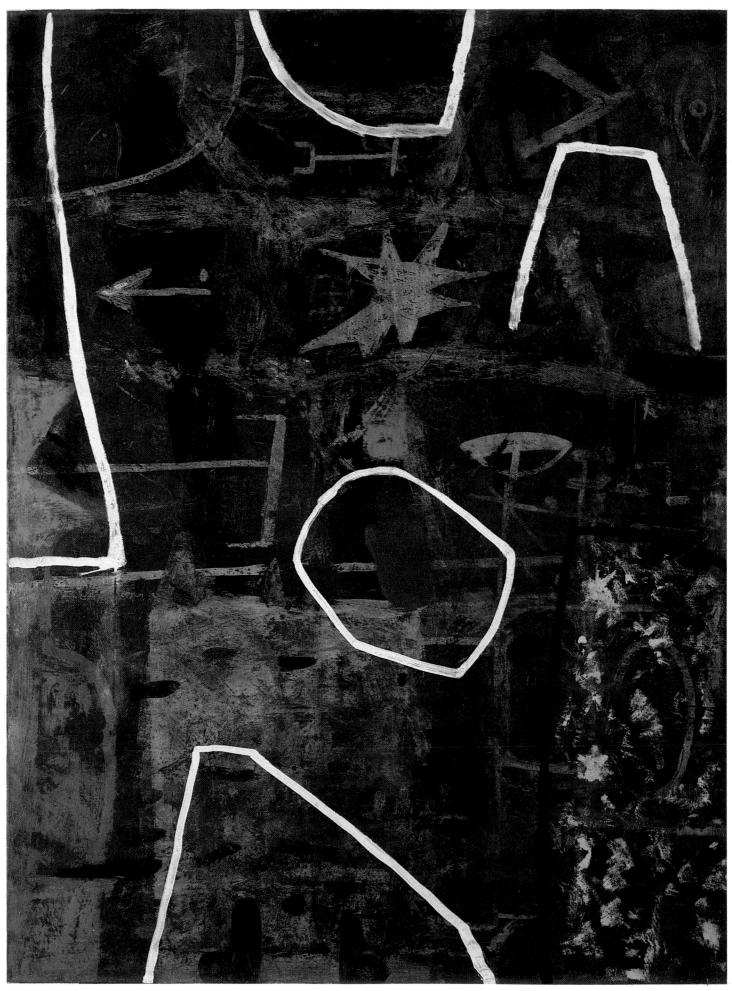

59. NIGHT FLIGHT 1951 oil, tempera, casein and gouache on canvas 48 x 35⅞″

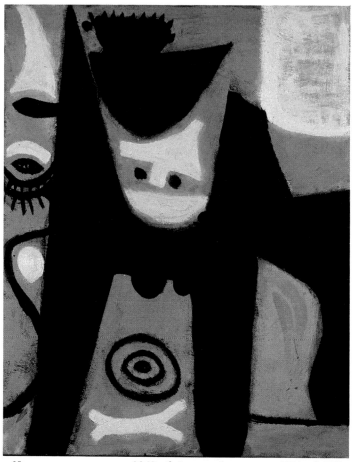

60. BLACK SILHOUETTE 1949 oil & enamel on canvas 31¾ x 24¾"

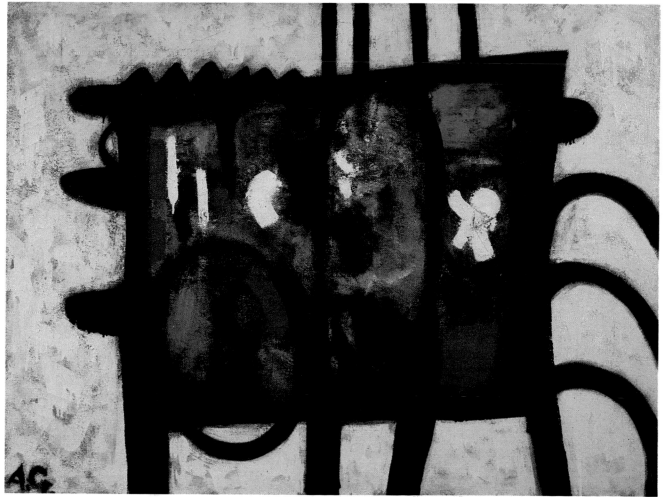

65. UNSTILL LIFE 1952 oil on canvas 36 x 48"

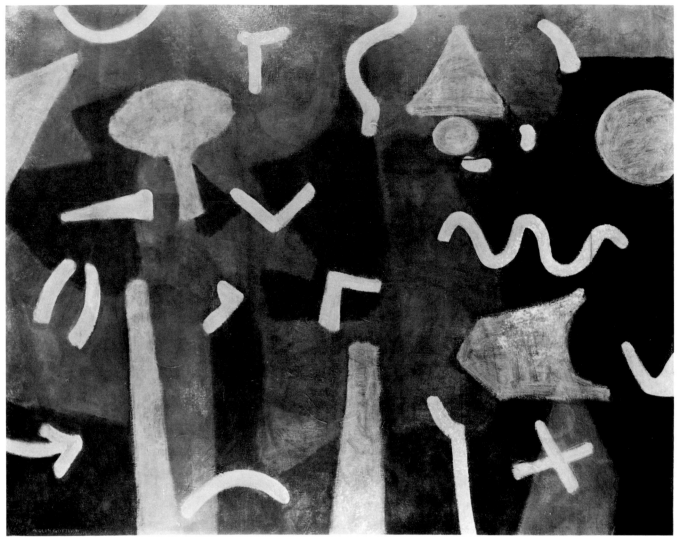

54. SOUNDS AT NIGHT 1948 oil & charcoal on linen 48⅛ x 60″

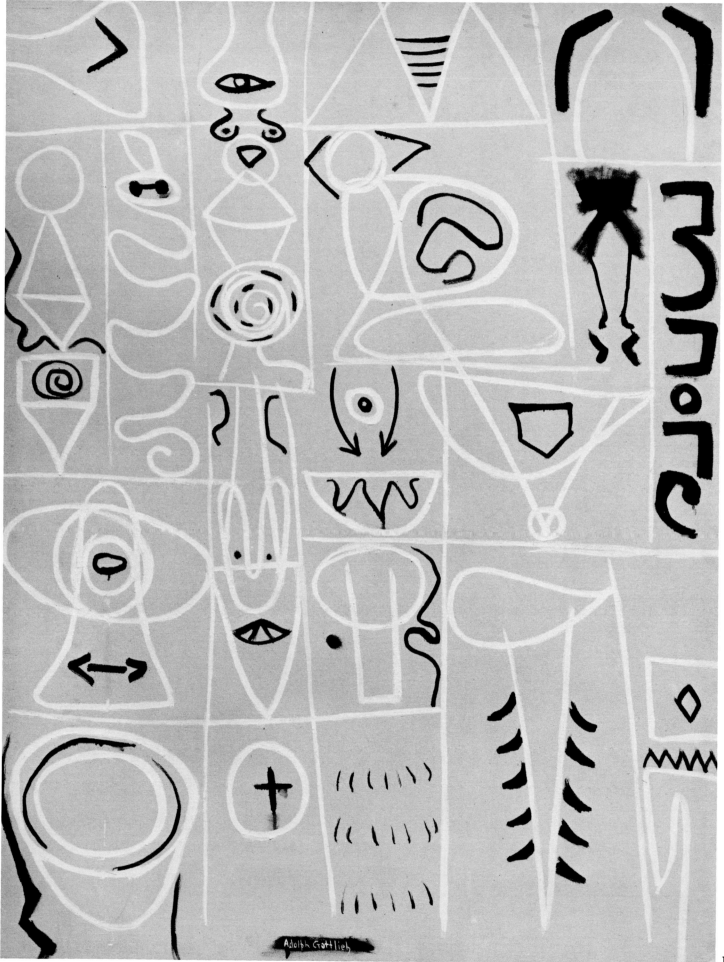

55. LETTER TO A FRIEND 1948 oil, tempera & gouache on canvas 47⅞ x 36¼"

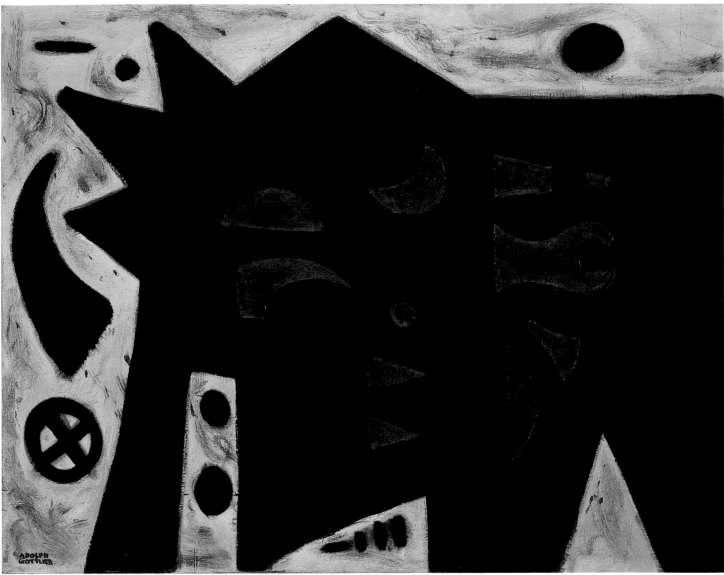

61. CASTLE 1950 oil & smalts on canvas 30 x 38"

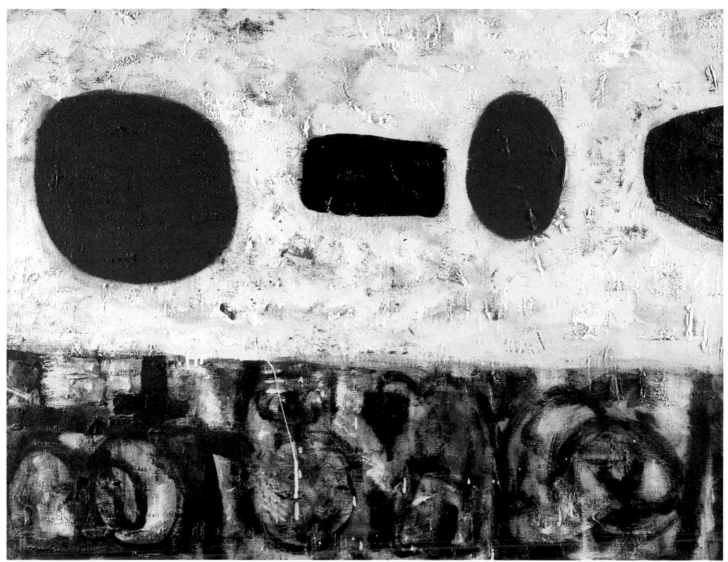

66. THE FROZEN SOUNDS #2 1952 oil on canvas 36 x 48″

113

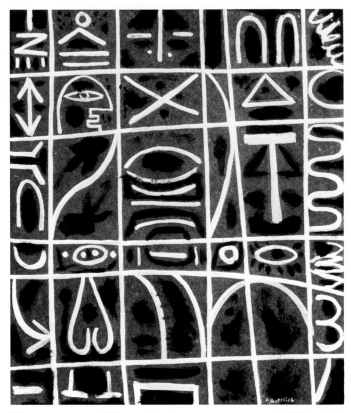

56. PICTOGRAPH 1950 gouache & tempera on masonite 23⅞ x 20″

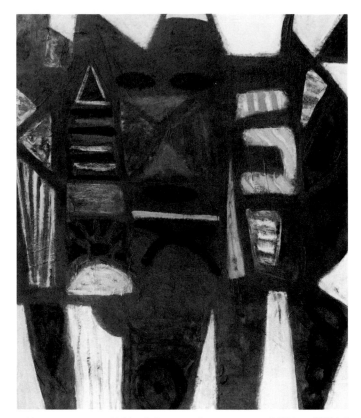

62. INDIAN RED 1950 oil & enamel on masonite 29¹⁵/₁₆ x 23¹⁵/₁₆″

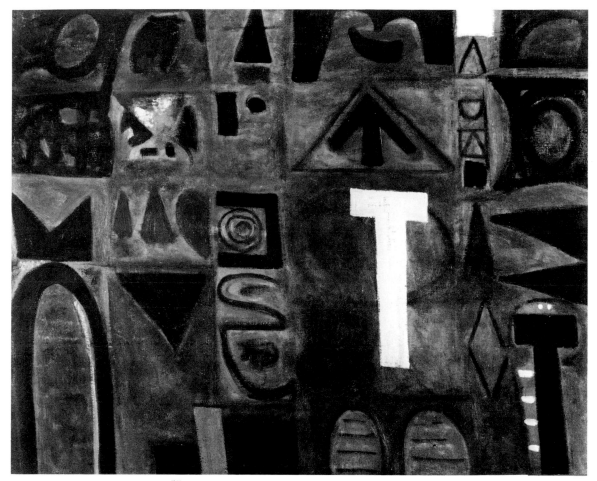

57. T—BLACK GROUND 1951 mixed media on canvas 48 x 60″

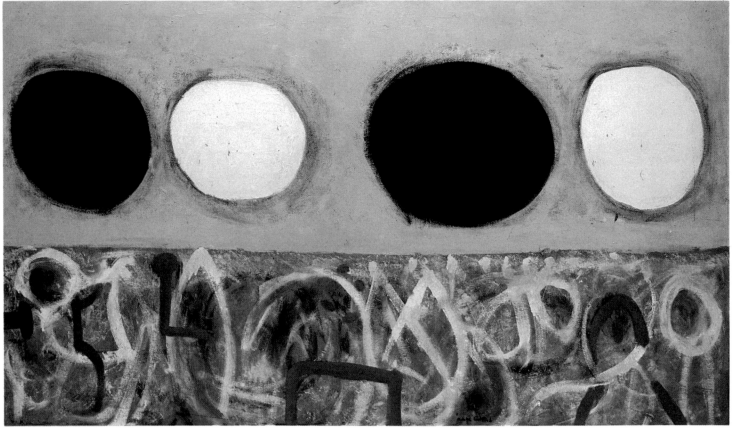

68. ECLIPSE 1952 oil on canvas 42 x 72"

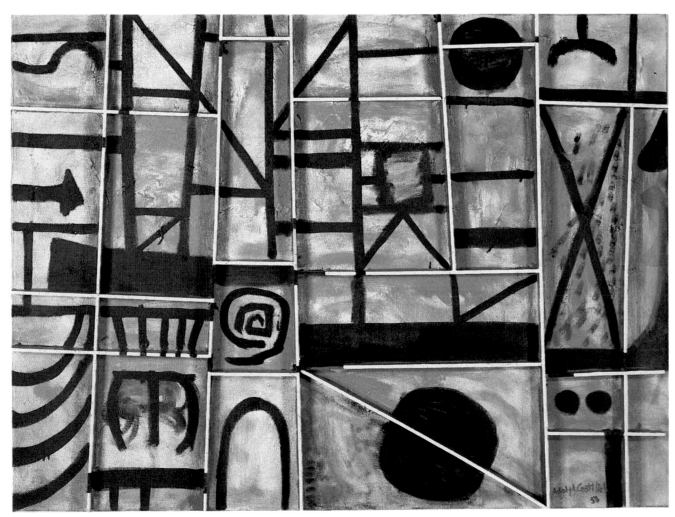

69. CONSTRUCTION #1 1953 oil & wood on canvas 36 x 47⅝"

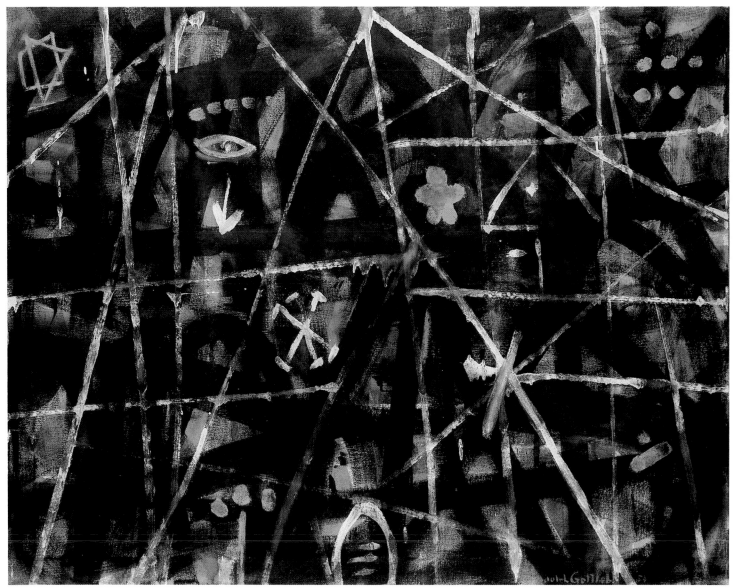

70. NOCTURNAL BEAMS 1954 oil, enamel & casein on canvas 47¹³⁄₁₆ x 59⅞″

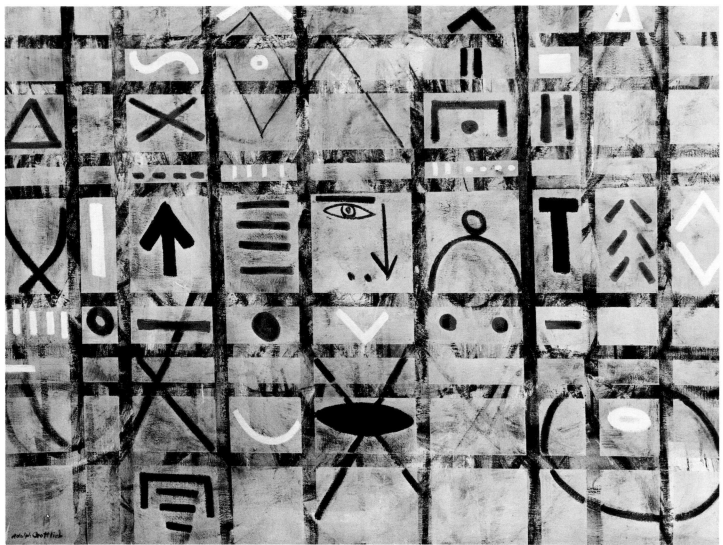

63. LABYRINTH #1 1950 oil on linen 36 x 48″

118

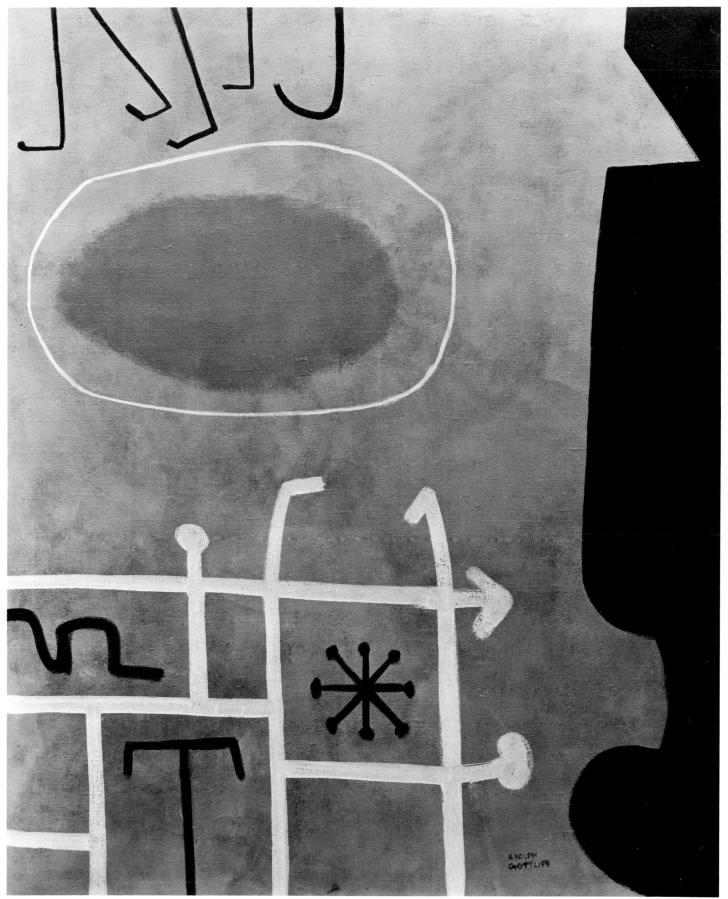

64. SENTINEL 1951 oil on canvas 60 x 48"

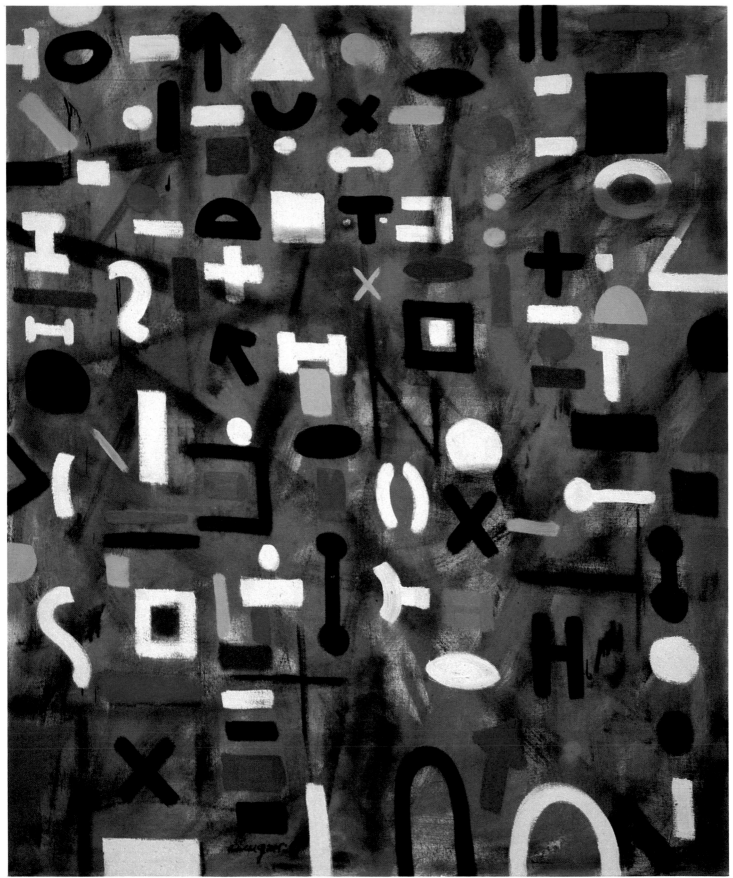

73. COMPOSITION 1955 oil on canvas 72 x 60"

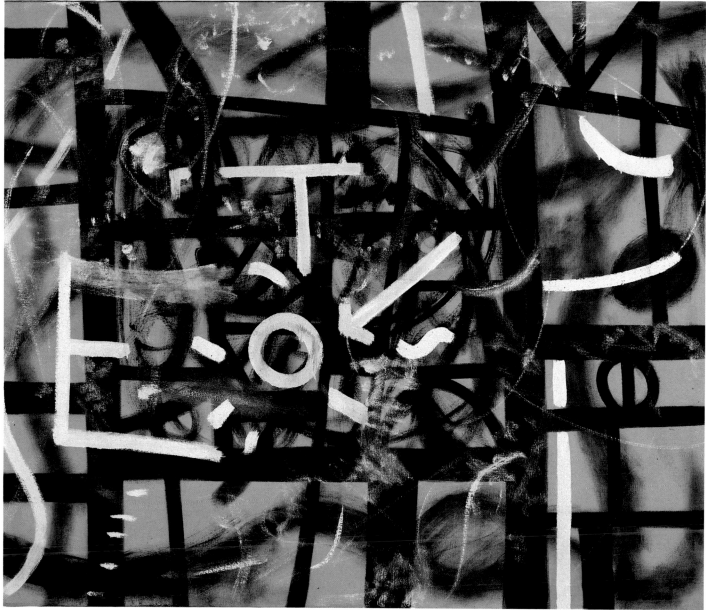

74. BLUE AT NOON 1955 oil on canvas 60 x 72"

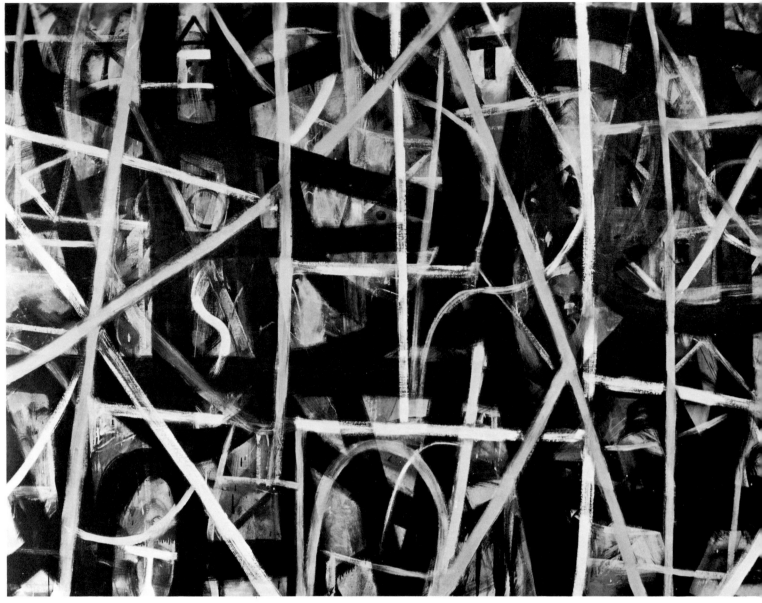

71. LABYRINTH #3 1954 oil on canvas 84 x 192″

72. TRAJECTORY 1954 oil & enamel on canvas 39¾ x 49⅞″

79. BLUE AT NIGHT 1957 oil on canvas 42 x 60"

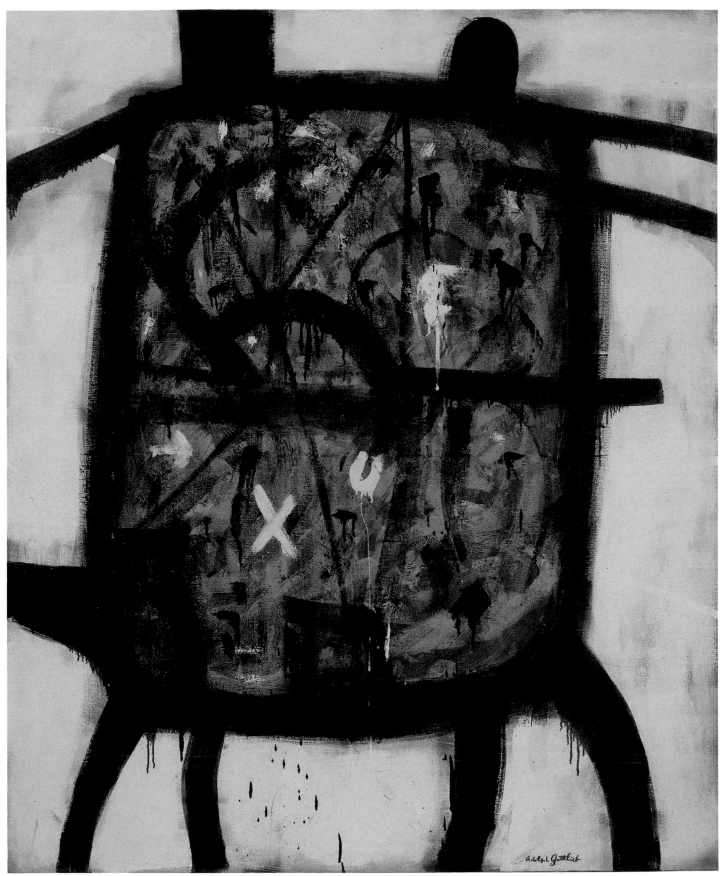

75. THE COUPLE 1955 oil & enamel on canvas 72 x 60"

77. FOUR RED CLOUDS 1956 oil on canvas 50 x 60″

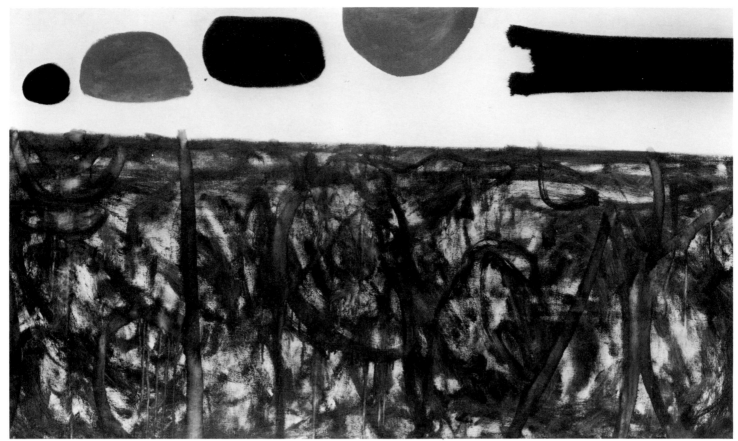

67. NADIR 1952 oil on canvas 42 x 72″

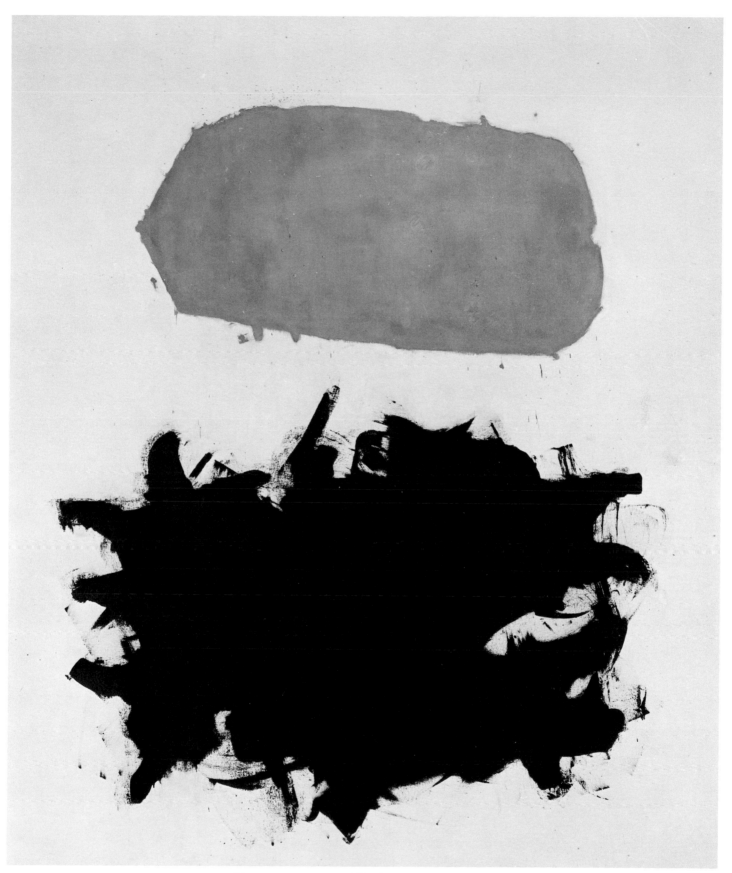

83. TAN OVER BLACK 1958 oil on canvas 108 x 90″

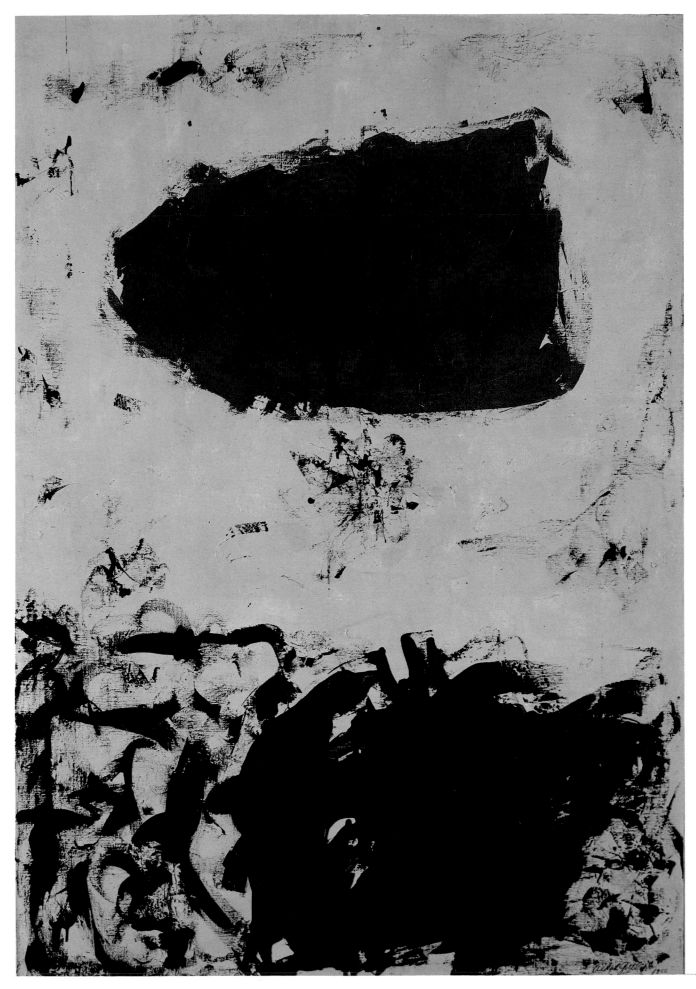

78. BLACK, BLUE, RED 1956 oil & enamel on linen 72 x 50″

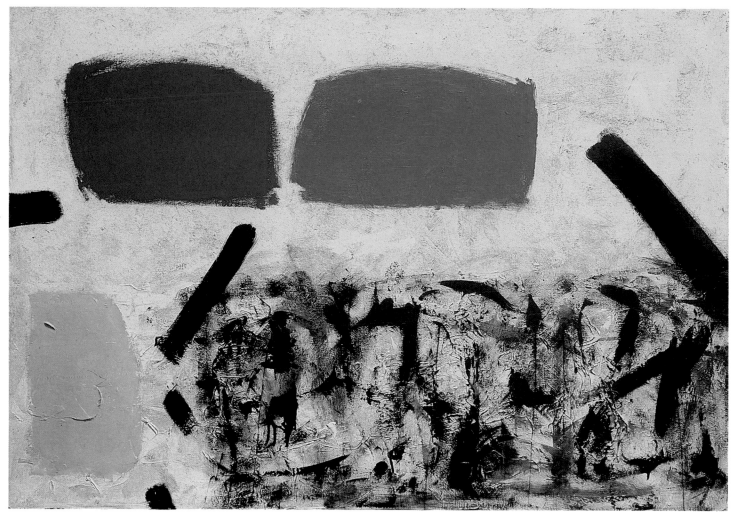

80. BIAS PULL 1957 oil on canvas 42 x 60″

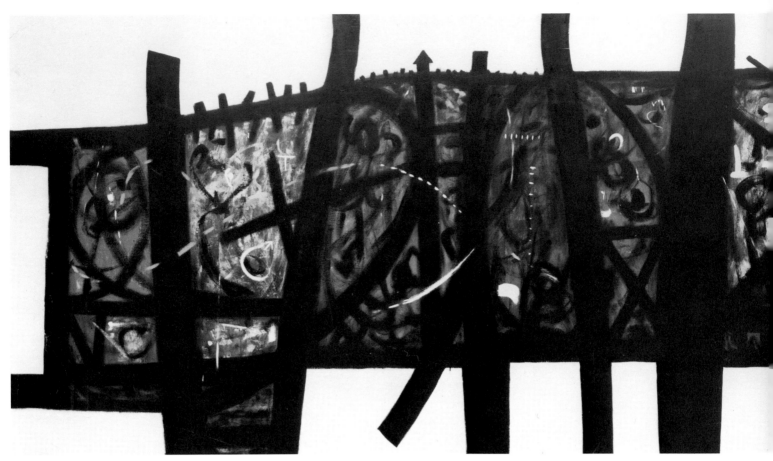

76. UNSTILL LIFE #3 1956 oil on canvas 84 x 192″

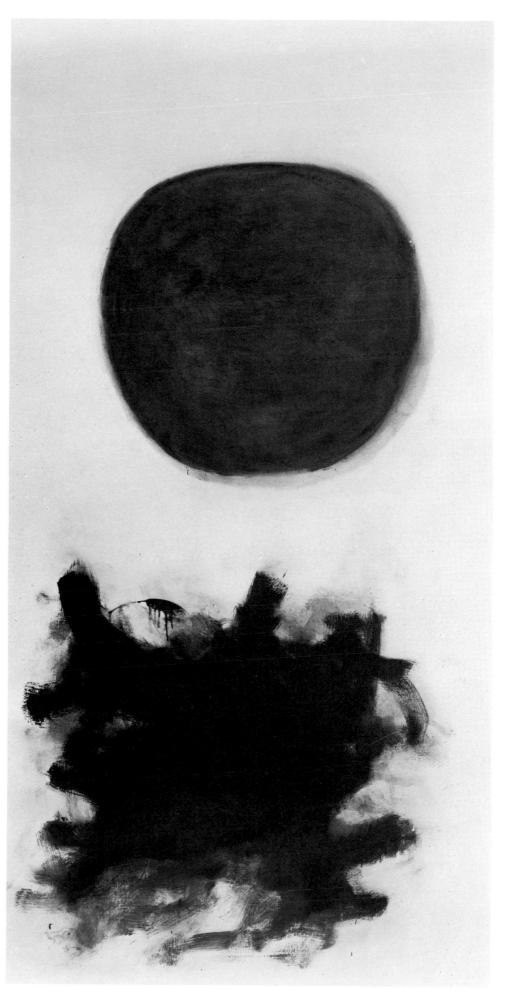

81. BLAST I 1957 oil on canvas 90 x 45″

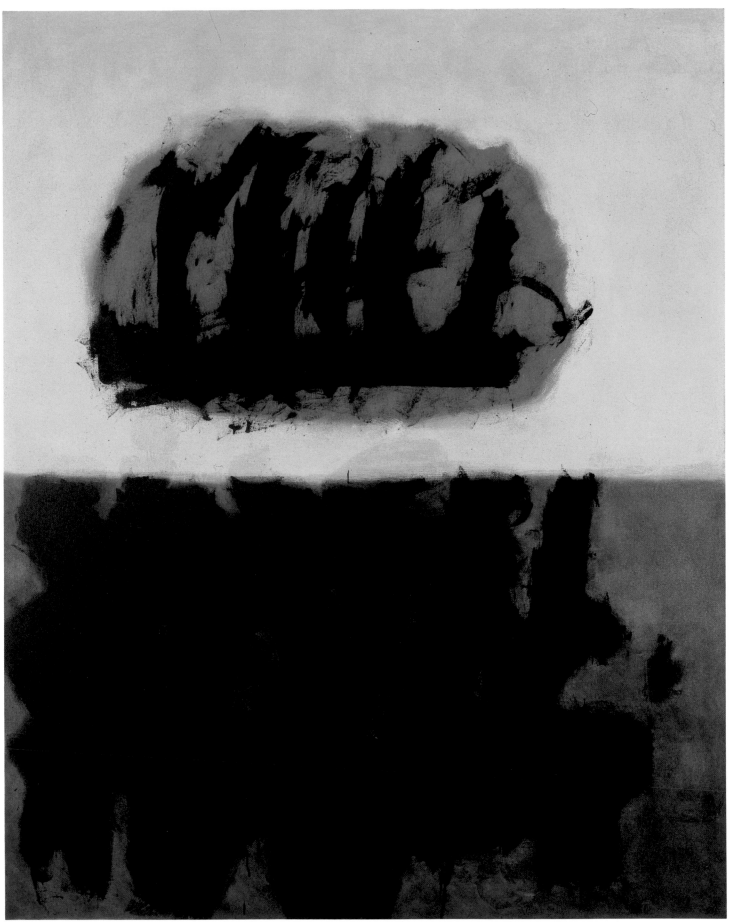

82. ARGOSY 1958 oil on canvas 90 x 72″

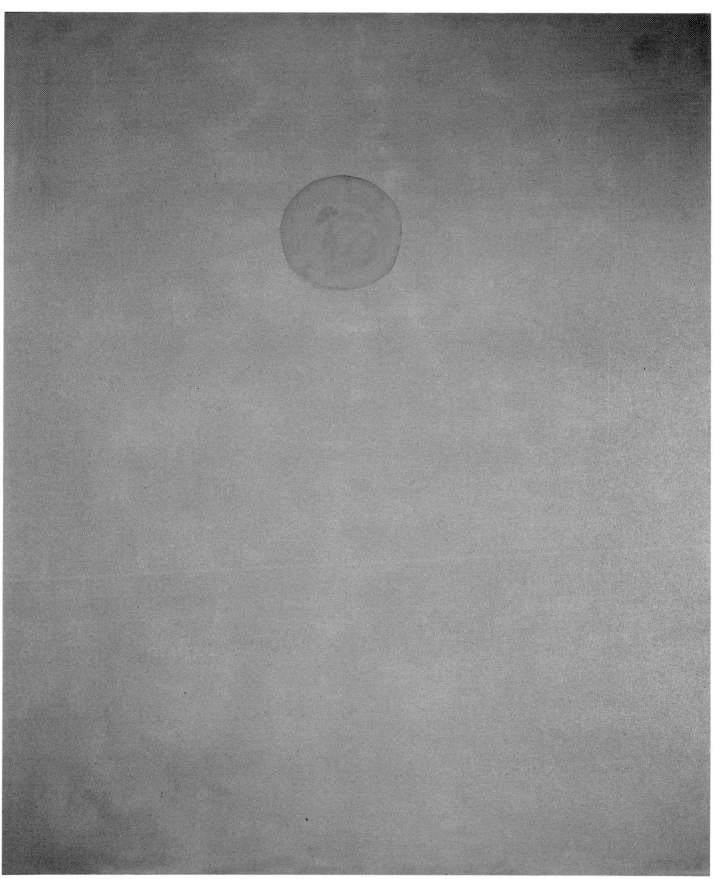

86. AFTERMATH 1959 oil on linen 108 x 90"

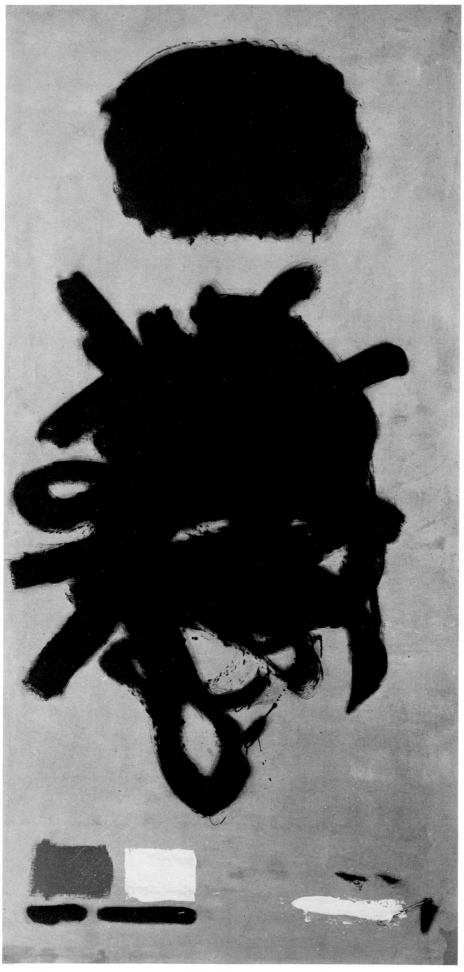

84. THE FORM OF THE THING 1958 oil on paper, mounted on canvas 78 x 38"

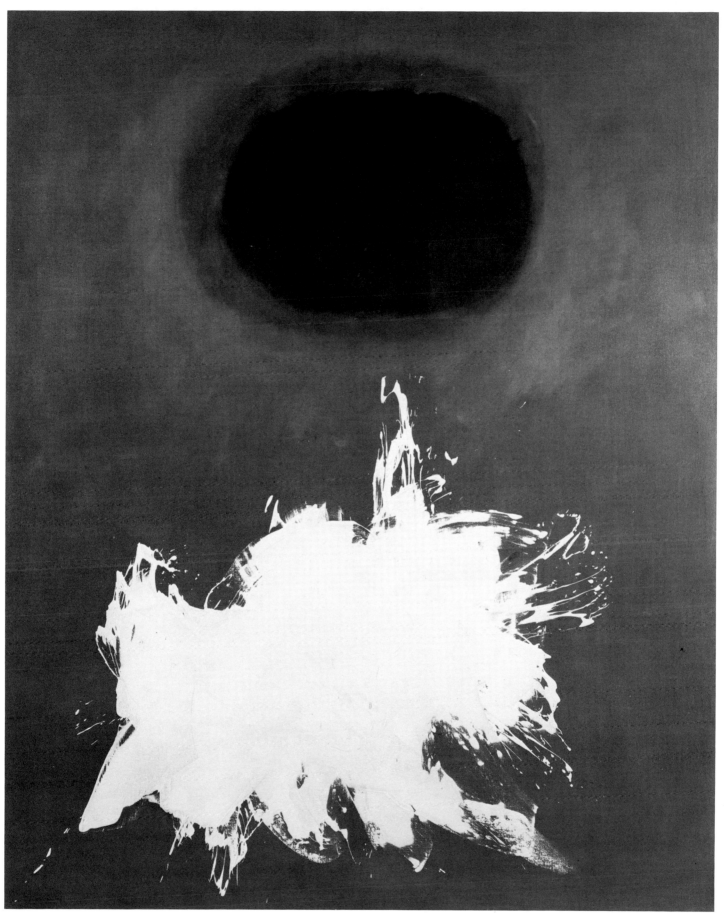

85. SPRAY 1959 oil on canvas 90 x 72"

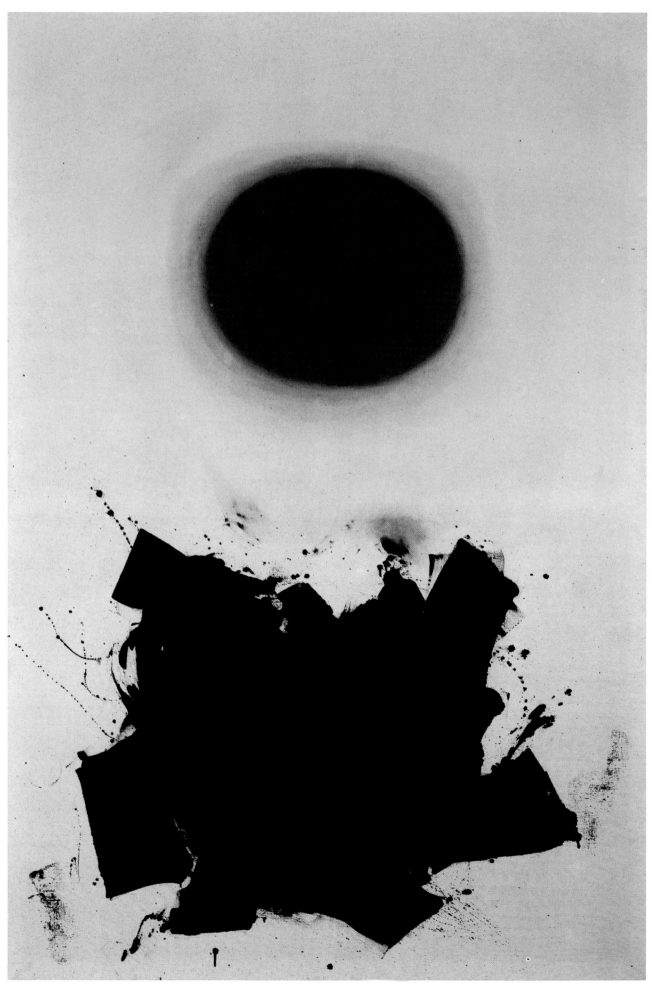

88. JAGGED 1960 oil on canvas 72 x 48″

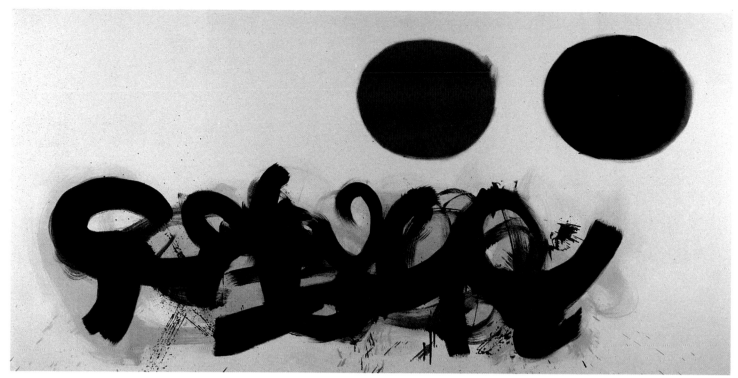

89. DIALOGUE #1 1960 oil on canvas 66 x 132″

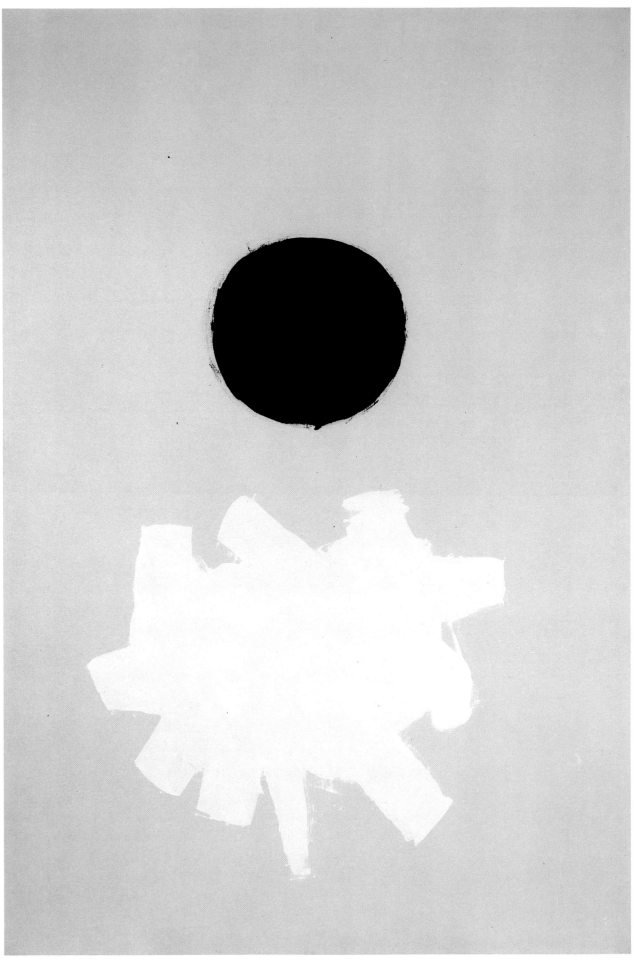

90. BLACK PLUS WHITE 1960 oil on canvas 90 x 60″

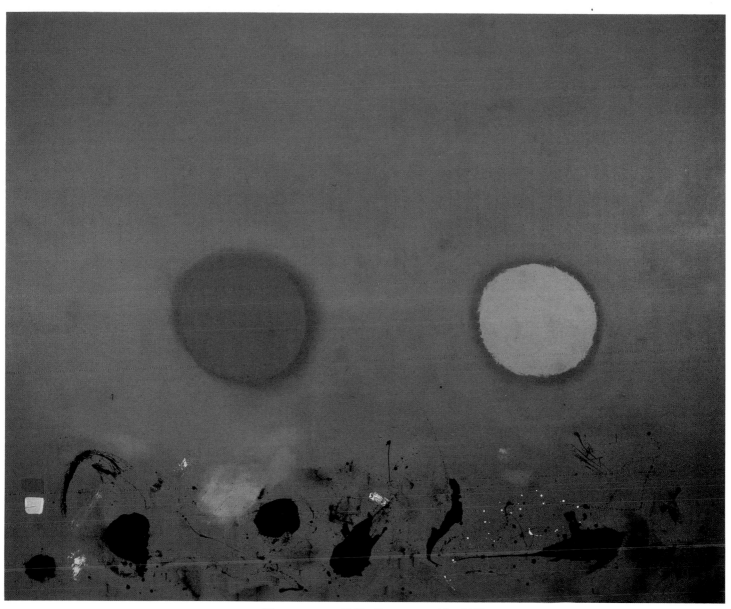

93. TWO DISCS 1963 oil on canvas 90 x 108″

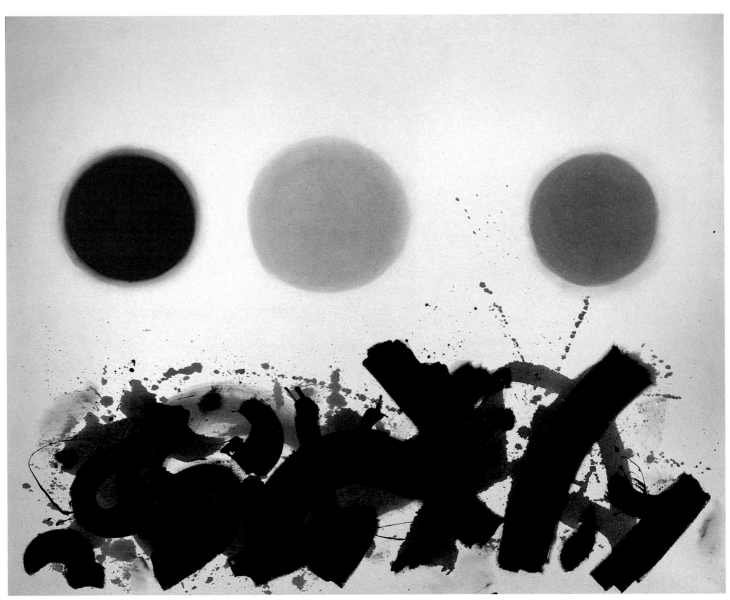

91. APAQUOGUE 1961 oil on canvas 72 x 90″

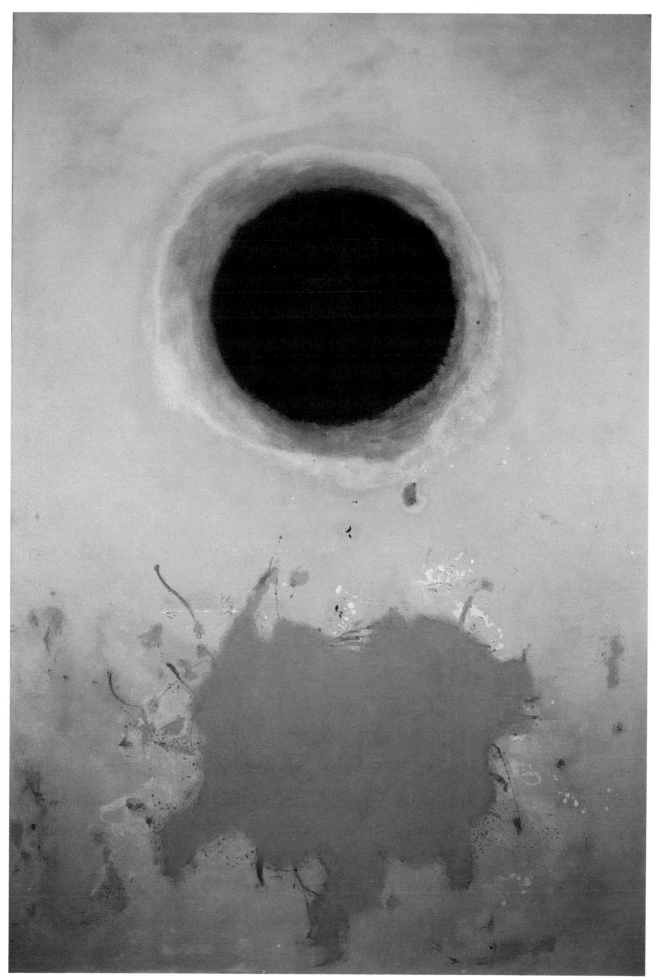

95. DEEP OVER PALE 1964 oil on canvas 90 x 60″

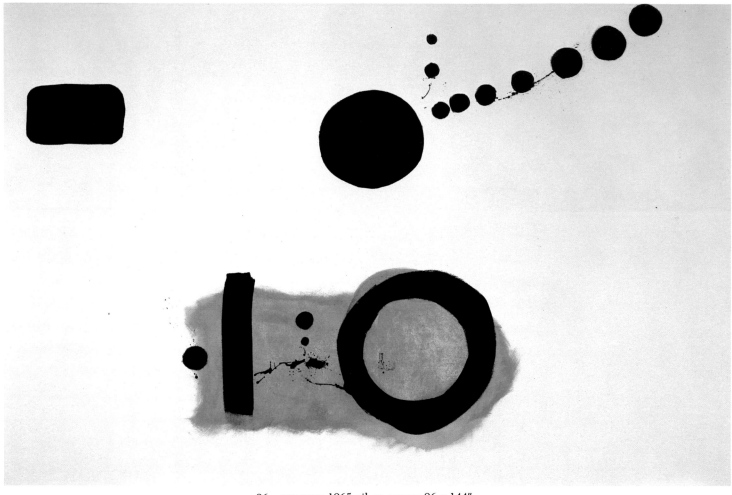

96. AZIMUTH 1965 oil on canvas 96 x 144"

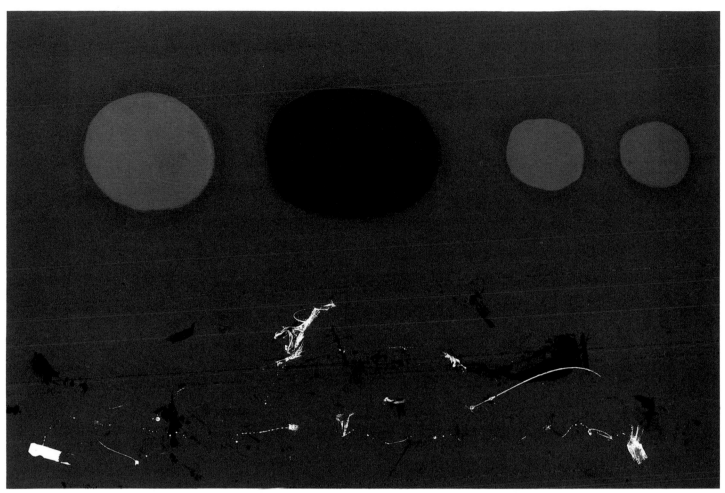

101. FLOTSAM 1968 oil on canvas 48 x 72″

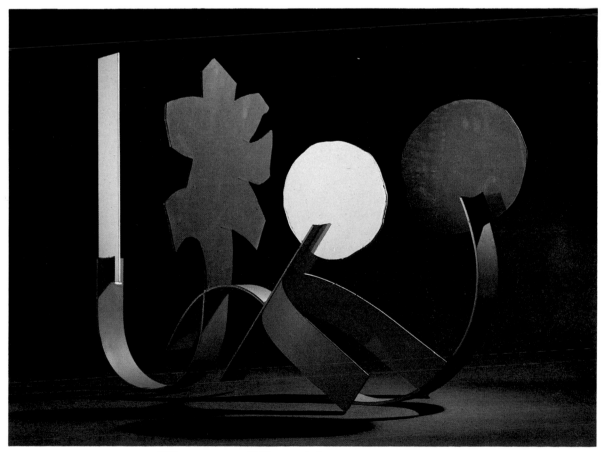

107. ARABESQUE 1968 painted aluminum 37 x 13 x 26½″

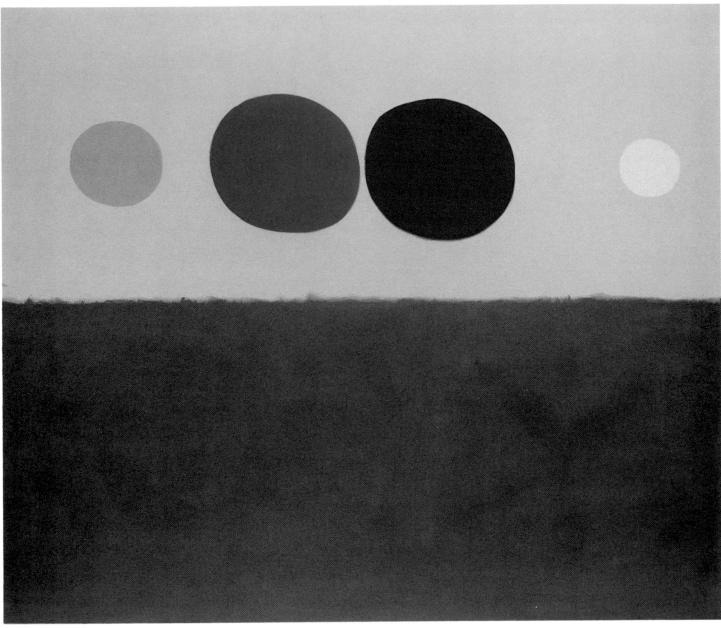

98. PRIMARIES AND GRAY 1967 oil on linen 66 x 78"

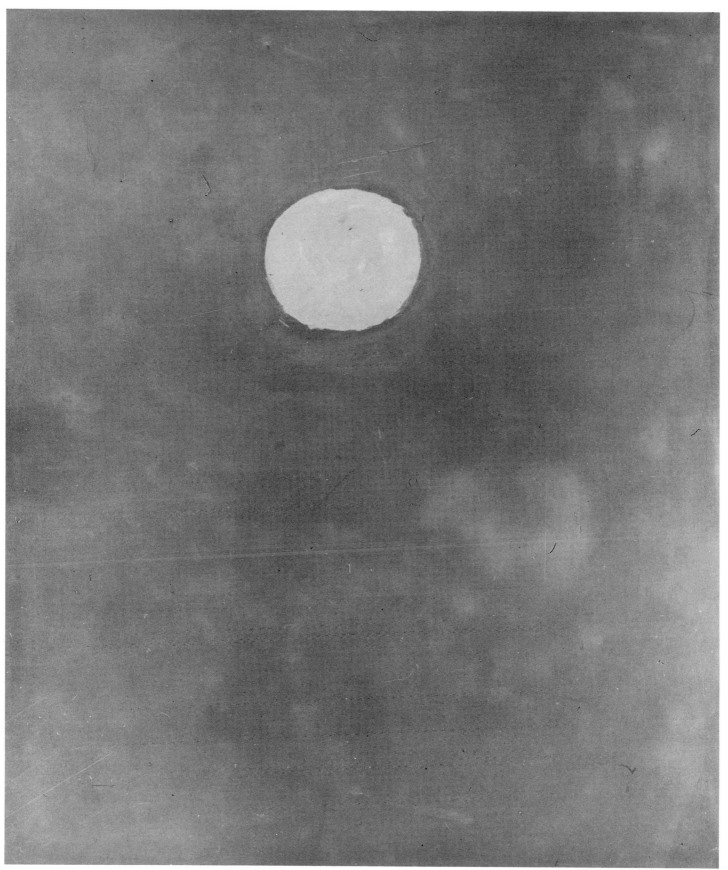

87. UNA 1959 oil on canvas 108 x 90"

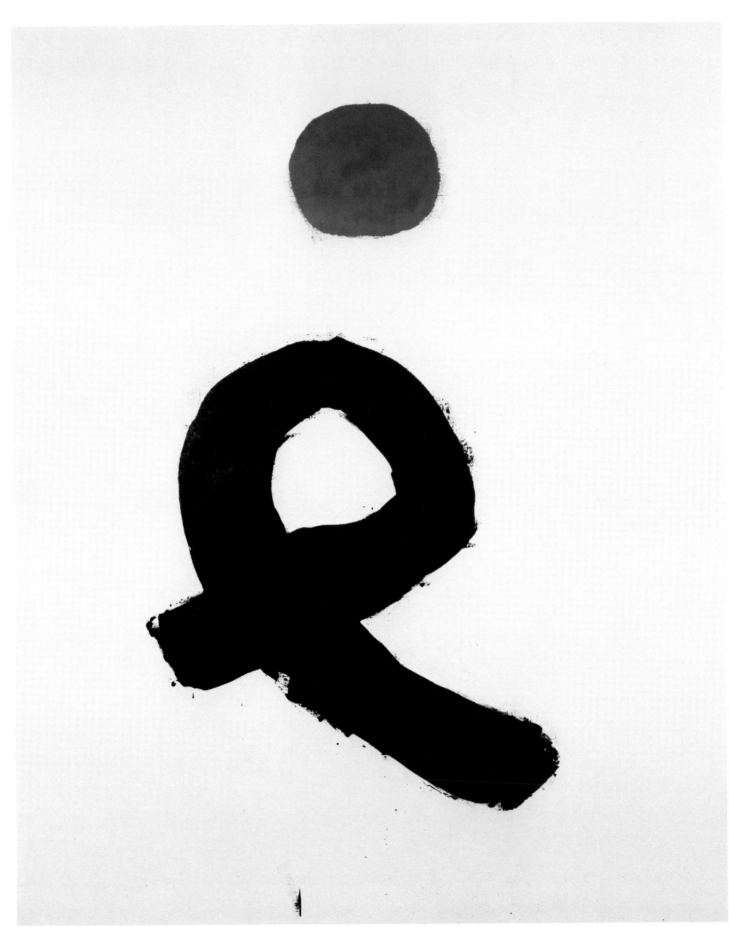

92. SIGN 1962 oil on canvas 90 x 84"

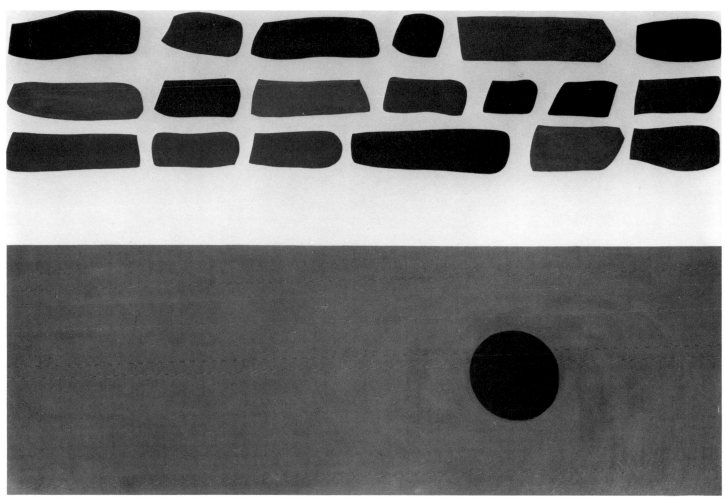

97. UNITS #4 1966 acrylic on canvas 96 x 144″

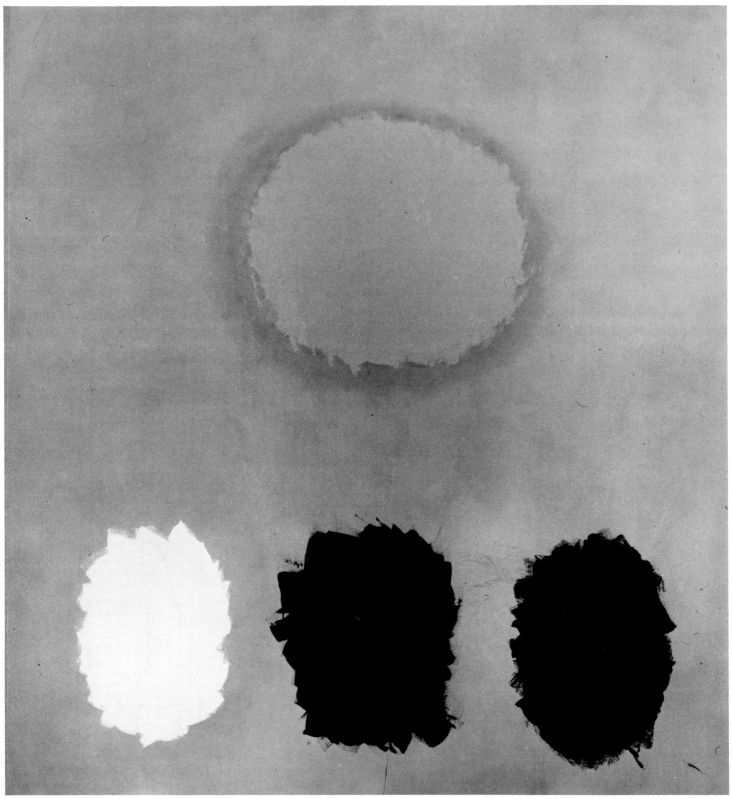

94. EQUINOX 1963 oil on canvas 90 x 84″

148

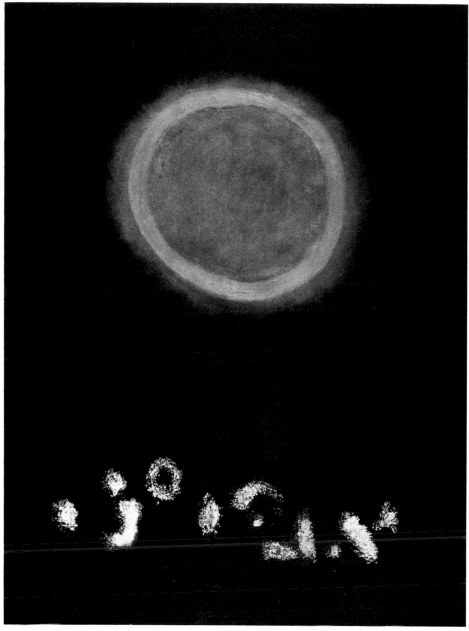

99. WHITE HALO-BLACK GROUND 1967 oil on canvas 40 x 30″

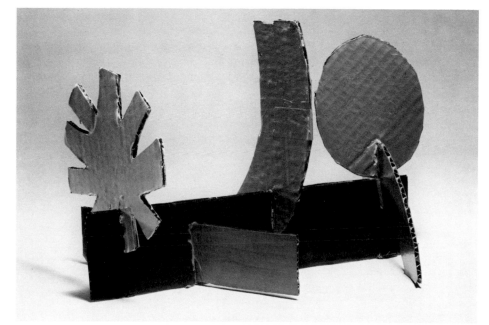

102. TWO ARCS (Maquette) 1968 acrylic on cardboard 8⅝ x 14 x 9″

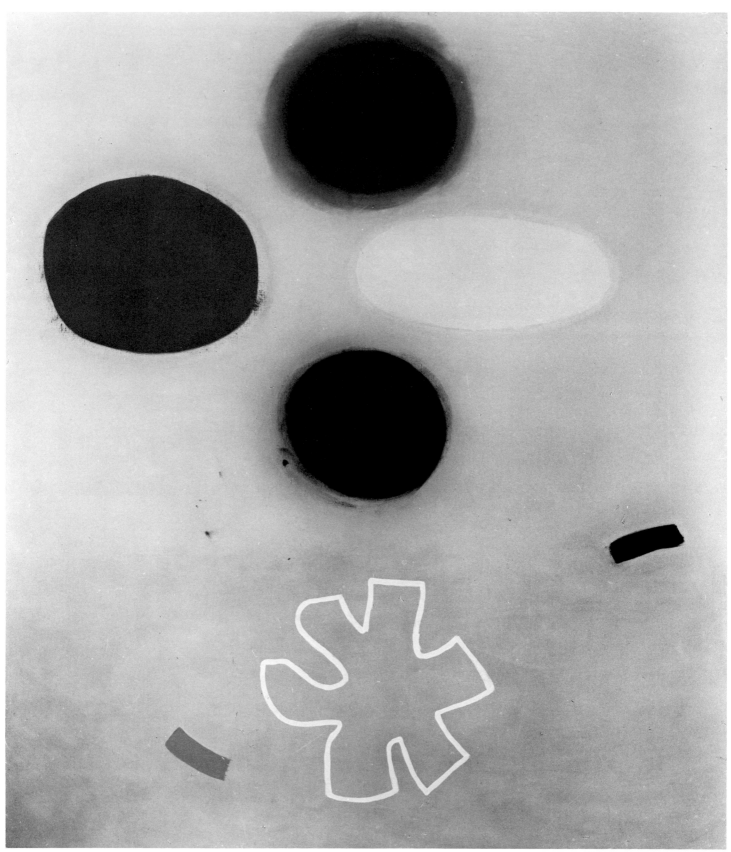

100. WHITE LINE 1968 oil on canvas 78 x 66"

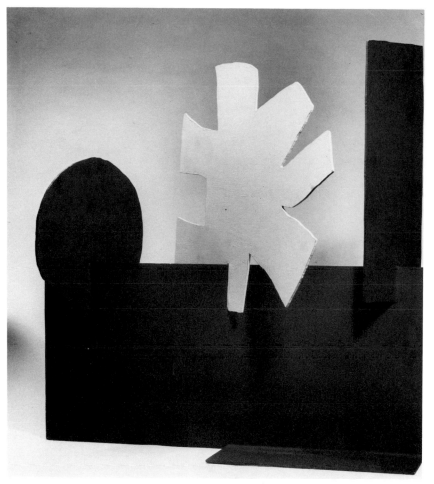

105. PETALOID #1 1968 painted steel 31½ x 12¼ x 31½"

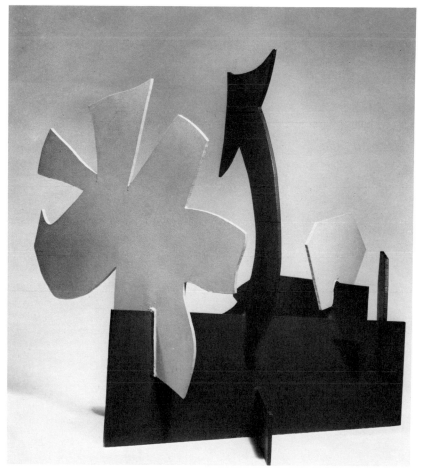

106. PETALOID WITH CURVED ARROW 1968 painted steel 26 x 19½ x 28"

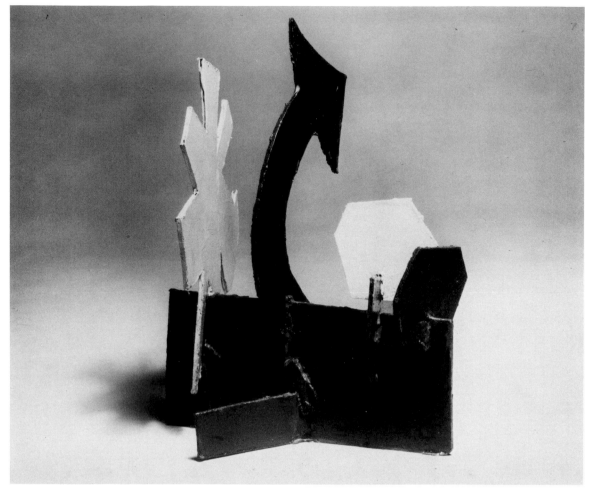

103. PETALOID WITH CURVED ARROW (Maquette) 1968 acrylic on cardboard 9½ x 8¾ x 6¾"

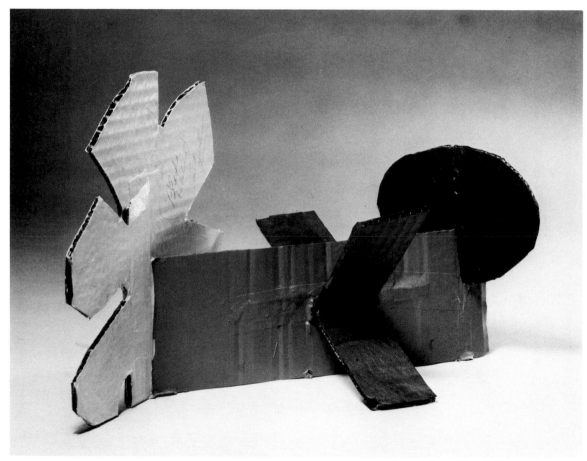

104. UNTITLED (Maquette) 1968 acrylic on cardboard 8¼ x 14 x 8¼"

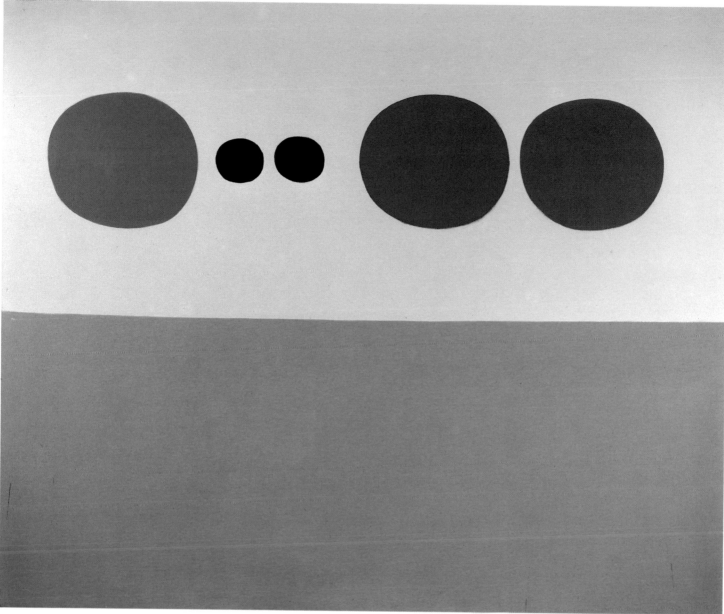

109. POND 1969 oil & acrylic on canvas 90 x 108"

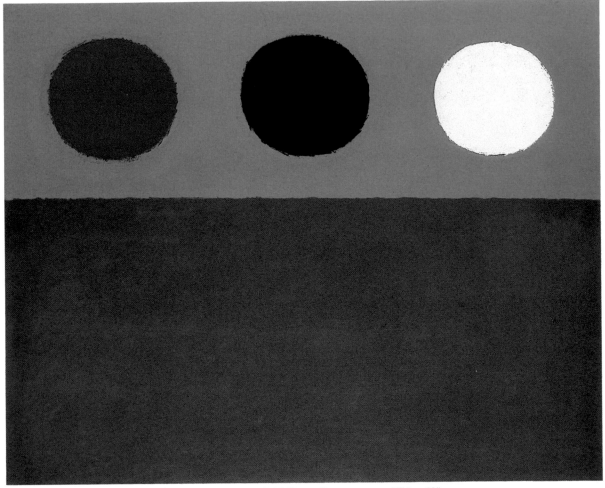

108. LOOMING #2 1969 acrylic on canvas 48⅛ x 60″

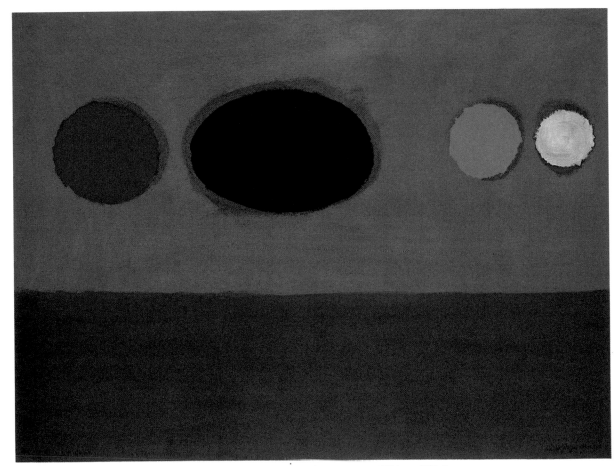

154

112. WARM MOOD 1970 acrylic on paper 30³⁄₁₆ x 40³⁄₁₆″

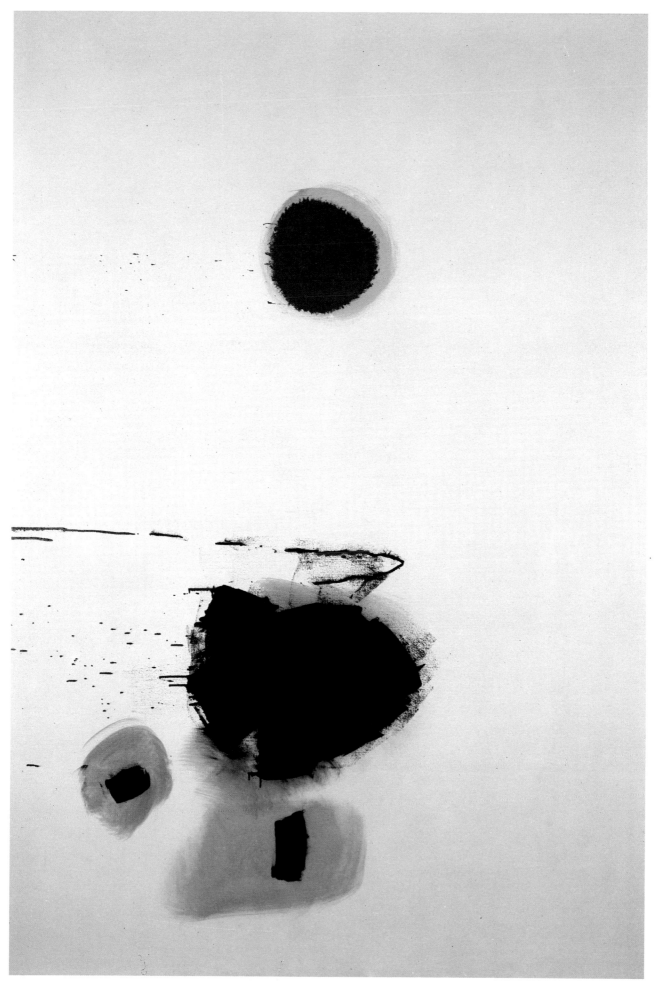

113. BULLET 1971 oil & acrylic on canvas 90 x 60″

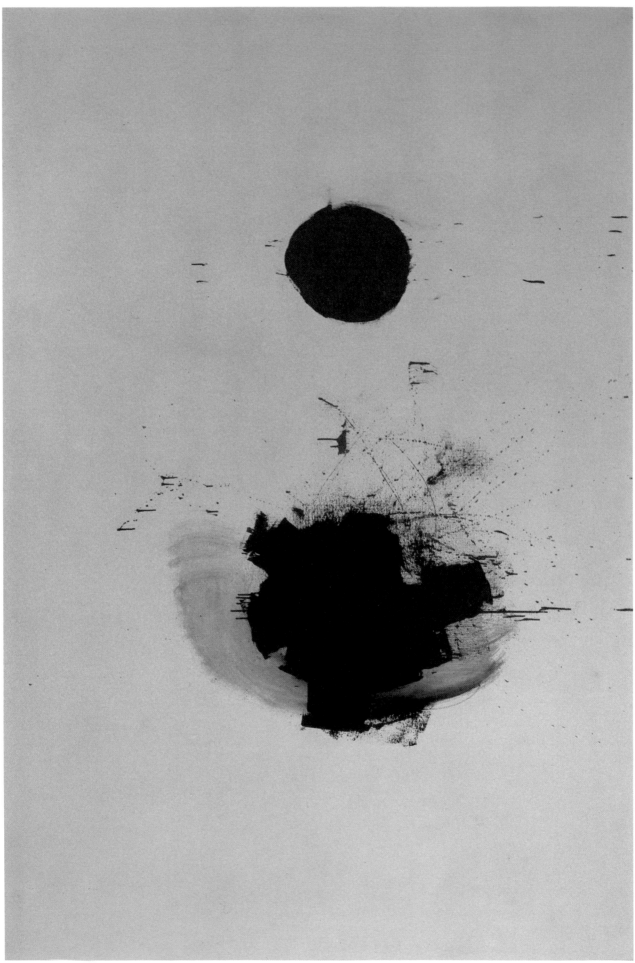

114. COLLISION 1971 oil & acrylic on canvas 90 x 60″

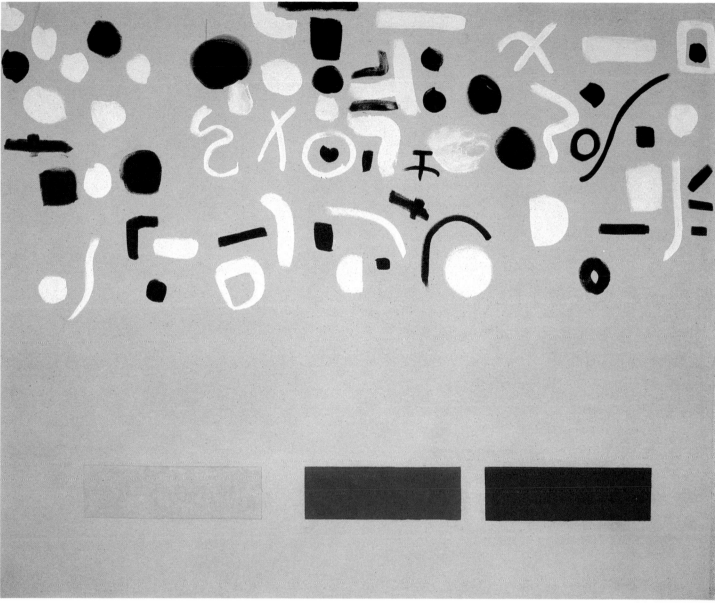

118. OPEN ABOVE 1972 acrylic on canvas 90 x 108"

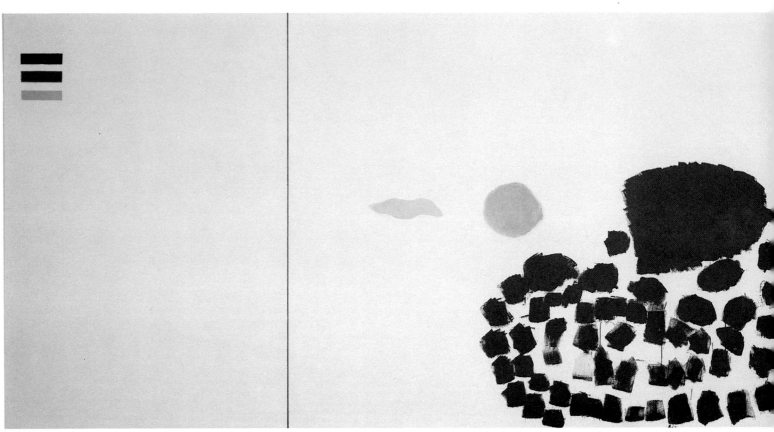

115. TRIPTYCH 1971 acrylic on canvas 90 x 228″

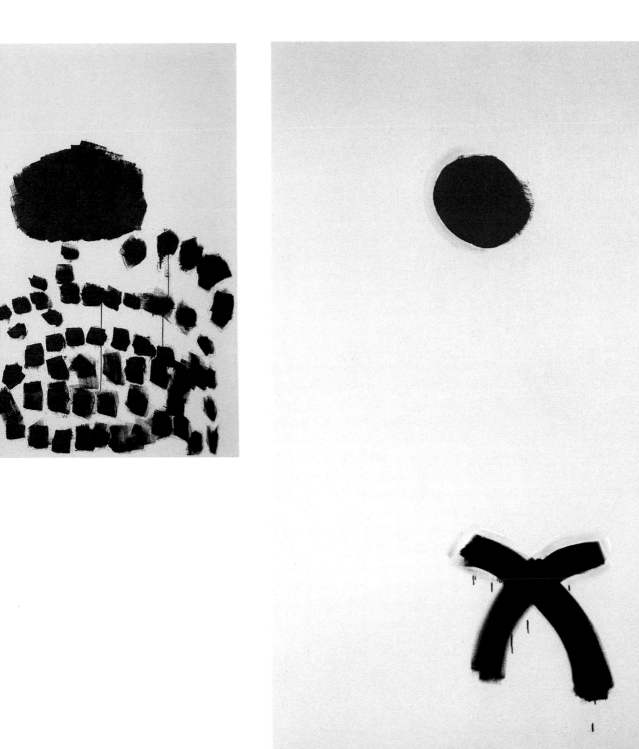

120. SIGN #2 1973 oil & alkyd resin on linen 103⅞ x 71½"

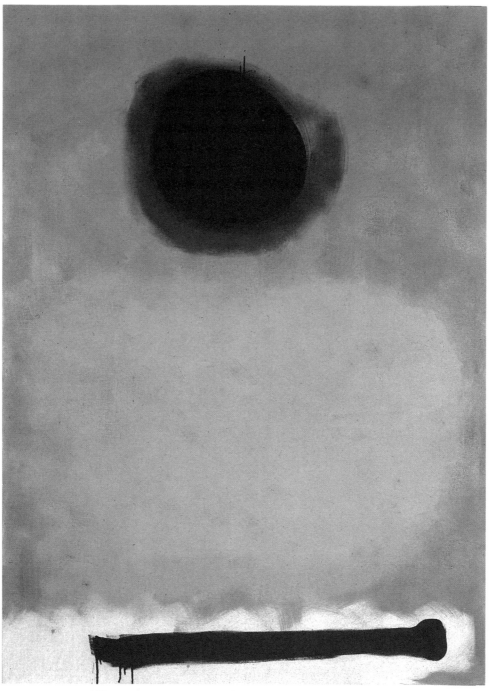

119. AMORPHOUS 1973 acrylic & alkyd resin on canvas 84 x 60″

110. GREEN NOTE 1970 acrylic on paper 40 x 30"

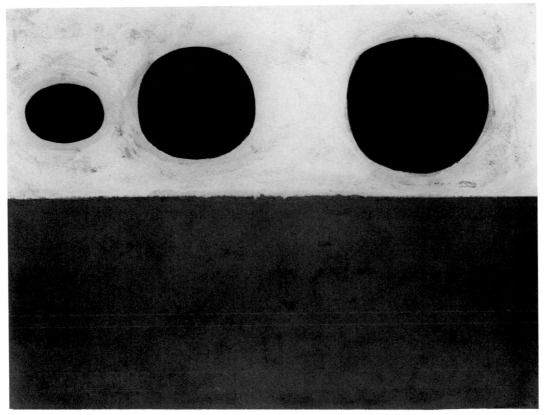

111. YELLOW OCHRE 1970 acrylic on paper 30 x 40"

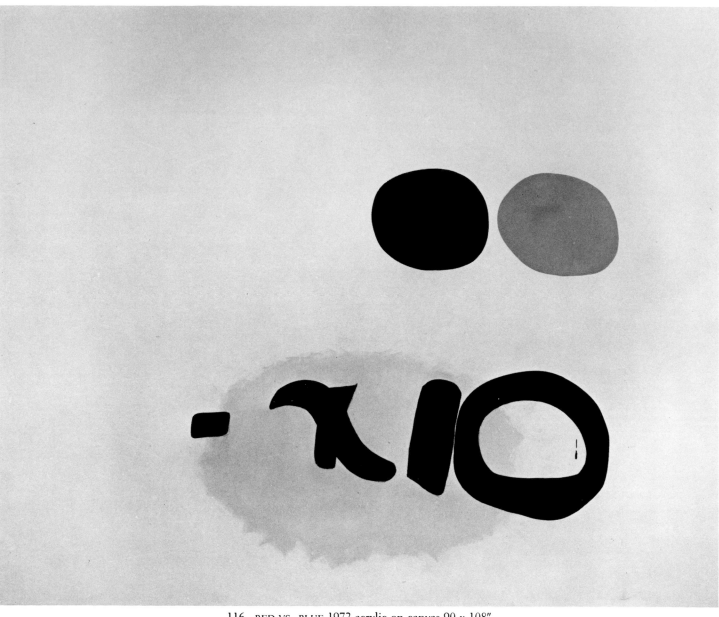

116. RED VS. BLUE 1972 acrylic on canvas 90 x 108″

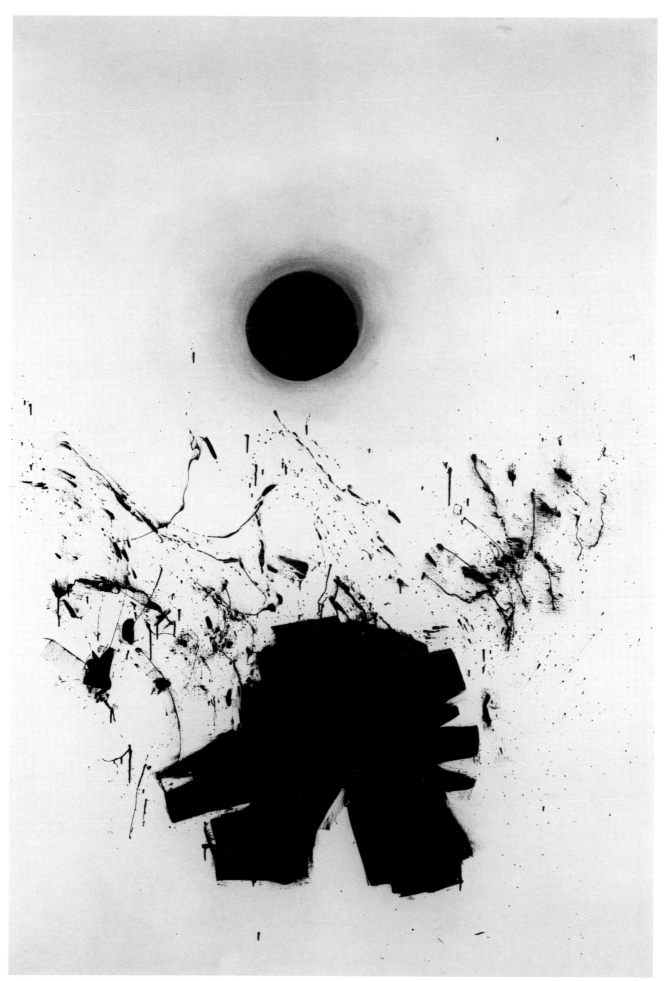

117. BURST II 1972 oil & acrylic on linen 90 x 60″

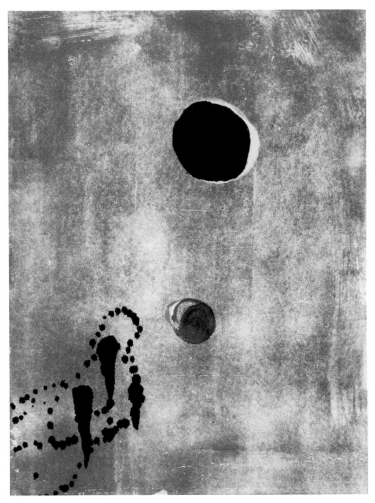

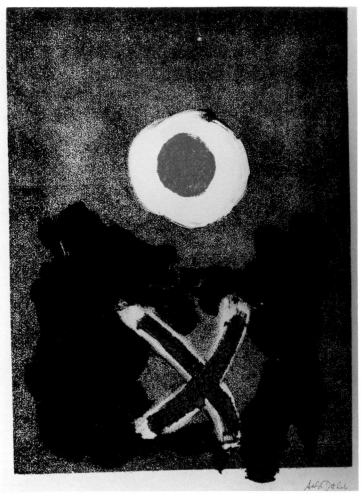

121. UNTITLED (M7310) 1973 monotype in oil & ink on paper
plate size: 18 x 24″

122. UNTITLED (M7319) 1973 monotype in oil & ink on paper
plate size: 18 x 24″

164

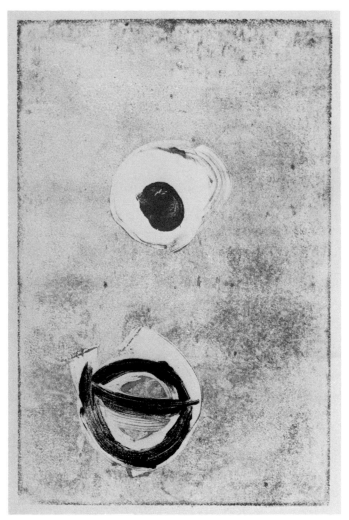

123. UNTITLED (M7409) 1974 monotype in oil & ink on paper
plate size: 12 x 17¾″

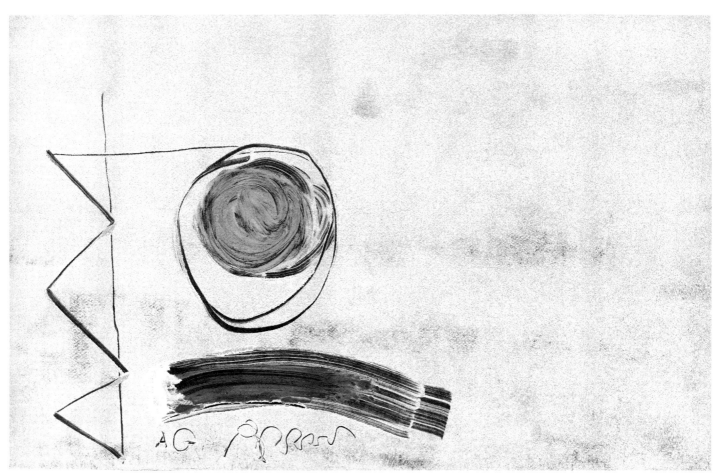

124. UNTITLED (M7416) 1974 monotype in oil & ink on paper
plate size: 19³⁄₁₆ x 29¹³⁄₁₆″

Checklist

1. PORTRAIT ca. 1923 oil on canvas 23⅟₁₆ x 17⅛"
Private Collection

2. STILL LIFE—GATE LEG TABLE 1925 oil on canvas 35⅝ x 24⅞"
Collection: Adolph & Esther Gottlieb Foundation, N.Y.

3. GRAND CONCOURSE ca. 1927 oil on canvas 29⅞ x 23⅞"
Collection: Adolph & Esther Gottlieb Foundation, N.Y.

4. AARON SISKIND ca. 1927 oil on canvas 27⅟₁₆ x 19³⁄₁₆"
Private Collection

5. INTERIOR ca. 1927 oil on canvas 24 x 30"
Collection: Adolph & Esther Gottlieb Foundation, N.Y.

6. SOUTH FERRY WAITING ROOM ca. 1929 oil on cotton 36 x 45"
Private Collection

7. BROOKLYN BRIDGE ca. 1930 oil on canvas 25¹⁵⁄₁₆ x 31¹⁵⁄₁₆"
Private Collection

8. THE WASTELAND 1930 oil on canvas 22 x 34"
Collection: Adolph & Esther Gottlieb Foundation, N.Y.

9. ESTHER 1931 oil on canvas 19 x 24"
Private Collection

10. MAN WITH PIGEONS 1932 oil on linen 14 x 18" Private Collection

11. UNTITLED (PORTRAIT OF EMIL) ca. 1934 oil on canvas 33⅞ x 25¹³⁄₁₆"
Collection: Adolph & Esther Gottlieb Foundation, N.Y.

12. SEATED NUDE 1934 oil on canvas 39⁹⁄₁₆ x 35½"
Collection: Adolph & Esther Gottlieb Foundation, N.Y.

13. SURF CASTING ca. 1935 oil on canvas 19⁷⁄₁₆ x 28⅝"
Private Collection

14. UNTITLED (MAX MARGOLIS) ca. 1935 oil on canvas 26⅜ x 19⅜"
Collection: Adolph & Esther Gottlieb Foundation, N.Y.

15. LUXEMBOURG GARDENS ca. 1936 oil on canvas 27¾ x 35⅞"
Collection: Adolph & Esther Gottlieb Foundation, N.Y.

16. THE SWIMMING HOLE ca. 1937 oil on canvas 25½ x 34¾"
Collection: Adolph & Esther Gottlieb Foundation, N.Y.

17. UNTITLED (ESTHER AT EASEL) 1937 oil on canvas 40 x 36⅛"
Private Collection

18. UNTITLED (PORTRAIT—BLUE BANDANA) ca. 1937 oil on canvas 29¹⁵⁄₁₆ x 23¾"
Private Collection

19. UNTITLED (SELF-PORTRAIT IN MIRROR) ca. 1938 oil on canvas 39⅞ x 29⅝"
Private Collection

20. UNTITLED (PINK STILL LIFE—CURTAIN AND GOURDS) 1938 oil on canvas 30 x 39¾"
Collection: Adolph & Esther Gottlieb Foundation, N.Y.

21. UNTITLED (GREEN STILL LIFE—GOURDS) 1938 oil on canvas 29⅞ x 39¾"
Collection: Adolph & Esther Gottlieb Foundation, N.Y.

22. UNTITLED (STILL LIFE—LANDSCAPE IN WINDOW) 1938 oil on canvas 29⅞ x 39⅞"
Collection: Adolph & Esther Gottlieb Foundation, N.Y.

23. SYMBOLS AND THE DESERT 1938 oil on canvas 39¾ x 35⅞"
Collection: Adolph & Esther Gottlieb Foundation, N.Y.

24. CIRCUS GIRL 1938 oil on canvas 23¾ x 29⅞"
Private Collection

25. CIRCUS PERFORMERS 1938 oil on linen 40 x 36"
Collection: Adolph & Esther Gottlieb Foundation, N.Y.

26. STILL LIFE—ALARM CLOCK 1938 oil on canvas 33⅞ x 25¹¹⁄₁₆"
Collection: Adolph & Esther Gottlieb Foundation, N.Y.

27. UNTITLED (CACTUS STILL LIFE—NEW YORK) 1939 oil on canvas 35¹³⁄₁₆ x 27¹¹⁄₁₆"
Private Collection

28. PICNIC (BOX AND FIGURES) ca. 1939 oil on linen 25⅞ x 33⅞"
Collection: Adolph & Esther Gottlieb Foundation, N.Y.

29. UNTITLED (BOXES ON BEACH AND FIGURE) 1940 oil on canvas 25 x 31⅞"
Collection: Adolph & Esther Gottlieb Foundation, N.Y.

30. UNTITLED (BOX AND SEA OBJECTS) 1940 oil on linen 25 x 31⅞"
Private Collection

31. UNTITLED (STILL LIFE) 1941 oil on canvas 25¹³⁄₁₆ x 24"
Private Collection

32. FEMALE FORMS 1941 oil on canvas 43 x 27"
Private Collection

33. PICTOGRAPH—TABLET FORM 1941 oil on canvas 48 x 36"
Private Collection

34. OEDIPUS 1941 oil on canvas 34 x 26"
Collection: Adolph & Esther Gottlieb Foundation, N.Y.

35. EYES OF OEDIPUS 1941 oil on canvas 32¼ x 25"
Private Collection

36. PICTOGRAPH—SYMBOL 1942 oil on canvas 54 x 40"
Private Collection

37. PICTOGRAPH 1942 oil on canvas 48 x 36"
Collection: Adolph & Esther Gottlieb Foundation, N.Y.

38. PERSEPHONE 1942 oil on canvas 34 x 26"
Private Collection

39. HANDS OF OEDIPUS 1943 oil on canvas 48 x 35¹⁵⁄₁₆"
Collection: Adolph & Esther Gottlieb Foundation, N.Y.

40. PICTOGRAPH #4 1943 oil on canvas 36 x 23"
Collection: Adolph & Esther Gottlieb Foundation, N.Y.

41. BLACK HAND 1943 oil on linen 30 x 26"
Private Collection

42. HOME 1943 oil & pencil on canvas 23⅞ x 19⅞"
Private Collection

43. NOSTALGIA FOR ATLANTIS 1944 oil on canvas 20 x 25"
Private Collection

44. THE RED BIRD 1944 oil on canvas 40 x 30"
Collection: The Solomon R. Guggenheim Museum, New York

45. BIRDS 1945 oil on canvas 54 x 42"
Private Collection

46. ALCHEMIST (RED PORTRAIT) 1945 oil on canvas 34 x 26"
Private Collection

47. EXPECTATION OF EVIL 1945 oil, gouache & tempera on canvas 43 x 27"
Collection: Adolph & Esther Gottlieb Foundation, N.Y.

48. MASQUERADE 1945 oil & egg tempera on canvas 36 x 24"
Private Collection

49. GREEN AND BLUE 1945 oil on canvas 39¾ x 35⅞"
Collection: Adolph & Esther Gottlieb Foundation, N.Y.

50. EVIL OMEN 1946 oil on canvas 38 x 30"
Collection: Neuberger Museum, State University of New York at Purchase; Gift of Roy R. Neuberger

51. WATER, AIR, FIRE 1947 oil on pressed board 30 x 24"
Brandeis University Art Collection, Rose Art Museum, Gift of Mr. & Mrs. Samuel M. Kootz, New York

52. ORACLE 1947 oil on canvas 60 x 44"
Albert A. List Family Collection

53. PICTOGRAPH—HEAVY WHITE LINES 1947 oil on canvas 24¹¹⁄₁₆ x 31¹¹⁄₁₆"
Collection: Adolph & Esther Gottlieb Foundation, N.Y.

54. SOUNDS AT NIGHT 1948 oil & charcoal on linen 48⅛ x 60"
Private Collection

55. LETTER TO A FRIEND 1948 oil, tempera & gouache on canvas 47⅞ x 36¼"
Collection: Adolph & Esther Gottlieb Foundation, N.Y.

56. PICTOGRAPH 1950 gouache & tempera on masonite 23⅞ x 20"
Collection: Adolph & Esther Gottlieb Foundation, N.Y.

57. T—BLACK GROUND 1951 mixed media on canvas 48 x 60"
Collection: Adolph & Esther Gottlieb Foundation, N.Y.

58. FIGURATIONS OF CLANGOR 1951 oil, gouache & tempera on burlap 48⅟₁₆ x 60⅛"
Collection: Adolph & Esther Gottlieb Foundation, N.Y.

59. NIGHT FLIGHT 1951 oil, tempera, casein and gouache on canvas 48 x 35⅞"
Collection: Adolph & Esther Gottlieb Foundation, N.Y.

60. BLACK SILHOUETTE 1949 oil & enamel on canvas 31¾ x 24¾"
Collection: Adolph & Esther Gottlieb Foundation, N.Y.

61. CASTLE 1950 oil & smalts on canvas 30 x 38"
Private Collection

62. INDIAN RED 1950 oil & enamel on masonite 29¹⁵/₁₆ x 23¹⁵/₁₆"
Private Collection

63. LABYRINTH #1 1950 oil on linen 36 x 48"
Private Collection

64. SENTINEL 1951 oil on canvas 60 x 48"
Private Collection

65. UNSTILL LIFE 1952 oil on canvas 36 x 48"
Lent by the Whitney Museum of American Art, New York; Gift of Mr. & Mrs. Alfred Jaretzki Jr., 1956. 56.25

66. THE FROZEN SOUNDS #2 1952 oil on canvas 36 x 48"
Albright-Knox Art Gallery, Buffalo, New York; Gift of Seymour H. Knox, 1956

67. NADIR 1952 oil on canvas 42 x 72"
Private Collection

68. ECLIPSE 1952 oil on canvas 42 x 72"
Private Collection

69. CONSTRUCTION #1 1953 oil & wood on canvas 36 x 47⅝"
Collection: Adolph & Esther Gottlieb Foundation, N.Y.

70. NOCTURNAL BEAMS 1954 oil, enamel & casein on canvas 47¹³/₁₆ x 59⅞"
Collection: Adolph & Esther Gottlieb Foundation, N.Y.

71. LABYRINTH #3 1954 oil on canvas 84 x 192"
Collection: Adolph & Esther Gottlieb Foundation, N.Y.

72. TRAJECTORY 1954 oil & enamel on canvas 39¾ x 49⅞"
Collection: Adolph & Esther Gottlieb Foundation, N.Y.

73. COMPOSITION 1955 oil on canvas 72 x 60"
Museum of Modern Art, New York; Gift of the Artist

74. BLUE AT NOON 1955 oil on canvas 60 x 72"
Collection: Walker Art Center, Minneapolis; Gift of the Artist

75. THE COUPLE 1955 oil & enamel on canvas 72 x 60"
Private Collection

76. UNSTILL LIFE #3 1956 oil on canvas 84 x 192"
Private Collection

77. FOUR RED CLOUDS 1956 oil on canvas 50 x 60"
Private Collection

78. BLACK, BLUE, RED 1956 oil & enamel on linen 72 x 50"
Private Collection

79. BLUE AT NIGHT 1957 oil on canvas 42 x 60"
Collection: Virginia Museum of Fine Arts

80. BIAS PULL 1957 oil on canvas 42 x 60"
Collection: Hirshhorn Museum and Sculpture Garden, Washington, DC

81. BLAST I 1957 oil on canvas 90 x 45"
Museum of Modern Art, New York; Philip Johnson Fund

82. ARGOSY 1958 oil on canvas 90 x 72"
Private Collection

83. TAN OVER BLACK 1958 oil on canvas 108 x 90"
Collection: Adolph & Esther Gottlieb Foundation, N.Y.

84. THE FORM OF THE THING 1958 oil on paper, mounted on canvas 78 x 38"
Private Collection

85. SPRAY 1959 oil on canvas 90 x 72"
Collection: Hirshhorn Museum and Sculpture Garden, Washington, DC

86. AFTERMATH 1959 oil on linen 108 x 90"
Collection: Adolph & Esther Gottlieb Foundation, N.Y.

87. UNA 1959 oil on canvas 108 x 90"
Private Collection

88. JAGGED 1960 oil on canvas 72 x 48"
collection: Mr. Jay Braus, New York

89. DIALOGUE #1 1960 oil on canvas 66 x 132"
Albright-Knox Art Gallery, Buffalo, New York; Gift of Seymour H. Knox, 1961

90. BLACK PLUS WHITE 1960 oil on canvas 90 x 60"
Private Collection

91. APAQUOGUE 1961 oil on canvas 72 x 90"
Collection: Mrs. A. Lasker, New York

92. SIGN 1962 oil on canvas 90 x 84"
Collection: David Mirvish Gallery, Toronto, Ontario, Canada

93. TWO DISCS 1963 oil on canvas 90 x 108"
Collection: Hirshhorn Museum and Sculpture Garden, Washington, DC

94. EQUINOX 1963 oil on canvas 90 x 84"
The Phillips Collection, Washington, DC

95. DEEP OVER PALE 1964 oil on canvas 90 x 60"
Collection: Mr. & Mrs. Gilbert H. Kinney, Washington, DC

96. AZIMUTH 1965 oil on canvas 96 x 144"
Collection: Adolph & Esther Gottlieb Foundation, N.Y.

97. UNITS #4 1966 acrylic on canvas 96 x 144"
Collection: Adolph & Esther Gottlieb Foundation, N.Y.

98. PRIMARIES AND GRAY 1967 oil on linen 66 x 78"
Collection: Adolph & Esther Gottlieb Foundation, N.Y.

99. WHITE HALO-BLACK GROUND 1967 oil on canvas 40 x 30"
Collection: Mr. & Mrs. Herman Neumann

100. WHITE LINE 1968 oil on canvas 78 x 66"
Collection: Gertrude Kasle

101. FLOTSAM 1968 oil on canvas 48 x 72"
Collection: Adolph & Esther Gottlieb Foundation, N.Y.

102. TWO ARCS (Maquette) 1968 acrylic on cardboard 8⅝ x 14 x 9"
Private Collection

103. PETALOID WITH CURVED ARROW (Maquette) 1968 acrylic on cardboard 9½ x 8¾ x 6¾"
Private Collection

104. UNTITLED (Maquette) 1968 acrylic on cardboard 8¼ x 14 x 8¼"
Private Collection

105. PETALOID #1 1968 painted steel 31½ x 12¼ x 31½"
Collection: Adolph & Esther Gottlieb Foundation, N.Y.

106. PETALOID WITH CURVED ARROW 1968 painted steel 26 x 19½ x 28"
Private Collection

107. ARABESQUE 1968 painted aluminum 37 x 13 x 26½"
Private Collection

108. LOOMING #2 1969 acrylic on canvas 48⅛ x 60"
Collection: Adolph & Esther Gottlieb Foundation, N.Y.

109. POND 1969 oil & acrylic on canvas 90 x 108"
Collection: Adolph & Esther Gottlieb Foundation, N.Y.

110. GREEN NOTE 1970 acrylic on paper 40 x 30"
Collection: Adolph & Esther Gottlieb Foundation, N.Y.

111. YELLOW OCHRE 1970 acrylic on paper 30 x 40"
Collection: Adolph & Esther Gottlieb Foundation, N.Y.

112. WARM MOOD 1970 acrylic on paper 30³/₁₆ x 40³/₁₆"
Collection: Adolph & Esther Gottlieb Foundation, N.Y.

113. BULLET 1971 oil & acrylic on canvas 90 x 60"
Collection: Mr. A. Steinberg, Montreal

114. COLLISION 1971 oil & acrylic on canvas 90 x 60"
Collection: Adolph & Esther Gottlieb Foundation, N.Y.

115. TRIPTYCH 1971 acrylic on canvas 90 x 228"
Private Collection

116. RED VS. BLUE 1972 acrylic on canvas 90 x 108"
Collection: Adolph & Esther Gottlieb Foundation, N.Y.

117. BURST II 1972 oil & acrylic on linen 90 x 60"
Collection: Adolph & Esther Gottlieb Foundation, N.Y.

118. OPEN ABOVE 1972 acrylic on canvas 90 x 108"
Private Collection

119. AMORPHOUS 1973 acrylic & alkyd resin on canvas 84 x 60"
Private Collection

120. SIGN #2 1973 oil & alkyd resin on linen 103⅞ x 71½"
Collection: Adolph & Esther Gottlieb Foundation, N.Y.

121. UNTITLED (M7310) 1973 monotype in oil & ink on paper plate size: 18 x 24"
Collection: Adolph & Esther Gottlieb Foundation, N.Y.

122. UNTITLED (M7319) 1973 monotype in oil & ink on paper plate size: 18 x 24"
Collection: Adolph & Esther Gottlieb Foundation, N.Y.

123. UNTITLED (M7409) 1974 monotype in oil & ink on paper plate size: 12 x 17¾"
Collection: Adolph & Esther Gottlieb Foundation, N.Y.

124. UNTITLED (M7416) 1974 monotype in oil & ink on paper plate size: 19³/₁₆ x 29¹³/₁₆"
Private Collection

Appendix A.

The following statements are typescripts from original documents; spelling and punctuation are that of the original authors.

Adolph Gottlieb and Mark Rothko (with the assistance of Barnett Newman), Letter to Edward Alden Jewell, Art Editor, *The New York Times*, June 7, 1943.

June 7, 1943

Mr. Edward Alden Jewell
Art Editor, New York Times
229 West 43 Street
New York, N. Y.

Dear Mr. Jewell:

To the artist, the workings of the critical mind is one of life's mysteries. That is why, we suppose, the artist's complaint that he is misunderstood, especially by the critic, has become a noisy commonplace. It is therefore, an event when the worm turns and the critic of the TIMES quietly yet publicly confesses his "befuddlement," that he is "non-plussed" before our pictures at the Federation Show. We salute this honest, we might say cordial reaction towards our "obscure" paintings, for in other critical quarters we seem to have created a bedlam of hysteria. And we appreciate the gracious opportunity that is being offered us to present our views.

We do not intend to defend our pictures. They make their own defense. We consider them clear statements. Your failure to dismiss or disparage them is prima facie evidence that they carry some communicative power.

We refuse to defend them because we cannot. It is an easy matter to explain to the befuddled that "The Rape of Persephone" is a poetic expression of the essence of the myth; the presentation of the concept of seed and its earth with all its brutal implications; the impact of elemental truth. Would you have us present this abstract concept with all its complicated feelings by means of a boy and girl lightly tripping?

It is just as easy to explain "The Syrian Bull", as a new interpretation of an archaic image, involving unprecedented distortions. Since art is timeless, the significant rendition of a symbol, no matter how archaic, has as full validity today as the archaic symbol had then. Or is the one 3000 years old truer?

But these easy program notes can help only the simple-minded. No possible set of notes can explain our paintings. Their explanation must come out of a consummated experience between picture and onlooker. The appreciation of art is a true marriage of minds. And in art, as in marriage, lack of consummation is ground for annulment.

The point at issue, it seems to us, is not an "explanation" of the paintings but whether the intrinsic ideas carried within the frames of these pictures have significance.

We feel that our pictures demonstrate our aesthetic beliefs, some of which we, therefore, list:

1. To us art is an adventure into an unknown world, which can be explored only by those willing to take the risks.

2. This world of the imagination is fancy-free and violently opposed to common sense.

3. It is our function as artists to make the spectator see the world our way—not his way.

4. We favor the simple expression of the complex thought. We are for the large shape because it has the impact of the unequivocal. We wish to reassert the picture plane. We are for flat forms because they destroy illusion and reveal truth.

5. It is a widely accepted notion among painters that it does not matter what one paints as long as it is well painted. This is the essence of academicism. There is no such thing as good painting about nothing. We assert that the subject is crucial and only that subject matter is *valid which is tragic and timeless*. That is why we profess spiritual kinship with primitive and archaic art.

Consequently if our work embodies these beliefs, it must insult anyone who is spiritually attuned to interior decoration; pictures for the home; pictures for over the mantle; pictures of the American scene; social pictures; purity in art; prize-winning potboilers; the National Academy, the Whitney Academy, the Corn Belt Academy; buckeyes; trite tripe; etc.

Sincerely yours,

Adolph Gottlieb *[signature]*
Marcus Rothko *[signature]*

130 State Street
Brooklyn, New York

Appendix B

Adolph Gottlieb and Mark Rothko, "The Portrait and the Modern Artist," typescript of a broadcast on "Art in New York," Radio WNYC, October 13, 1943.

ADOLPH GOTTLIEB: We would like to begin by reading part of a letter that has just come to us:

"The portrait has always been linked in my mind with a picture of a person. I was therefore surprized to see your paintings of mythological characters, with their abstract rendition, in a portrait show, and would therefore be very much interested in your answers to the following—"

Now, the questions that this correspondent asks are so typical and at the same time so crucial that we feel that in answering them we shall not only help a good many people who may be puzzled by our specific work but we shall best make clear our attitude as modern artists concerning the problem of the portrait, which happens to be the subject of today's talk. We shall therefore, read the four questions and attempt to answer them as adequately as we can in the short time we have. Here they are:

1 Why do you consider these pictures to be portraits?
2 Why do you as modern artists use mythological characters?
3 Are not these pictures really abstract paintings with literary titles?
4 Are you not denying modern art when you put so much emphasis on subject matter?

Now, Mr. Rothko, would you like to tackle the first question? Why do you consider these pictures to be portraits?

MR. ROTHKO: The word portrait cannot possibly have the same meaning for us that it had for past generations. The modern artist has, in varying degrees, detached himself from appearance in nature, and therefore, a great many of the old words, which have been retained as nomenclature in art have lost their old meaning. The still life of Braque and the landscapes of Lurcat have no more relationship to the conventional still life and landscape than the double images of Picasso have to the traditional portrait. New Times! New Ideas! New Methods!

Even before the days of the camera there was a definite distinction between portraits which served as historical or family memorials and portraits that were works of art. Rembrandt knew the difference; for, once he insisted upon painting works of art, he lost all his patrons. Sargent, on the other hand, never succeeded in creating either a work of art or in losing a patron—for obvious reasons.

There is, however, a profound reason for the persistence of the word 'portrait' because the real essence of the great portraiture of all time is the artist's eternal interest in the human figure, character and emotions—in short in the human drama. That Rembrandt expressed it by posing a sitter is irrelevant. We do not know the sitter but we are intensely aware of the drama. The Archaic Greeks, on the other hand used as their models the inner visions which they had of their gods. And in our day, our visions are the fulfillment of our own needs.

It must be noted that the great painters of the figure had this in common. Their portraits resemble each other far more than they recall the peculiarities of a particular model. In a sense they have painted one character in all their work. This is equally true of rembrandt, the Greeks or Modigliani, to pick someone closer to our own time. The Romans, on the other hand, whose portraits are facsimiles of appearance never approached art at all. What is indicated here is that the artist's real model is an ideal which embraces all of human drama rather than the appearance of a particular individual.

Today the artist is no longer constrained by the limitation that all of man's experience is expressed by his outward appearance. Freed from the need of describing a particular person, the possibilities are endless. The whole of man's experience becomes his model, and in that sense it can be said that all of art is a portrait of an idea.

MR. GOTTLIEB: That last point cannot be overemphasized. Now, I'll take the second question and relieve you for a moment. The question reads "Why do you as modern artists use mythological characters?"

I think that anyone who looked carefully at my portrait of Oedipus, or at Mr. Rothko's Leda will see that this is not mythology out of Bulfinch. The implications here have direct application to life, and if the presentation seems strange, one could without exaggeration make a similar comment on the life of our time.

What seems odd to me, is that our subject matter should be questioned, since there is so much precedent for it. Everyone knows that Grecian myths were frequently used by such diverse painters as Rubens, Titian, Veronese and Velasquez, as well as by Renoir and Picasso more recently.

It may be said that these fabulous tales and fantastic legends are unintelligible and meaningless today, except to an anthropologist or student of myths. By the same token the use of any subject matter which is not perfectly explicit either in past or contemporary art might be considered obscure. Obviously this is not the case since the artistically literate person has no difficulty in grasping the meaning of Chinese, Egyptian, African, Eskimo, Early Christian, Archaic Greek or even pre-historic art, even though he has but a slight acquaintance with the religious or superstitious beliefs of any of these peoples.

The reason for this is simply, that all genuine art forms utilize images that can be readily apprehended by anyone acquainted with the global language of art. That is why we use images that are directly communicable to all who accept art as the language of the spirit, but which appear as private symbols to those who wish to be provided with information or commentary.

And now Mr. Rothko you may take the next question. Are not these pictures really abstract paintings with literary titles?

MR. ROTHKO: Neither Mr. Gottlieb's painting nor mine should be considered abstract paintings. It is not their intention either to create or to emphasize a formal color—space arrangement. They depart from natural representation only to intensify the expression of the subject implied in the title—not to dilute or efface it.

If our titles recall the known myths of antiquity, we have used them again because they are the eternal symbols upon which we must fall back to express basic psychological ideas. They are the symbols of man's primitive fears and motivations, no matter in which land or what time, changing only in detail but never in substance, be they Greek, Aztec, Icelandic, or Egyptian. And modern psychology finds them persisting still in our dreams, our vernacular, and our art, for all the changes in the outward conditions of life.

Our presentation of these myths, however, must be in our own terms, which are at once more primitive and more modern than the myths themselves—more primitive because we seek the primeval and atavistic roots of the idea rather than their graceful classical version; more modern than the myths themselves because we must redescribe their implications through our own experience. Those who think that the world of today is more gentle and graceful than the primeval and predatory passions from which these myths spring, are either not aware of reality or do not wish to see it in art. The myth holds us, therefore, not thru its romantic flavor, not thru the remembrance of the beauty of some bygone age, not thru the possibilities of fantasy, but because it expresses to us something real and existing in ourselves, as it was to those who first stumbled upon the symbols to give them life. And now Mr. Gottlieb, will you take the final question? Are you not denying modern art when you put so much emphasis on subject matter?

MR. GOTTLIEB: It is true that modern art has severely limited subject matter in order to exploit the technical aspects of painting. This has been done with great brilliance by a number of painters, but it is generally felt today that this emphasis on the mechanics of picture making has been carried far enough. The surrealists have asserted their belief in subject matter but to us it is not enough to illustrate dreams.

While modern art got its first impetus thru discovering the forms of primitive art, we feel that its true significance lies not merely in formal arrangements, but in the spiritual meaning underlying all archaic works.

That these demonic and brutal images fascinate us today, is not because they are exotic, nor do they make us nostalgic for a past which seems enchanting because of its remoteness. On the contrary, it is the immediacy of their images that draws us irresistibly to the fancies, the superstitions, the fables of savages and the strange beliefs that were so vividly articulated by primitive man.

If we profess a kinship to the art of primitive men, it is because the feelings they expressed have a particular pertinence today. In times of violence, personal predilections for niceties of color and form seem irrelevant. All primitive expression reveals the constant awareness of powerful forces, the immediate presence of terror and fear, a recognition and acceptance of the brutality of the natural world as well as the eternal insecurity of life.

That these feelings are being experienced by many people thruout the world today is an unfortunate fact, and to us an art that glosses over or evades these feelings, is superficial or meaningless. That is why we insist on subject matter, a subject matter that embraces these feelings and permits them to be expressed.

A Selected Bibliography

This bibliography is expanded and updated from the bibliography by Patricia FitzGerald Mandel in Robert Doty and Diane Waldman, *Adolph Gottlieb*, exhib. cat. (The Solomon R. Guggenheim Museum, New York, 1968), pp. 116–121.

This bibliography is divided into two sections: Adolph Gottlieb and General. In the first section are statements by the artist, interviews with the artist, letters, and archival material. In the second section are books, catalogues, and articles on related topics in modern art, focusing on The New York School. Items are arranged alphabetically except where otherwise noted.

I. Adolph Gottlieb

A. Statements by the Artist (chronological)

Gottlieb, Adolph and Rothko, Mark. Letter to the Editor in Jewell, Edward Alden. "The Realm of Art: A New Platform and Other Matters: 'Globalism' Pops Into View." *The New York Times*, June 13, 1943, p. 9, see appendix.

———. The Portrait and the Modern Artist. Typescript of a radio broadcast on WNYC, "Art in New York," Program Director Hugh Stix, October 13, 1943, see appendix.

Gottlieb, Adolph. in Janis, Sidney. *Abstract and Surrealist Art in America*. New York: Reynal and Hitchcock, 1944, p. 119.

———. *Personal Statement: A Painting Prophecy—1950*. The David Porter Gallery, Washington, D.C., May 14–July 7, 1945.

———. "New York Exhibitions." *Limited Editions*, No. 5, December 1945, pp. 4, 6.

———. Letter to the Art Editor, *The New York Times*, July 22, 1945.

———. "The Ides of Art: The Attitudes of Ten Artists on Their Art and Contemporaneousness." *The Tiger's Eye*, I, No. 2, December 1947, p. 43.

———. Unintelligibility. Typescript from the forum The Artist Speaks, Museum of Modern Art, May 5, 1948, pp. 1–4, The Adolph and Esther Gottlieb Foundation, New York.

———. "The Ides of Art: Eleven Graphic Artists Write." *The Tiger's Eye*, I, No. 8, June 1949, p. 52.

———. *Selected Paintings by the Late Arshile Gorky*. Kootz Gallery, New York, March 28–April 24, 1950.

———. in *American Vanguard Art for Paris*. Sidney Janis Gallery, New York, December 26, 1951–January 5, 1952.

———. in *Forty American Painters, 1940–1950*. University of Minnesota, Minneapolis. June 4–August 30, 1951.

———. *Modern Artists in America*. Eds. Robert Motherwell and Ad Reinhardt. Ser. I, New York: Wittenborn-Schultz, 1951, pp. 9–10, 17–22, Sec. rpt. in *New York School: The First Generation, Paintings of the 1940s and 1950s*. Ed. Maurice Tuchman. Greenwich: New York Graphic Society Ltd., 1965, pp. 33–41.

———. "My Painting." *Arts and Architecture*, 68, No. 9, Spring 1951, p. 21.

———. in *Contemporary American Painting and Sculpture*. Urbana: University of Illinois, 1955, p. 202.

———. in *The New Decade: Thirty-Five American Painters and Sculptors*. Ed John I.H. Baur. New York: The Whitney Museum of American Art, 1955, pp. 34–36.

———. "Integrating the Arts." *Interiors*, 114, June 1955, pp. 20, 171.

———. "Letters to the Editor." *College Art Journal*, 14, Summer 1955, p. 373.

———. "Artist and Society: A Brief Case History." *College Art Journal*, 14, Winter 1955, pp. 96–101. Rev. from "The Artist and the Public." *Art in America*, 42, No. 4, December 1954, pp. 267–272.

———. in Baur, J.I.H. *Bradley Walker Tomlin*. New York: The MacMillan Company, 1957, pp. 26–28.

———. in Baur, J.I.H. *Nature in Abstraction*. New York: The MacMillan Company, 1958, p. 58.

———. in *The New American Painting*. New York: International Council at The Museum of Modern Art, 1959, p. 36.

———. in Talese, Gay. "Stevenson Studying Abstract Art." *The New York Times*, December 23, 1959.

———. "Representational or Abstract?" *Junior League Magazine*, 50, November–December 1962, p. 2.

———. *Adolph Gottlieb: Estados Unidos da America*. VII Bienal do Museu de Arte Moderna, Sao Paulo, 1963, pp. 6–29.

———. "Postcards from Adolph Gottlieb." *Location*, I, Summer 1964, pp. 19–26.

———. in Willard, Charlotte. "In the Art Galleries." *New York Post*, January 10, 1965, p. 20.

———. Meeting of the International Association of Art Critics. Unpublished typescript of a tape recording, Metropolitan Museum of Art, May 22, 1959. Archives of American Art, Smithsonian Institution, Washington, D.C.

———. Art Education Forum. Unpublished typescript of a tape recording, New York University, 1965.

———. in Gruen, John. *The Party's Over Now: Reminiscences of the Fifties*. New York: The Viking Press, 1967.

———. Questions for Artists Employed on the WPA Federal Art Project in New York City and State. New Deal Research Project, March 5, 1968, Archhives of American Art, Smithsonian Institution, Washington, D.C.

———. in Hudson, Andrew. "Gottlieb Finds Today's Shock-Proof Audience Dangerous." *Washington Post*, July 31, 1966.

———. "Jackson Pollock: An Artists' Symposium." *Art News*, 66, April 1967, p. 31.

———. in Varian, Elayne. *Twenty-One Over Sixty*. Museum Section, Guild Hall, East Hampton, July 21–August 12, 1973, n. pag.

B. Interviews with Gottlieb (chronological)

Celentano, Francis. The Origins and Development of Abstract Expressionism in the United States. Unpublished Master's thesis. New York University, 1957. Appendix, notes from conversation with Adolph Gottlieb, May 15, 1955.

Rodman, Selden. *Conversation with Artists*. New York: Devin Adair, 1957.

Friedman, Martin. Interview with Adolph Gottlieb. East Hampton, 1962. Unpublished typescript of tape recordings. The Adolph and

Esther Gottlieb Foundation, New York. Tape 1A, pp. 1–24; 1b, pp. 1–29; 2A, pp. 1–23; 2B, pp. 1–26; 3A, pp. 1–31; 3B, pp. 1–52.

Sylvester, David. "Adolph Gottlieb: An Interview with David Sylvester." *Living Arts*, 1, June 1963, pp. 2–10.

Brown, Gordon. "A New York Interview with Adolph Gottlieb." *Art Voices*, 3, No. 2, February 1964, pp. 12–13.

Corita, Sister. "Art 1964." *Jubilee*, 12, December 1964, pp. 17–21.

Kashdin, Gladys. Conversation with Adolph Gottlieb. New York, April 28, 1965. Unpublished typescript of a tape recording, The Adolph and Esther Gottlieb Foundation, New York, pp. 1–20.

Jones, John. Interview with Adolph Gottlieb. New York, November 3, 1965. Unpublished typescript of a recording, Archives of American Art, Smithsonian Institution, Washington, D.C., pp. 1–19.

Hudson, Andrew. "Interview with Adolph Gottlieb." *The Washington Post*, July 31, 1966, quoted in Hudson, Andrew, "Adolph Gottlieb: An Artist Who is Surviving." *Art Magazine* (Canada), March–April 1978, p. 18–23.

Seckler, Dorothy. Interview with Adolph Gottlieb. New York, October 25, 1967. Unpublished typescript of a tape recording, Archives of American Art, pp. 1–27.

Hudson, Andrew. Dialogue with Adolph Gottlieb. New York, 1968. Unpublished typescript of a tape recording. The Adolph and Esther Gottlieb Foundation, New York, pp. 1–3.

Siegel, Jeanne. "Adolph Gottlieb: Two Views." *Arts Magazine*, February 1968, pp. 30–33. Transcript of an interview with Adolph Gottlieb, originally broadcast on WBAI-FM, New York, May 1967.

————. "Adolph Gottlieb at 70: I would Like to Get Rid of the Idea that Art is for Everybody." *Art News*, 72, December 1973, pp. 57–59.

C. Archival Material and Letters

American Artists' Congress. Papers. Archives of American Art, Smithsonian Institution, Washington, D.C.

Baumbach, Harold. Papers. Archives of American Art, Smithsonian Institution, Washington, D.C., containing letters from Adolph Gottlieb to Baumbach from Arizona, December 12, 1937–April 19, 1938.

Bodin, Paul. Letters from Gottlieb to Bodin from Brooklyn, Arizona and East Gloucester, Massachusetts, June 20, 1932–July 19, 1944. Collection of Paul Bodin.

Federation of Modern Painters and Sculptors. Papers. Archives of American Art, Smithsonian Institution, Washington, D.C.

Gottlieb, Adolph. Papers. Archives of American Art. Smithsonian Institution, Washington, D.C.

————. Papers. The Adolph and Esther Gottlieb Foundation, New York.

Kootz, Samuel M. Papers. Archives of American Art, Smithsonian Institution, Washington, D.C.

Pearson, Stephen. An Interview with Esther Gottlieb. Master's thesis, Hunter College, The City University of New York, 1975.

Provincetown Art Association. Papers. Archives of American Art, Smithsonian Institution, Washington, D.C.

Registrar's records for Adolph Gottlieb. The Art Student's League, Cooper Union, Parsons School of Design, New York.

D. One-Man Exhibition Catalogues (chronological)

Adolph Gottlieb: Paintings. Artists' Gallery, New York, December 28–January 11, 1943.

Newman, Barnett. *Adolph Gottlieb: Drawings*. Wakefield Gallery, New York, February 7–19, 1944.

Stroup, Jon. *Adolph Gottlieb*. 67 Gallery, New York, March 12–31, 1945.

Wolfson, Victor. *Adolph Gottlieb*. Kootz Gallery, New York, January 6–25, 1947.

Adolph Gottlieb. Jacques Seligmann Galleries, New York, January 24–February 12, 1949.

Kootz, Samuel M. *New Paintings by Adolph Gottlieb*. Kootz Gallery, New York, January 10–30, 1950.

Gottlieb: New Paintings. Kootz Gallery, New York, January 2–22, 1951.

Adolph Gottlieb. Kootz Gallery, New York, January 8–26, 1952.

Kootz, Samuel M. *Imaginary Landscapes and Seascapes by Adolph Gottlieb*. Kootz Gallery, New York, January 5–24, 1953. EP

————. *Adolph Gottlieb: An Exhibition of Recent Paintings*. Kootz Gallery, New York, April 5–24, 1954.

Greenberg, Clement. A *Retrospective Show of the Paintings of Adolph Gottlieb*. Bennington College Gallery, Bennington, Vermont, April 23–May 5, 1954 and Lawrence Museum, Williamstown, Massachusetts, May 7–23, 1954.

Adolph Gottlieb. Martha Jackson Gallery, New York, January 29–February 23, 1957.

Greenberg, Clement. An *Exhibition of Oil Paintings by Adolph Gottlieb*. The Jewish Museum, New York, November and December, 1957.

Adolph Gottlieb: New Work. André Emmerich Gallery, New York, January 3–31, 1958.

Adolph Gottlieb: New Paintings. André Emmerich Gallery, New York, January 5–31, 1959.

Greenberg, Clement. *Gottlieb: École de New York*. Galerie Rive Droite, Paris, April 3–30, 1959. rpt. of essay in exhibit., The Jewish Museum, 1957. text in French and English.

Adolph Gottlieb: Paintings 1949–1959. Institute of Contemporary Art, London, June 4–July 4, 1959.

Adolph Gottlieb. Paul Kantor Gallery, Los Angeles, April 27–May 23, 1959.

Adolph Gottlieb: New Paintings. French & Co., Inc., New York, January 1960.

Gottlieb. Galeria del Ariete, Milan, May 1961.

Gottlieb. Galerie Handschin, Basel, September–October 1962.

An Exhibition of Sixteen Recent Paintings by Adolph Gottlieb. Sidney Janis Gallery, New York, October 1–27, 1962.

Friedman, Martin. *Adolph Gottlieb*. Walker Art Center, Minneapolis, Minnesota, April 28–June 9, 1963.

————. *Adolph Gottlieb: Estados Unidos da America*. VII Bienal do Museu de Arte Moderna, Sao Paulo, September–December 1963. Text in English and Portuguese.

Adolph Gottlieb. Marlborough-Gerson Gallery, New York, February 18–March 3, 1964.

Adolph Gottlieb: Twelve Paintings. Marlborough-Gerson Gallery, New York, February 16–March 15, 1966.

Adolph Gottlieb. Hayden Gallery, Massachusetts Institute of Technology, Cambridge, Massachusetts, May 7–June 12, 1966.

Recent Works of Adolph Gottlieb. The Arts Club of Chicago, May 22–June 23, 1967.

Doty, Robert and Waldman, Diane. *Adolph Gottlieb*. The Solomon R. Guggenheim Museum, New York, February 14–April 7, 1968; The Whitney Museum of American Art, New York, February 14–March 31, 1968; The Corcoran Gallery of Art, Washington, D.C., April 26–June 2, 1968; and the Rose Art Museum, Brandeis University, Waltham, Massachusetts, September 9–October 20, 1968.

Adolph Gottlieb. Marlborough Galeria d'Arte, Rome, March 1970.

Landgren, Marchal E. *Gottlieb: Sculpture*. University of Maryland, College Park, Maryland, 1970.

Passoni, Aldo. *Adolph Gottlieb*. Gallerie Lorenzelli, Bergamo, May 1970.

Adolph Gottlieb: Paintings and Sculpture. Gertrude Kasle Gallery, Detroit, December 5–29, 1970.

Adolph Gottlieb: Works on Paper 1970. Marlborough Gallery, New York, February–March 1971.

Adolph Gottlieb: Acrylics on Paper. Norman Mackenzie Art Gallery, Regina, January 22–February 21, 1971; Edmonton Art Gallery, Alberta, March 4–28, 1971.

Adolph Gottlieb: Paintings 1959–1971. Marlborough Gallery, London, November 1971; Marlborough Gallery, Zurich, February–March 1972.

Adolph Gottlieb. Marlborough Gallery, New York, November 1972.

Adolph Gottlieb. Gertrude Kasle Gallery, Detroit, November 24, 1973–January 4, 1974.

Memorial Exhibition: Adolph Gottlieb. American Academy of Arts and Letter, National Institute of Arts and Letters, New York, 1975

Sandler, Irving. *Adolph Gottlieb: Paintings 1945–1974*. André Emmerich Gallery, New York, January 29–February 23, 1977.

Wilkin, Karen. *Adolph Gottlieb: Pictographs*. The Edmonton Art Gallery, Edmonton, Alberta, November 11–December 18, 1977; The Vancouver Art Gallery, Vancouver, British Columbia, January 5–February 12, 1978; The Glenbow-Alberta Institute, Calgary, Alberta, February 24–April 3, 1978; The Art Gallery of Windsor, Windsor, Ontario, April 12–May 14, 1978; Musée d'art contemporain, Montreal, Quebec, June 8–July 9, 1978; The Art Gallery of Ontario, Toronto, Ontario, July 22–September 3, 1978.

Adolph Gottlieb: Monotypes and Other Late Works. André Emmerich Gallery, New York, February 4–22, 1978.

MacNaughton, Mary Davis. *Adolph Gottlieb: Pictographs 1941–1953*. André Emmerich Gallery, New York, March 10–April 4, 1979.

Roberts, Miriam. *Adolph Gottlieb: Paintings 1921–1956*. The Joslyn Art Museum, Omaha, Nebraska, May 12–June 24, 1979; Phoenix Art Museum, Phoenix, Arizona, September 4–October 14, 1979, Currier Gallery of Art, Manchester, New Hampshire, March 9–May 4, 1980.

E. Articles and Reviews

Alloway, Lawrence. "The Biomorphic Forties." *Artforum*, 4, No. 1, September 1965, pp. 18–22.

————. "Melpomene and Graffiti." *Art International*, 12, April 1968, pp. 21–22.

———. "The New American Painting." *Art International*, 3, 1959, pp. 3–4, 21–29.

———. "Residual Sign Systems in Abstract Expressionism." *Artforum*, 12, No. 3, November 1973, pp. 36–42.

———. "Sign and Surface: Notes on Black and White Painting in New York." *Quadrum*, No. 9, 1960, pp. 49–62.

Anon. Review. "The Bienal's Best." *Time*, 82, October 4, 1963, p. 90.

———. "Konrad Cramer, Adolph Gottlieb, Dudensing Galleries." *Art News*, 28, May 17, 1930, p. 15.

———. "Revolt of the Pelicans." *Time*, June 5, 1950, p. 54.

———. "Wild Ones." *Time*, 67, February 20, 1956, p. 70.

———. "Young American Extremists: A Life Round Table on Modern Art." *Life*, 25, October 11, 1948, pp. 62–63.

Ashton, Dore. "Adolph Gottlieb at the Guggenheim and Whitney Museum." *Studio*, 175, April 1968, pp. 201–202.

Bowness, Alan. "Review," *The Observer*, London, June 7, 1959.

Cavaliere, Barbara. "Adolph Gottlieb." *Arts Magazine*, 53, No. 9, p. 4.

Cone, Jane Harrison. "Adolph Gottlieb." *Artforum*, 6, No. 8, April 1968, pp. 36–40.

Davis, Mary R. "The Pictographs of Adolph Gottlieb." *Arts Magazine*, 52, No. 3, November 1977, pp. 141–147.

Doty, Robert McIntyre. "Adolph Gottlieb: Printmaker." *The American Way*, 1, No. 6, 1968, n. pag.

Emmerich, André. "The Artist as Collector." *Art in America*, 46, Summer 1958, p. 25.

Fitzsimmons, James. "Adolph Gottlieb." *Everyday Art Quarterly*, No. 25, 1953, pp. 1–4.

Fried, Michael, "New York Letter." *Art International*, 6, October 25, 1962, pp. 75–76.

Friedman, B.H. "'The Irascibles': A Split Second in Art History." *Arts Magazine*, September 1978, pp. 96–102.

Goldwater, Robert. "Reflections on the New York School." *Quadrum*, No. 8, 1960, pp. 17–36.

Goosen, E.C. "Adolph Gottlieb." *Monterey Peninsula Herald*, May 12, 1954.

Greenberg, Clement. "After Abstract Expressionism." *Art International*, 6, October 25, 1962, pp. 24–32. rpt. in Geldzahler, *New York Painting and Sculpture, 1940–1970. New York: E.P. Dutton, 1969, pp. 360–371.*

———. "'American-Type' Painting." *Partisan Review*, 22, Spring 1955, pp. 185–196, rpt. in Greenberg, *Art and Culture: Critical Essays*, Boston: Beacon Press, 1961, pp. 208–235.

———. "Art." *The Nation*, 165, December 6, 1947, p. 629.

Hess, Thomas B. "The Artist as Pro." *New York Magazine*, December 1972, pp. 96–97.

———. "Reluctant Symbolist." *New York Magazine*, February 7, 1977, pp. 63–64.

Hudson, Andrew. "Adolph Gottlieb's Paintings at the Whitney." *Art International*, 12, No. 4 (April 20, 1968), pp. 24–29.

———. "Adolph Gottlieb: An Artist Who is Surviving." *Artmagazine*, Canada, March–April 1978, pp. 18–23.

Huxtable, Ada Louise. "Gottlieb's Glass Wall." *Arts Digest*, 29, January 15, 1955, p. 9.

Jewell, Edward Alden. "The Realm of Art: A New Platform and Other Matters: 'Globalism' Pops into View." *The New York Times*, June 13, 1943, p. 9.

J.L. "'Whitney Dissenters' Hold Their Own Exhibition." *Art News*, 38, No. 7, November 12, 1938, p. 15.

Kainen, Jacob. "Our Expressionists." *Art Front*, 3, No. 1, February 1937, pp. 14–15.

Klein, Jerome. "Ten Who are Nine Return for Second Annual Exhibition." *New York Sun*, December 19, 1936.

Kozloff, Max. "The Critical Reception of Abstract Expressionism." *Arts,*, 40, December 1965, pp. 27–33.

Kramer, Hilton. "Art: A Perspective on Adolph Gottlieb." *The New York Times*, March 23, 1979.

———. "Art: Two Periods of Adolph Gottlieb." *The New York Times*, February 15, 1968.

Newman, Barnett B. "La pintura de Tamayo y Gottlieb." *La revista Belga*, 2, April 1945, pp. 16–25. Text in Spanish.

O'Doherty, Brian, "Adolph Gottlieb: The Dualism of an Inner Life." *The New York Times*, February 23, 1964.

Polcari, Stephen. "Gottlieb on Gottlieb." *Nightsounds*, **New York, March 1969, p. 11.**

Rand, Harry. "Adolph Gottlieb in Context." *Arts Magazine*, 51, No. 6, February 1977, pp. 112–136.

Read, Sir Herbert and Arnason, H. Harvard. "Dialogue on Modern U.S. Painting." *Art News*, 59, May 1960, pp. 32–36.

Riley, Maude Kemper. "New York Exhibitions." *MKR's Art Outlook*, 1, No. 28, January 20, 1947, p. 2.

Rosenberg, Harold. "The Concept of Action in Painting." *New Yorker*, May 25, 1968.

Rosenblum, Robert. "Adolph Gottlieb: New Murals." *Art Digest*, 28, April 15, 1954, p. 11.

Rubin, William. "Adolph Gottlieb." *Art International*, 3, 1959, pp. 3–4, 34–37.

———. "The New York School—Then and Now." *Art International*, 2, May–June 1958, pp. 4–5, 19–22.

Sandler, Irving. "Adolph Gottlieb." *Art News*, 57, February 1959, p. 10.

———. "Adolph Gottlieb." *Art International*, **May–June 1977, pp. 35–38.**

Seckler, Dorothy Gees. "Adolph Gottlieb Makes a Facade." *Art News*, 54, March 1955, pp. 42–45, 61–62.

Tillim, Sidney. "New York Exhibitions: In the Galleries." *Arts*, 38, April 1964, p. 32.

Wilkin, Karen. "Adolph Gottlieb: The Pictographs." *Art International*, 21, No. 6, December 1977, pp. 27–33, prt. of catalogue essay also rpt. in Vanguard, Vancouver, December 1977–January 1978, n. pag.

II. General

A. Books and Catalogues

Alloway, Lawrence. *Topics in American Art Since 1945*. New York: W.W. Norton & Co., 1975.

Arnason, H.H. *American Abstract Expressionists and Imagists*. exhib. cat., The Solomon R. Guggenheim Museum, New York, 1961.

Ashton, Dore. *The New York School: A Cultural Reckoning*. New York: The Viking Press, 1972, pp. 1, 20, 34–35, 64, 68, 72, 77–78, 99, 118–119, 122–123, 127–129, 132, 147, 160, 168–171, 173, 184, 187, 209–210.

———. *The Unknown Shore: A View of Contemporary Art*. Boston: Little, Brown and Company, 1962, pp. 25–26, 57–59.

Carmean, E.A., Jr. and Rathbone, Eliza E. *American Art at Mid-Century: The Subjects of the Artist*. Washington, D.C.: The National Gallery of Art, 1978.

Celentano, Francis. The Origins and Development of Abstract Expressionism in the United States. Master's Thesis, New York University, 1957.

Frazer, Sir James George. *The New Golden Bough*. ed. Dr. Theodore H. Gaster, 1890; rpt. New York: New American Library, Inc., 1959.

Freud, Sigmund. A *General Selection from the Works of Sigmund Freud*. ed. John Rickman, M.D., 1937; rpt. Garden City: Doubleday & Company, Inc., 1957.

Geldzahler, Henry. *American Painting in the Twentieth Century*. New York: The Metropolitan Museum of Art, 1965, pp. 189–191.

———. *New York Painting and Sculpture, 1940–1970*. New York: E.P. Dutton & Co., 1969, pp. 30–32, 36, 366, 375, 378, 462–463.

Graham, John. *System and Dialectics of Art*. New York: Delphic Studios, 1937, rpt. Baltimore: Johns Hopkins University Press, 1971.

Greenberg, Clement. *Art and Culture: Critical Essays*. Boston: Beacon Press, 1961, pp. 216–217.

Guggenheim, Peggy. *Art of This Century: Informal Memoirs of Peggy Guggenheim*. New York: Dial Press, 1946.

Gruen, John. *The Party's Over: Reminiscences of the Fifties*. New York: The Viking Press, 1967.

Henry, Sara Lynn. Paintings and Statements of Mark Rothko (and Adolph Gottlieb), 1941 to 1949: Basis of the Mythological Phase of Abstract Expressionism. Master's Thesis, New York University, 1966.

Hess, Thomas B. *Abstract Painting*. New York: Viking Press, 1951, pp. 122, 125, 145.

Janis, Sidney. *Abstract and Surrealist Art in America*. New York: Reynal and Hitchcock, 1944, p. 88.

Jung, Carl G. *The Basic Writings of C.G. Jung*. ed. V.S. de Laszlo, New York: Modern Library, 1959.

Modern Artists in America. eds. Robert Motherwell, Ad Reinhardt, First ser. New York: Wittenborn-Schultz, Inc., 1951.

Motherwell, Robert. *Seventeen Modern American Painters*. exhib. cat., Frank Perls Gallery, Beverly Hills, 1951.

The New York School: The First Generation Paintings of the 1940s and 1950s. ed. Maurice Tuchman, Los Angeles: Los Angeles County Museum of Art, 1965.

O'Connor, Francis V. *The New Deal Art Projects: An Anthology of Memoirs*. Washington, D.C.: Smithsonian Institution Press, 1972.

Rose, Barbara. *American Art Since 1900*. Rev. ed. New York: Frederick A. Praeger, 1975, pp. 104, 112, 135, 138, 141, 161, 169, 170–171, 177, 192.

Rosenberg, Harold. *The Tradition of the New*. New York: Horizon, 1959; rpt. New York: Grove, 1961.

Sandler, Irving. The New York School: The Painters and Sculptors of the Fifties. *New York: Harper & Row, Publishers, 1978.*

———. *The Triumph of American Painting: A History of Abstract Expressionism*. New York: Harper & Row, 1970, pp. 6, 20, 23, 31–32,

41, 60, 62, 64, 67–69, 74, 79, 80–81, 88, 141, 163, 185, 193–201, 211–214, 216–217, 239.

Seckler, Dorothy. *Provincetown Painters, 1890's–1970's.* exhib. cat., Everson Museum of Art, Syracuse, New York, 1977, pp. 13–112.

Seitz, William. Abstract Expressionist Painting in America: An Interpretaton Based on the Work and Thought of Six Key Figures. Dissertation, Princeton University, 1955.

Sloan, John. *Gist of Art: Principles and Practice Expounded in the Classroom and Studio, Recorded with the Assistance of Helen Farr.* New York: American Artists Group, 1939.

B. Articles

Cavaliere, Barbara and Hobbs, Robert C. "Against a Newer Laocoön." *Arts Magazine,,* 51, No. 8, April 1977, pp. 110–118.

Elderfield, John. "Grids." *Artforum,* 10, May 1972, pp. 52–59.

Graham, John. "Primitivism and Picasso." *Magazine of Art,* 30, No. 4, April 1937, pp. 236–239, 260.

Hobbs, Robert C. "Early Abstract Expressionism: A Concern with the Unknown Within." *Abstract Expressionism: The Formative Years.* New York: The Whitney Museum of American Art, 1978, pp. 8–26.

Kagan, Andrew. "Paul Klee's Influence on American Painting: New York School." Part II, *Arts Magazine,* 50, No. 1 September 1975, pp. 84–90.

Levin, Gail. "Miro, Kandinsky, and the Genesis of Abstract Expressionism." *Abstract Expressionism: The Formative Years.*

Monroe, Gerald. "The American Artists' Congress and the Invasion of Finland." *Archives of American Art Journal,* 15, No. 1, 1975, pp. 14–20.

Motherwell, Robert. "The Modern Painter's World." *Dyn,* No. 6, November 1944, pp. 9–14.

Rosenberg, Harold. "The American Action Painters." *Art News,* 51, No. 5, September 1952, rpt. Geldzahler, *New York Painting and Sculpture, 1940-1970,* pp. 72-402.

Rosenblum, Robert. "The Abstract Sublime." *Art News,* 59, No.10, February 1961, rpt. Goldzahler, *New York Painting and Sculpture,* pp.351-359.

Rubin, William. "Arshile Gorky, Surrealism and the New American Painting." *Art International,* 8, No. 3, February 1963, rpt. Geldzahler, *New York Painting and Sculpture,* pp. 372–402.

————. "Pollock as Jungian Illustrator: The Limits of Psychological Criticism." *Art in America,* Part I, 67, No. 7, November 1979, pp. 104–123; Part II, 67, No. 8, December 1979, pp. 72–92.

Solman, Joseph. "The Easel Division of the WPA Federal Art Project." *New Deal Art Projects: An Anthology of Memoirs.* ed., Francis V. O'Connor. Washington, D.C.: Smithsonian Institution Press, 1972, pp. 115–130.